An Illustrated Glossary of Film Terms

Harry M. Geduld
Ronald Gottesman

AN illustrated Glossary of film terms

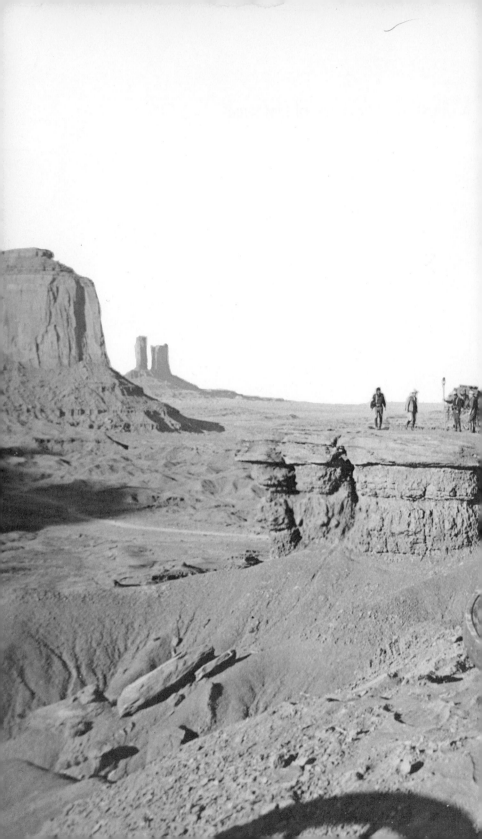

AN ILLUSTRATED
Glossary of film TERMS

HARRY M. GEDULD INDIANA UNIVERSITY

RONALD GOTTESMAN UNIVERSITY OF WISCONSIN

HOLT, RINEHART AND WINSTON, INC.

NEW YORK CHICAGO SAN FRANCISCO ATLANTA
DALLAS MONTREAL TORONTO LONDON SYDNEY

To *Dick, Felice, Fred and Jessie,*
Harry and Josie, Ron and Hilda—with affection.

Title page: A striking LONG SHOT from Warner Bros.' *Cheyenne Autumn* (1964). A John Ford-Bernard Smith production in Technicolor and SuperPanavision. Produced by Bernard Smith and directed by John Ford. Reprinted by permission of Warner Bros.

Library of Congress Catalog Card Number: 77-167811
ISBN: 0-03-086720-7
Printed in the United States of America
3456 090 987654321

prefAce

Dictionaries and glossaries of film terms have been published before and the usefulness of some of them has been more than adequately proven. But most, if not all, suffer from two shortcomings. That is, they are either too highly technical for the layman or beginning student or they lack illustrations and examples that relate their definitions to specific film experience. The present work has therefore been prepared with the intention of avoiding technical jargon and highly specialized terms out of the conviction that definition in the abstract is insufficient or irrelevant to the needs of the majority of film students or others interested in its special vocabularies. Whenever possible and appropriate, therefore, we have moved from the term and its general definition to specific instances or illustrations in important, available films. The illustrations are, basically, of two kinds: pictorial illustrations, consisting of line drawings and photographs; and verbal illustrations, consisting of descriptions of and references to pertinent examples from a wide range of well-known films.

It is worth emphasizing that in addition to terms usually found in other film glossaries, the reader also will find here definitions of terms used in film acting, film criticism, and film theory. As film study expands to include students of diverse training and interest, it is important that its roots and branches, its debts and relationships be understood as fully and clearly as possible. Moreover, appropriate bibliographical references have been provided so that the user will know where to pursue a specific topic of interest beyond the confines of the necessarily succinct definitions in this volume. In particular, we have directed users to standard works such as *The Focal Encyclopedia of Film and Television Techniques,* Raymond Spottiswoode's *Film and Its Techniques,* Roberts and Sharples' *A Primer for Filmmaking,* and to various volumes in the Hastings House Library of Communication Techniques—to all of which, of course, we are greatly indebted, and particularly to Focal Press Ltd., London for graciously permitting us to include thirty-eight diagrams from *The Focal Encyclopedia of Film and Television Techniques.*

The reader will be spared most of the inevitable nuisance of hunting down cross-references if he remembers that certain terms are clustered

for the sake of convenience and clarity. Some of the terms which contain a number of subdefinitions are:

ACTING	COLOR CINEMATOGRAPHY	PROCESSES
ANGLES	EDITING	SCRIPT
APERTURE	FILM	SHOTS
APPARATUS and EQUIPMENT	GENRE	SOUND
AUDIENCE RATING	LENS	SPECIAL EFFECTS
CAMERAS	LIGHTING	TITLES
CAMERA SPEED	PERSONNEL	TRANSITIONS

We wish to thank Phillip Leininger for believing in this book when it was only an idea, the Rutgers University Research Council for a grant which made some of the work on it possible, and Eric Krueger, Richard Henshaw, Mary Corliss of the Museum of Modern Art, and Valerie Gottesman and Carolyn Geduld for assistance of various kinds—all important. We're also grateful to Jane Ross and Ruth Chapman for patient and professional assistance in transforming a rough manuscript into a finished book.

Most important of all, though, were the careful, professional, and helpful readings of the manuscript by Professors Gerald Mast and Harlan M. Mendenhall.

H. M. G.,
Indiana University

R. G.,
University of Wisconsin, Parkside

CONTENTS

illustrations

abbreviations

abbreviations

AA	ACADEMY AWARD(S). See OSCAR.
ACE	American Cinema Editors (organization).
AFFS	American Federation of Film Societies (organization).
AFI	American Film Institute (organization).
AFM	American Federation of Musicians (organization).
AGVA	American Guild of Variety Artists (organization).
ALA	Authors' League of America (organization).
AMPTP	Association of Motion Picture and Television Producers, Inc. (organization).
AP	ANSWER PRINT.
ARRI	An ARRIFLEX camera. See CAMERA.
ASA	American Standards Association. Refers to the rating of SPEEDS of raw film emulsions according to standards set by the former American Standards Association.
ASC	American Society of Cinematographers (organization).
ASCAP	American Society of Composers, Authors & Publishers (organization).
BCU	Big (or bold) CLOSE-UP. See SHOTS.
BFI	British Film Institute (organization).
BG	Background.
BMI	Broadcast Music, Inc. (organization).
BNC	A MITCHELL sound camera.
BO	BOX OFFICE.
B/W or **B & W**	Black-and-white film. See MONOCHROME.
CCC	Central Casting Corporation (organization).
CU	CLOSE-UP. See SHOTS.
DGA	Directors' Guild of America (organization).
Diff.	Diffused (lighting).
Dir.	Director/Directed by. See PERSONNEL.
DP	(1) Day player. See ACTING. (2) Director of photography.
DS	DOLLY SHOT. See SHOTS.
DX	DOUBLE EXPOSURE.
ECU	EXTREME CLOSE-UP. See also XCU. See SHOTS.
EVR	Electric Video Recording. See CARTRIDGE.
Ext.	Exterior shot or scene conveying the impression of having been shot out-of-doors.
FC	Friars Club (organization).

FG FINE GRAIN. Refers to FINE GRAIN NEGATIVE or to quality MASTER POSITIVE print.

FIAF Federation Internationale des Archives du Film.

FPS FRAMES PER SECOND. Refers to the number of pictures filmed or projected per second.

FS FOLLOW SHOT. See SHOTS.

FX Effects.

HS HIGH SHOT/HIGH SPEED. See SHOTS.

IATSE International Alliance of Theatrical Stage Employees and Moving Picture Machine Operators of the United States and Canada (organization).

IDHEC Institute de Haute Etude Cinéma (associated with Cinématèque Français).

IMPPA Independent Motion Picture Producer's Association (organization).

INT. Interior shot or scene.

J.S.M.P.T.E. *Journal of the Society of Motion Picture and Television Engineers.*

KDs Portable dressing rooms used by actors on location or alongside a sound stage; can be "knocked down" and moved easily.

LA LOW ANGLE/LIVE ACTION. See SHOTS.

LD LAP DISSOLVE. See TRANSITIONS.

LS LONG SHOT. See SHOTS.

MCS MEDIUM CLOSE SHOT. See SHOTS.

MM. Millimeter.

MOS Without sound; silent. The term is supposed to have originated with a German-speaking director in Hollywood who apparently pronounced "without sound" as "mit-out sound."

MPAA Motion Picture Association of America, Inc. (organization of film distributors).

MPPDA Motion Picture Producers and Distributors of America (organization).

MS MEDIUM SHOT. See SHOTS.

NAME National Association of Media Educators (organization).

NATAS National Academy of Television Arts and Sciences (organization).

ND Nondescript: refers to details of properties or sets.

NET National Educational Television (noncommercial television network).

NFB National Film Board of Canada (film-producing organization).

NG No good: film material that cannot be used by the filmmaker.

NIT National Instructional Television (organization).

NVA	National Variety Artists (organization).
OS	OVERHEAD SHOT. See SHOTS.
OSS	OVER-THE-SHOULDER SHOT.
PBS	Public Broadcasting System (noncommercial television network).
Prod.	Producer/produced by. See PERSONNEL.
SA	SIDE ANGLE. See ANGLES.
SAG	Screen Actors' Guild (organization).
SCS	Society for Cinema Studies (organization); formerly known as the Society of Cinematologists.
SDG	Screen Directors' Guild.
SE	SOUND EFFECTS.
SEG	Screen Extras' Guild (organization).
SF	SOFT FOCUS.
SM	SLOW MOTION.
SMPTE	Society of Motion Picture and Television Engineers (organization).
SP	Silent speed.
SP-EFX	SPECIAL EFFECTS.
SP-FX	See SP-EFX.
SS	STOCK SHOT. See FILM: STOCK FOOTAGE.
3-D	THREE-DIMENSIONAL films or stereoscopic effects.
TR	TRUCKING SHOT/TRACKING SHOT. See SHOTS.
TS	TWO SHOT.
UFA	(1) University Film Association (organization); (2) Universum Film A.G. (German film company).
US	Under speed.
VCI	Variety Clubs International (organization).
VO	VOICE OVER.
WGA	Writers' Guild of America (organization).
WP	WORK PRINT.
X CROSSES:	Direction to actor in script, as in "Jack Xes to frame left."
XCU	EXTREME CLOSE-UP. See SHOTS.

GLOSSARY

A and B PRINTING: Used for 16mm release prints when the process of INTERNEGATIVE is by-passed. The method allows production of lap dissolves, fades, etc. in a release printer.

A and B WIND: Terms applied essentially to 16mm raw stock, with perforations only on one edge. The "wind" is of primary concern to the laboratory. Some film-printing machines require "A" wind and some "B" wind.

ABERRATION: An imperfection in lens focus. The lens does not bring all light rays to focus at the same place on film emulsion.

ABRASION: A mark on a film caused by the rubbing or scratching of its emulsion surface. Abrasions impair the quality of a film, and sometimes appear as lines cutting across the projected image. See also FILM: SCRATCHES.

ABSOLUTE FILM: An ABSTRACT FILM showing nonrepresentational designs or patterns in motion. Norman McLaren's films *Begone Dull Care* (1949), *Serenal* (1959), and *Horizontal Lines* (1962) are well-known examples.

ABSTRACT FILM: (1) An ABSOLUTE FILM. (2) A film in which the separate shots have a formal relationship but no representational or obvious content relationships. For an example of the first kind see ABSOLUTE FILM. An example of the second kind is Walter Ruttmann's *Opera* (1921) which Hans Richter describes as "improvisations with forms united by an accidental rhythm. There was nothing of an articulate language. . . ." On the ABSOLUTE and ABSTRACT FILM see further Hans Richter, "Avant-Garde Film in Germany," in Roger Manvell, ed., *Experiment in the Film*, 1949. See also Gregory Battcock, ed., *The New American Cinema*, 1967, on abstract films by such recent filmmakers as Bruce Baillie and Stan Brakhage.

ABSTRACT SET: A set used primarily for decorative purposes or for abstract or irrational work. Examples of abstract sets are frequent in Hollywood musicals—and particularly in the Busby Berkeley musicals of the thirties.

ACADEMY AWARDS (Abbrev.: AA): The annual awards of merit conferred by the Academy of Motion Picture Arts and Sciences on outstanding films and on distinguished members of the film industry. The awards recognize numerous categories of skills involved in professional filmmaking; these include: directing, screenwriting, composing, cinematography, acting, special effects, and sound recording. Established in 1927, when the Academy was founded, the awards take the form of golden statuettes, nicknamed OSCARS. The Academy itself consists of about 3000 elected members who are themselves distinguished members of the film industry. Specialist-members representing 13 categories select the nominated achievement in their own fields. However, the final awards are decided by the ballots of the entire membership of the Academy.

ACADEMY LEADER: See FILM.

ACADEMY STANDARDS: Standards pertaining to film material and practices established by the Academy of Motion Picture Arts and Sciences. Academy practices have been widely adopted—as may be exemplified by the term *Academy Leader,* which refers to a strip of film attached to the beginning of a movie reel that bears the name of the picture and relevant information for the projectionist. Academy Leader is designed and offered for sale by S.M.P.T.E.

ACCELERATED MOTION CINEMATOGRAPHY: See CAMERA SPEED.

"A" CERTIFICATE: A certificate bestowed on a film by the British Board of Film Censors; it indicates that the film receiving the award is not to be seen by children under 16 unless they are in the company of a parent or guardian. The certificate usually appears on the screen prior to the showing of the film. See also "H," "U" CERTIFICATES; RATING.

ACETATE FILM: See TRI-ACETATE FILM.

ACETONE: Principal ingredient of film CEMENT.

ACTING—STOCK CHARACTERS:

Anti-hero: "Anti-heroes (or non-heroes) are . . . loners. They are cynical men with no idealism at all but they have a strong personal code. *They* [unlike rebel heroes] do not 'drop out' [of society] but endure and conquer in a corrupt society. But the traditional hero and the anti-hero fight only

outside forces and always overcome their problems. Like the character Bogart introduced in *Dark Victory* [1939] then later played to perfection in *The Maltese Falcon* [1941] and *Casablanca* [1942], and the characters Dick Powell and Robert Montgomery portrayed in their postwar detective films, anti-heroes are sophisticated, know both sides of the law but are tough enough to win out while they maintain their personal code and are still romantic enough to get the girl." (Joe Morella and Edward Z. Epstein, *Rebels*: The *Rebel Hero in Films,* 1971.)

Bit Part: A minor but nevertheless differentiated role in a film: e.g., the role of the stewardess who retrieves Dr. Floyd's pen in Stanley Kubrick's *2001: A Space Odyssey* (1968).

Character Actor: An actor or actress who specializes in playing well-defined types. A well-known example is Eric Blore (1888–1959) who played the role of valet or butler in innumerable Hollywood movies.

Extra: See EXTRA and DAY PLAYER.

Flapper: A young girl, living in the 1920s, who dressed and behaved in daring or unconventional ways in defiance of the

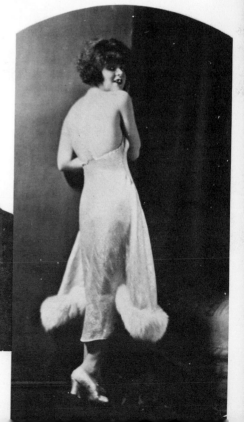

FLAPPER. Clara Bow, the "It" girl. Picture Collection, New York Public Library.

ANTI-HERO. Humphrey Bogart. Quigley Publications, 1946.

more conservative or reactionary mores of older people. Clara Bow (1905–1965), the celebrated "It" girl, specialized in such roles in films like *Dancing Mothers* (1926).

Heavy: The villain or "bad guy"—frequently a role for a CHARACTER ACTOR. Early screen villains were often fat or heavy men—hence the name. On the whole range of HEAVIES, see further: William K. Everson, *The Bad Guys* (1964) and Ian and Elisabeth Cameron, *The Heavies* (1969). Familiar contrasts among famous heavies are Peter Lorre (short and slight) and Sidney Greenstreet (tall and heavy).

Ingénue: The role of a guileless, innocent or inexperienced girl or young woman: e.g., Patty O'Neill (played by Maggie McNamara) in Otto Preminger's *The Moon Is Blue* (1953).

Juvenile: A young male; or the role of a young person, frequently a main or integral part. Among the most famous specialists in juvenile roles were Mickey Rooney (a juvenile) and Judy Garland (an ingénue), in such films as *Strike Up the Band* (1940). Dick Powell in Lloyd Bacon's *42nd Street* (1933) identifies himself to the heroine, Ruby Keeler, as a leading juvenile.

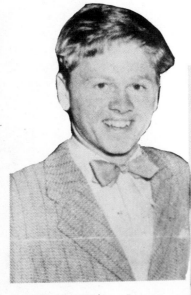
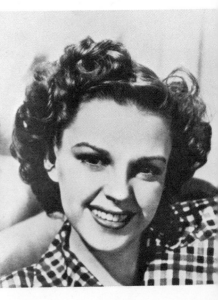

JUVENILE Mickey Rooney and INGENUE Judy Garland. Picture Collection, New York Public Library.

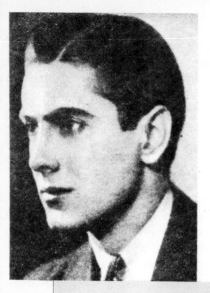

ROMANTIC LEAD. Tyrone Power.
The Herald Tribune, June 20, 1948.

ROMANTIC TEAM. Nelson Eddy and
Jeanette MacDonald. Picture Collec-
tion, New York Public Library.

Romantic Lead: The main or most important character (male or female) in a love story or musical picture. Rudolph Valentino (1895–1926) and Charles Boyer (1899–) were perhaps the most famous romantic leads in Hollywood films.

Romantic Teams: An actor and actress famous for co-starring as a young couple in love stories and/or musical pictures. Fred Astaire and Ginger Rogers, Walter Pidgeon and Greer Garson, Nelson Eddy and Jeannette MacDonald are celebrated examples of romantic teams.

Sidekick: The inveterate companion of the hero (or heroine), usually a humorous character and frequently played by a character actor. Well-known examples are George "Gabby" Hayes, sidekick to Roy Rogers, and Satch (Huntz Hall), sidekick to Leo Gorcey in many *Bowery Boys* films.

Stand-in: Surrogate for an actor who, after a scene has been blocked out, duplicates the actor's movements to enable lighting and camera movements to be plotted for the actual shooting of the picture.

Roy Rogers and Gabby Hayes in *Roll on Texas Moon* (Republic, 1946). Hayes was one of the best known SIDEKICKS of American films, appearing with Rogers in scores of films during the 1930s and 1940s. Wisconsin Center for Theatre Research, Blum Collection.

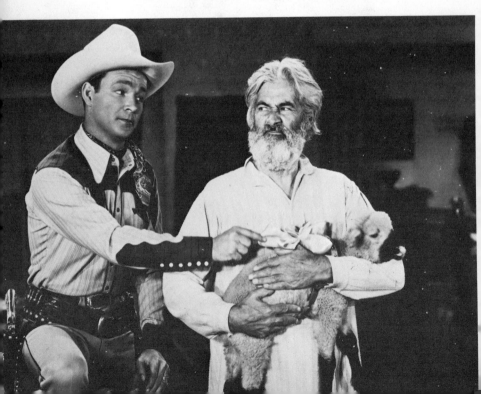

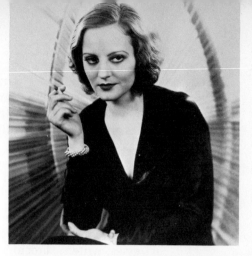

VAMP. Tallulah Bank-
head about to go to
work.

Vamp (Abbrev. of Vampire): A *femme fatale* or female charac-
ter who uses her feminine charms to beguile or seduce a
man, usually for destructive purposes. The first movie
"Vamp" was Theda Bara (real name Theodosia Goodman)
whose screen name was an anagram of Death Arab. She
first played the role in William Fox's *A Fool There Was*
(1914), based on a poem by Rudyard Kipling.

Walk-on: A minor role in which the actor or actress has no
actual speaking lines. The role is often more prominent than
that of an EXTRA but less differentiated than a BIT PART.

ACTION!: The director's order to cameramen to start shooting or for
the actors to begin a scene. (Also journal published by
DGA.)

ACTION NEGATIVE: See MUTE NEGATIVE.

ACTUALITIES: See GENRE, DOCUMENTARY.

ACTUAL SOUND: See SOUND.

ADAPTATION: The technique of changing a story, novel, play, or
poem so that it becomes suitable for filming. Many feature
films are adaptations. Famous examples include Olivier's
Henry V (1945) based on Shakespeare's play, and David
Lean's *Doctor Zhivago* (1966) based on Pasternak's novel.
Siodmak's *The Killers* (1946) and Kubrick's *2001: A Space
Odyssey* (1968) are notable examples of films adapted from
and amplifying short stories (by Ernest Hemingway and
Arthur C. Clarke, respectively). D. W. Griffith's *Pippa Passes*
(1909) was an attempt to adapt a poem (by Browning) to
the screen. For a lengthy bibliography of books and articles
on this aspect of filmmaking, see Gottesman and Geduld,
Guidebook to Film, 1971.

ADDITIONAL DIALOGUE: Lines written into the screenplay after it has been completed but before the film has been shot. Frequently the lines provide transitions whose need only becomes apparent when the film is being made.

ADDITIVE PROCESS: See COLOR CINEMATOGRAPHY.

AERIAL PERSPECTIVE: An impression of depth in a picture created by progressively diminishing detail as though caused by haze.

AGENT: In the film industry this refers to the person or persons who negotiate contracts or assignments on behalf of actors and actresses, writers, directors, and so on. Their job is to seek out assignments, and traditionally they receive 10 percent of every client's salary as commission. Billy Wilder's film *Sunset Boulevard* (1950) has some interesting scenes depicting relationships between a screenwriter and his agent.

AGF COLOR: See COLOR CINEMATOGRAPHY.

ALLEFEX: A machine for providing up to fifty different sound-effect accompaniments. Invented c. 1910 and used in conjunction with showing silent films. A picture of the machine appears in Frederick A. Talbot, *Moving Pictures*, opposite p. 140.

AMERICAN CINEMATOGRAPHER'S MANUAL: An official publication of the American Society of Cinematographers. Generally known, in the trade, as "The Bible" for motion picture cameramen.

AMERICAN SOCIETY OF CINEMATOGRAPHERS: Organization of professional motion picture cameramen. Dates from 1913 with the creation of the Static Club. The ASC was created in 1919 dedicated to the idea of promoting the motion picture as an art form. Its membership is now worldwide.

AMERICAN STANDARD SPEED: The generally accepted method of the American Standards Association (ASA) for estimating the SPEED of film emulsion in daylight lighting. The measurement is expressed in an ASA number.

ANAGLYPH PROCESS: A method of achieving a stereoscopic effect by printing a pair of pictures, each in a color that is complementary to the other, and superimposing them on the same strip of film. The pictures combine to give a three-dimensional effect when they are viewed through an anaglyphoscope—a pair of glasses with eyepieces of complementary colors.

ANAMORPHIC LENS: See LENS.

ANASTIGMAT LENS: See LENS.

ANDREOTTI LAW: A measure that placed the Italian film industry in the control of a government bureau. The law was passed by the Italian government on December 29, 1949. Named for Giulio Andreotti, head of the Direzione Generale dello Spettacolo, it bestowed on Andreotti's bureau powers of censorship affecting the entire Italian film industry. It also gave the Andreotti office the right to prohibit the export of Italian films that "might give an erroneous view of the true nature of our country." Several film historians have attributed the demise of Italian neorealist cinema to the effect of the Andreotti Law. See further George A. Huaco, *The Sociology of Film Art*, 1965, pp. 186, 192, 195–196. See also NEO-REALISM.

ANGLE OF VIEW: See LENS.

ANGLES: The directions of viewpoints from which the camera films the subjects, or the angles the filmmakers set up for particular shots. The main camera angles are:

Dutch: The camera is placed at any unusual angle. The aim is often to express the subjective state of a character or to produce a bizarre or disturbing effect. In Duvivier's *Un Carnet de Bal* (1938) an entire sequence, that of the heroine's visit to an old friend who she discovers is a criminal abortionist, is filmed Dutch angle. See *Night of the Living Dead* (1970).

Eye Level: The camera is located at normal eye level (five to six feet from ground level) in relation to the subject. This is often an undramatic viewpoint used mainly as a frame of reference for other angles. However, it can be strikingly effective when used to show a subject hurtling toward the camera: e.g., a fist or a speeding car. The Lumières' *Arrivée d'un train en gare* (1895) was probably the first dramatic use of the eye-level angle.

High (also called a "down shot"): The camera is located above the subject and shoots down at it. This has the effect of diminishing the height of the subject, reducing its importance and retarding the action of the film. Viewers have the impression that they are towering over the subject. High angles have been used to great effect in such films as *The Hunchback of Notre Dame* (1939), *Dr. Cyclops* (1940), and *The Incredible Shrinking Man* (1957).

Low: The camera is positioned below the subject. An angle that speeds up the action of the film and heightens the importance of the subject being filmed. Low-angle shots are frequently used in Welles' *Citizen Kane* (1941) to show Kane as a person who towered above his fellow men.

Reverse: The camera is positioned directly opposite another camera recording the same scene. Frequently used in filming conversation between two speakers or fight scenes in which the viewpoint switches from observing one boxer to observing the other as in Mark Robson's *Champion* (1949).

Side: The camera is positioned at approximately 30 to 90 degrees from the front of the subject. This can provide a greater sense of perspective and depth than is possible with low and high angles—depending on focal length of lens used; it can also be used to frame actions or subjects that are at a distance from one another but which the filmmaker desires to bring into meaningful relationships. Side-angle shots are frequently used in a long sequence in Alain Resnais' *Hiroshima, Mon Amour* (1959) during which Eiji Okada (the architect) pursues Emmanuele Riva (the heroine) at a distance through the streets of Hiroshima.

Subjective: The camera is positioned at an angle which suggests that it is the viewpoint of a specific character in the film. The angle will change as the character moves, sits, or stands, and so on. There are numerous examples in Robert Montgomery's *The Lady in the Lake* (1946) in which the entire story is told subjectively from the hero's viewpoint.

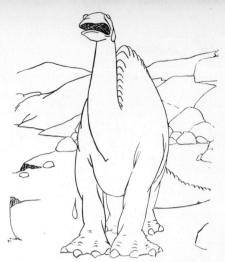

A drawing by Winsor McCay used in *Gertie the Dinosaur* (c. 1909), purportedly the first animated cartoon. Wisconsin Center for Theatre Research, Leibowitz Collection.

ANIMAL PICTURE: See GENRE.

ANIMAL STAR: An animal who has become famous for playing leading roles in popular films. Outstanding examples are the dogs, Rin-Tin-Tin and Lassie and the lioness, Elsa, in *Born Free* (1966).

ANIMATION:
The process of filming anything one frame at a time (i.e., drawings, designs, and people) so that when the film is projected the drawings or designs appear to move.

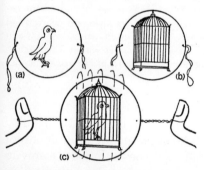

THAUMATROPE. Toy demonstrating PERSISTENCE OF VISION, devised by J. A. Paris (1826) on basis of P. M. Roget's experiments (1824). (a) Bird on one side of card. (b) Cage on reverse. (c) Twirling of card reveals bird in cage. From *The Focal Encyclopedia of Film and Television Techniques*, Focal Press, Ltd. Reprinted by permission.

ZOETROPE. Drum with viewing slits rotates on vertical axis and contains card showing phases of action. Brief viewing time through slits arrests action, and PERSISTENCE OF VISION makes motion seem continuous. From *The Focal Encyclopedia.*

Robert Montgomery and Audrey Totter in *The Lady in the Lake* (MGM, 1946). Filmed from the SUBJECTIVE CAMERA point of view, the action reveals the hero only occasionally in mirrors—as in this shot. Wisconsin Center for Theatre Research, Hamilton Collection.

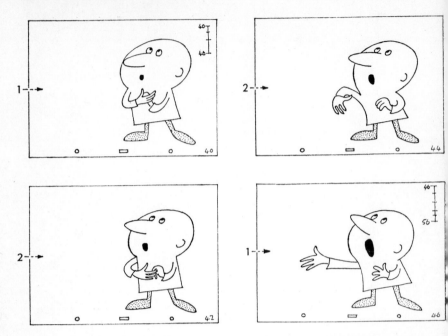

PLANNING OF CARTOON ANIMATION. 1. Extremes of movement de-
picted by animator provide key drawings and set style and character of
sequence. 2. Representative in-between animation drawn by assistant ani-
mators. Scale at upper right indicates span of frames within which action
has to be carried out and spacing of movement. From *The Focal Encyclo-
pedia*.

Cameraless Animation: The technique of drawing or painting
directly on film frames in order to create the illusion of mo-
tion when the film is projected. The technique seems to
have been used first in the 1920s by French surrealist film-
makers. More recently, Canadian filmmaker Norman Mc-
Laren produced some of the most interesting cameraless
animated films.

Cell Animation: Cell (or cel) is the name given to the transparent
celluloid material on which drawings are made in the tech-
nique of cell animation. This kind of animated film is usually
made by exposing one frame for each cell, on which there
is a slightly displaced image; the projection of the frames
creates the illusion of motion. Most animated cartoons, such
as those of Disney, and Hanna and Barbera, use this familiar
technique.

Puppet Animation: Animation in which three-dimensional figures rather than drawings or paintings are photographed. Between single-frame exposures, the puppet figures are moved very slightly. The displacement is eventually registered on the screen as an illusion of movement by the puppets themselves. The finest puppet-animation films are those of Jiri Trnka of Czechoslovakia. Trnka's most ambitious film so far is a puppet version of *A Midsummer Night's Dream* (1959). *King Kong* (1933), makes use of this technique also; Willis O'Brien, the director of special effects for this film, was an important innovator in the technique in the late 1920s.

Silhouette Animation: Frame-by-frame filming of silhouette figures and shapes which appear to move when the film is projected. The outstanding artist of the silhouette film is Lotte Reiniger, a German filmmaker, whose most ambitious work was a 65-minute silhouette film titled *Prince Achmed* (1926), based on an *Arabian Nights* story. See also PIXILATION.

ANIMATION CAMERA: See CAMERA.

ANSWER PRINT: See FIRST ANSWER PRINT.

ANTIHALATION BACKING: See HALATION FILM.

ANTI-HERO: See ACTING.

APERTURE:

Lens Aperture: An adjustable opening that limits the amount of light that can pass through a lens.

Camera Aperture: A masked orifice that restricts the area of each frame of film as it is exposed.

Projector Aperture: A masked orifice that restricts the area of each frame of film as it is projected. Also called *Aperture plate*.

Printer Aperture: An opening that limits the amount of light being used in a PRINTER while a film print is being made.

"A"-RATED PICTURE: A film that has received an "A" CERTIFICATE from the British Board of Film Censors (and thus not to be seen by children under 16 without parent or guardian). In the United States during the days of double-feature programs the "A" picture was also known as the number one feature.

APOCHROMATIC LENS: See LENS.

APPARATUS and EQUIPMENT:

Arc Lamp: A high-powered electric light used for studio lights and projectors. Its illumination is provided by an electric flow crossing a gap between two electrodes.

Baby: A 750-watt light used in lighting a set. Also called a "Seven-fifty."

Barney: A substitute for a BLIMP. It is either (1) a leaded container for a movie camera used in reducing camera noise, or (2) a blanket used to muffle the sound of the camera when shooting a sound movie with a silent camera.

Blimp: A soundproof camera housing that eliminates the noise of camera mechanism, which might otherwise interfere with the recording of dialogue. See also BARNEY.

Boom: A multiposition, mobile camera mount that is used for a wide variety of high-angle shots and to record sound. The term BOOM used to be associated with microphone positioning and CRANE used to refer to the camera mount, but the terms are now commonly used interchangeably.

Broad: A floodlamp that is used to light a set in a film studio. It gives flat, even lighting with few shadows. Often used as a FILL LIGHT.

Brute: A high intensity arc spotlight (10,000 watts) often used in illuminating sets during the making of color films. Sometimes called a "10 K."

Camera Tracks: Metal or wooden tracks or planks set down on the ground in order to carry a camera BOOM or CRAB DOLLY smoothly along a required straight line.

Clapboard (also called CLAPPER or CLAPSTICK): A board hinged to a SLATE. It can be opened and then clapped sharply down on the top edge of the slate to make a loud noise. This noise provides a sync mark or reference mark for the editor when he synchronizes soundtrack and visuals. Usually the clapboard is used to signal the beginning (and sometimes the end) of a TAKE. It is clapped down on the slate when the speeds of the picture and sound-recording devices are running at a proper, i.e., synchronous, speed. On the slate is written the number of the take and other information used in the editing process.

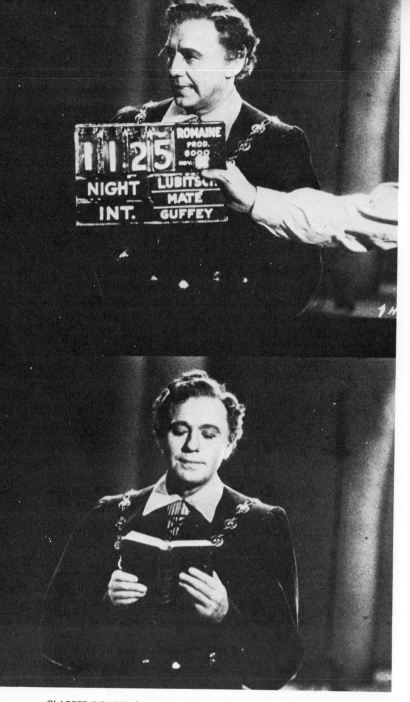

CLAPPER BOARD showing the beginning of a TAKE of Jack Benny delivering a soliloquy in Ernst Lubitsch's *To Be or Not To Be* (United Artists, 1942), in which Benny starred as a Polish Shakespearean actor who impersonates a German officer. Wisconsin Center for Theatre Research, United Artists Collection.

Core: A small plastic or metal rimless spool on which film is wound. Raw film stock is often wound on cores rather than on reels in order to prevent ABRASIONS that are likely to occur from winding the film unevenly on reels.

Crab Dolly: A small mobile DOLLY that can easily be moved in various directions thereby enabling the camera mounted on it to be put into the required position for filming a specific shot.

Crane: (1) A large BOOM; (2) a camera trolley that carries a jib or projecting arm supporting a microphone which can be extended out over a set.

Dolly: A mobile, usually wheeled, camera mount that is used, typically, to follow action at eye-level in what are called *dolly,* tracking, or trucking shots.

Editola: The trade name for a portable editing machine used for 35mm film.

Finder: A small tubular eyepiece that shows the field of view of the camera lens. Often held or worn round the neck of the director or cameraman.

Fishpole: A bamboo stick or any other kind of long pole to which a microphone is fixed; it is required for situations in which the use of a BOOM would be difficult, inconvenient, or impossible.

Flood: A lamp used for illuminating a film set during shooting. It provides a general "wash" lighting, but allows little or no focusing adjustments to be made.

Kem Universal Editing Table: A modern, sophisticated editing machine that has a great combination of capabilities. It can handle 8mm, Super-8, 16, 35, and 70mm film, sound and picture, and greatly speeds up the editing process.

Moviola: Strictly speaking this is the trade name of a kind of portable film-viewing machine frequently used in EDITING. The picture and sound can be run together, in synchronization, or may be run separately. The term "Moviola" has also become a generic name for any kind of editing machine, regardless of its brand name.

Photoflood: A high-intensity lamp bulb made of incandescent tungsten. It is often used in making color films.

Printer: A machine that makes PRINTS from an original film. See further PROCESSING.

MOVIOLA MECHANISM. Basic Moviola picture head used (often without feed and take-up spools) for picture editing. Film is placed under hinged aperture, 2, and examined through magnifier, 3. It is fed to and from aperture by continuous sprocket, 5, with loops at 4 and 6, between which is intermittent sprocket driven by Maltese cross, inset at 1. Reversible motor, 7, actuates mechanism. No shutter is used. From *The Focal Encyclopedia*.

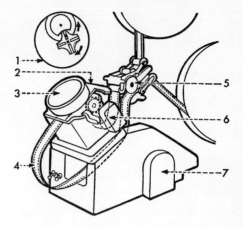

Recording System: The various devices that feed into a film or tape recorder: these often comprise microphones, monitors, mixers, compressors, and equalizers.

Recorder: A machine for making either optical or magnetic recording but not both. If the first, it is called an optical recorder; if the second, a magnetic recorder.

Reel: A spool on which film is wound. The term also refers to specific lengths of film: 1000 feet of 35mm film or 400 feet of 16mm film. This provides a showing time of about 12 minutes. A *full reel* (1200 feet) of 16mm film usually requires a showing time of 30 minutes. See also CORE.

Reflector: An aluminum foil or silvered reflecting surface used to direct sunlight where it is needed during the filming of an exterior scene. A soft reflector diffuses or softens the light reflected on the subject; a hard reflector works like a mirror.

Rewinds: Two geared "arms" used for rewinding film. Also used by an editor when he is passing film through a viewfinder. Some are hand-driven, some are motor-driven.

Rifle Spot: A spotlamp which provides a narrow beam of light. It is sometimes used in film studios. Also called a SNOOT.

Rigging: The studio light fixtures usually located above the sets. The *act* of rigging involves positioning studio lights in locations prior to their adjustment for the specific needs of a scene to be filmed.

Set: Constructed scenery providing a setting used for interiors or exteriors in filmmaking.

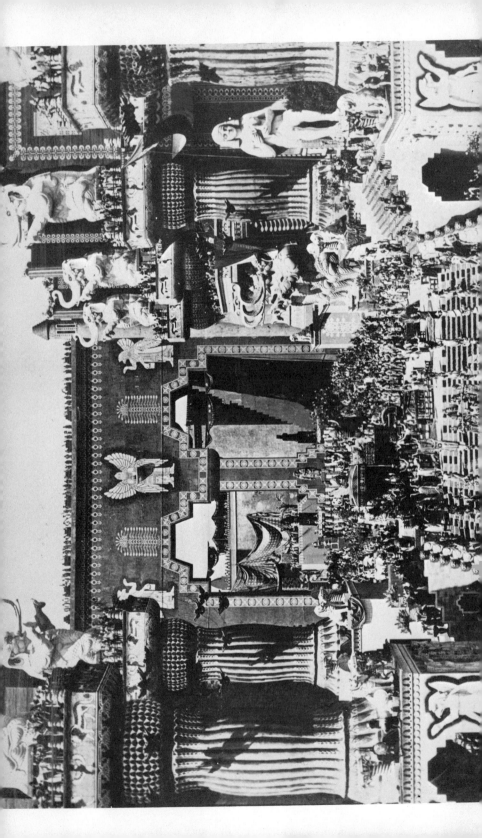

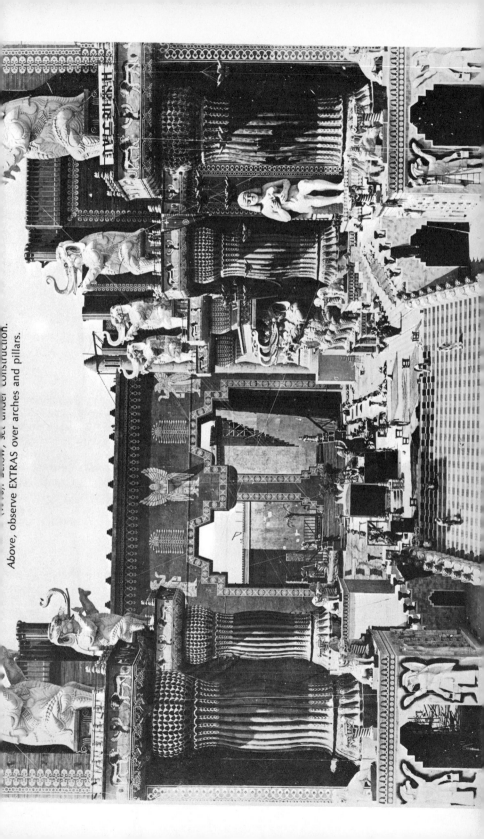

Above, observe EXTRAS over arches and pillars.

Slate: A notice board on which is chalked information that is filmed before or after each TAKE in order to identify the take when the film is edited. The CLAPBOARD is hinged to it.

Snoot: See RIFLE SPOT.

Softlite: A light that provides soft, diffuse illumination.

Sound Apparatus and **Equipment:** See SOUND.

Splicer: A machine used by a film editor in joining or patching strips of film together. Also called a SPLICING MACHINE.

Spotlamp: A lamp used to project a strong beam of light and to illuminate prominently scenes, persons, and so on. SPOT-LIGHT is the theatre term. See also BRUTE, FLOOD, PHOTO-FLOOD, RIFLE SPOT, SNOOT.

Sync Machine: See SYNCHRONIZER.

Synchronizer: A machine used in editing: it keeps the picture and the sound track in synchronization. Also called A SYNC MACHINE.

SYNCHRONIZER. Maintains synchronism between two or more lengths of film. It consists of two or more sprockets rigidly mounted on a revolving shaft. The films are placed on the sprockets and accurately positioned by their perforations, so that they can be moved along by rewinds while maintaining a proper synchronous relationship. Synchronizers are often provided with magnetic sound readers. From *The Focal Encyclopedia*.

Telephoto Lens: (1) A lens that has a focal length that is larger than normal. (2) A lens that helps produce enlarged photographs of objects at a distance. Magnification is usually much greater than with a normal lens.

Viewfinder: An optical device attached to the camera that provides a means of viewing through the camera lens the scene that is being filmed. There is usually compensation for PARALLAX.

ARC LAMP: See APPARATUS and EQUIPMENT.

ARRIFLEX: See CAMERA.

ART DIRECTOR: See PERSONNEL.

ART FILM: (1) The kind of movie usually shown exclusively in an ART HOUSE—e.g., such films as Wiene's *The Cabinet of Dr. Caligari* (1919) and Resnais' *Last Year in Marienbad* (1961). (2) A film about some aspect of painting and/or sculpture, e.g., Luciano Emmer's *Picasso* (1955).

ART HOUSE: A cinema theatre that specializes in showing films to audiences who are interested in film as art, to MOVIE BUFFS, to filmgoers who are attracted by the work of directors rather than movie stars, and to people interested in foreign, offbeat, and experimental pictures.

ART STILL: A photograph of a movie actor or actress.

ASA: See ABBREVIATIONS.

ASPECT RATIO: The ratio of the width to the height of the picture on the film or when the film is projected on a screen. The usual aspect ratio for theatrical films (not wide screen) is 1:1.85. The aspect ratio of narrow-gauge film is usually 4.3. Wide-screen aspect ratios may range from 1.65:1 through 2.55:1. The aspect ratio of television is 4:3. Also called FORMAT. See also WIDE SCREEN.

ASSEMBLE: See EDITING.

ASSISTANT DIRECTOR: See PERSONNEL.

ASSISTANT PRODUCER: See PERSONNEL.

ASSOCIATE PRODUCER: See PERSONNEL.

ATMOSPHERE: A general term for the various EXTRAS who appear as crowds in many motion pictures. Also a critical term for the mood created by the various elements of a film including sound, composition, pace, angles, sets, acting style, makeup, and lighting. James Whale, Ingmar Bergman, Alfred Hitchcock, Orson Welles, and Stanley Kubrick all excel at creating mood or atmosphere.

AUDIENCE RATING: An assessment of the worth, popularity of, or interest in a motion picture based on a poll or survey of audience reactions to it. The rating may be indicated in a verbal comment or in terms of a numerical or letter grade. Various devices and methods have been developed for ascertaining audience-ratings; among these are the following:

Analytical Preview: A SNEAK PREVIEW that is used for audience research. The audience may be shown either an uncut version or a final version of the film. Their opinions about the picture are then sought by either personal interviews or by mail questionnaires.

Audience-Appeal Index: Provides a rating of a film by questioning a sample proportion of the general population—including people who may not have seen the picture. The index is particularly helpful in ascertaining the success of advertising a specific film.

Cirlin Reactograph: A device invented by Bernard D. Cirlin. It records the reactions of the audience while they are watching a film. The individual viewer pushes a green button to indicate his approval of specific sections of the film and a red button to indicate his disapproval. Pressure on a button activates a stylus which records the individual reaction on a moving tape. The machine can be used with a totalizer which expresses on a graph the total reactions of the whole audience.

Hopkins Electric Televoting Machine: Each viewer of a film is given a dial marked with five possible responses to scenes in a film: very dull, dull, neutral, like, like very much. As the film is being shown, the viewer moves the hands to points on the dial that indicate his reactions to the picture. The reactions indicated are recorded on a tape in graphic form.

Lazarsfeld-Stanton Program Analyzer: A machine system similar to the CIRLIN REACTOGRAPH and differing from it only in minor technical details.

Schwerin System: A method of determining audience reactions to a film by having its viewers answer a questionnaire at intervals while a film is being shown. While the film is being projected, numbers are shown on a separate screen. Whenever one of these numbers appears, the individual members of the audience check one of the boxes alongside the corresponding number in the questionnaire. The boxes indicate: poor, fair, or good. No machine is used in this survey method.

AUDIO: See SOUND.

AUDIOTAPE: See CARTRIDGE.

AUTEUR: The dominant artistic creator or author of a film—usually the director—according to exponents of the AUTEUR THEORY.

AUTEUR THEORY: The "translation" by Andrew Sarris of the term *Politique des auteurs*. The theory is essentially an approach to film initiated in 1954 by filmmaker François Truffaut, in an article in *Cahiers du Cinéma,* and given somewhat clearer theoretical status by André Bazin in the April 1957 issue of the same journal. Basically it is a point of view that values the director as the dominant artistic author of a film (at the expense, chiefly, of the screenwriter and actors) and looks for the characteristic qualities of his technique and vision as they define themselves in his total output.

 Andrew Sarris, America's leading auteur critic, published his influential "Notes on the Auteur Theory in 1962" in the issue of *Film Culture* for winter 1962–63. Sarris indicates three premises of the Auteur Theory: (1) the technical competence of the director as a criterion of value; (2) the distinguishable personality of the director as a criterion of value; (3) interior meaning extrapolated from the tension between a director's personality and his material. These criteria and the auteur theory generally have been vigorously attacked by Pauline Kael in her essay, "Circles and Squares," in her book, *I Lost It at the Movies,* 1965. See also PANTHEON DIRECTORS.

AVANT-GARDE: Describes in a restricted sense the work of experimental and usually noncommercial filmmakers who flourished in France and Germany, c. 1916–1933 and who were closely associated with the dadaist and surrealist art movements. Germaine Dulac, Man Ray, Dali and Buñuel, Hans Richter and Erno Metzner were leading members of the avant-garde during this period. The term also applies in a general sense to any films of an abstract or experimental nature. See also ABSTRACT FILM and STRUCTURAL FILM.

BABY: A 750-watt light used in lighting a set. Also called a "Seven-fifty."

B & W: Common term for black-and-white, or monochrome, film. When film is processed, the brightness values of a scene are produced in tones of the GRAY SCALE.

BACKGROUND MUSIC: See FUNCTIONAL MUSIC.

BACKGROUND PLATE: A picture print made for BACK PROJECTION and other process work. See SPECIAL EFFECTS.

BACK LIGHTING: See LIGHTING.

BACK LOT: Part of the studio grounds next to the main lot on which the exterior sets are erected.

BACK PROJECTION: See SPECIAL EFFECTS: COMBINATION TECHNIQUES.

BALANCE: The relationship between the light and shade in a film.

BAREMO: A unique method of controlling and restricting foreign film imports into Spain established by the Spanish government in 1958 in retaliation for an earlier boycott of the Spanish film market by an American cartel, The Motion Picture Export Association. The baremo is "a system of calculation by which distribution companies are awarded points according to certain standards, the points becoming the basis upon which the government allocates import and dubbing permits. The more points a company has, the more foreign films it is permitted to import and distribute. . . . The baremo . . . has severely hindered American operations in Spain and has cost American companies a conservatively estimated $10,000,000 in business. . . . The accomplishment of the baremo is that it treats equally all distributors of equal size regardless of nationality." Thomas H. Guback, *The International Film Industry*, 1969, pp. 29–32.

BARNEY: See APPARATUS and EQUIPMENT.

BASE: See FILM: FILM BASE.

BEACH PARTY MOVIE: See GENRE.

BEADED SCREEN: A projection screen which has tiny glass beads embedded in its surface. Such screens provide a bright picture even when the projector light source is low-powered. See also SCREEN.

BEAULIEU: See CAMERA.

BEHIND-SIGNAL NOISE: See MODULATION NOISE.

BELL & HOWELL: See CAMERA.

BENSHI: In Japanese cinema during the silent period this was the name given to the live commentator who provided a narrative accompaniment to the films during a filmshow.

BIOGRAPH FILMS: (1) Films produced by the American Mutoscope and Biograph Company which flourished in the first decade of the twentieth century. (2) Films made by D. W. Griffith for the American Mutoscope and Biograph Company during 1908 through 1914—i.e., the one- and two-reel films in which Griffith developed most of the techniques he was to use in his major pictures. Biograph was the studio which provided the beginnings of many film careers: Sennett, Pickford, the Gishes, and so on. Today it seems the most impressive of the film companies established in America before World War I. See further Robert M. Henderson, *D. W. Griffith, the Years at Biograph,* 1970 and Kemp R. Niver, *Biograph Bulletins 1896–1908,* 1971.

BIOGRAPHY: See GENRE.

BIOGRAPHICAL PICTURE: See GENRE.

BIPACK: See COLOR CINEMATOGRAPHY.

BIT PART: See ACTING.

BIT PLAYER: An actor or actress who specializes in BIT PARTS.

BLACK COMEDY: See GENRE.

BLACKLIST: The names of persons who are or have been refused employment by the film studios—usually because they are politically "suspect" or unreliable or because they have a reputation for breaking contracts. The most famous blacklist was the one used against the HOLLYWOOD TEN. See further John Cogley, *Report on Blacklisting, I: Movies,* 1956, the special issue of *Film Culture* (Winter 1970–1971) devoted to movie industry blacklisting, and Dalton Trumbo, *Additional Dialogue,* 1970.

BLEND: A direction to an actor to remain close to another actor as he moves, so that both may be filmed in the same shot.

BLIMP: See APPARATUS and EQUIPMENT.

BLOCK BOOKING: A film rental arrangement which permits an exhibitor to rent a desirable (presumably very popular) film on condition that he rents (books) other films that may be less attractive to the public. This practice, which forces the exhibitor to book *en bloc* many films whose stars or even titles he may not know, enables the studios and distributors to guarantee income on all their films.

BLOOP: A small opaque patch over a splice in a positive sound track to prevent a "plop" in the speaker as the splice passes the sound head.

BLOOPER: On radio or television this refers to an unintentional funny or embarrassing mistake during a live performance; e. g. introducing President Herbert Hoover as "Hoobert Heever."

BLOW-UP: (1) The process of making a large GAUGE film from a smaller gauge one. (2) The process of making a photographic enlargement from a negative image. This last process is vividly depicted in Antonioni's film, *Blow-Up* (1967).

BLUE MOVIE: See GENRE.

BOLEX: See CAMERA.

BOMB: A film that is a disastrous failure; the term often refers, in a restricted sense, to a failure at the BOX OFFICE. *Cleopatra* (1962) was reputedly a bomb. Note also the use of the verb: TO BOMB, in reference to films and plays that are failures: cf. the title of Joseph Heller's play, *We Bombed in New Haven*.

BOOM: See APPARATUS and EQUIPMENT.

BOXING PICTURE: See GENRE.

BOX OFFICE: (1) The booth at the front of most cinemas where tickets of admission are sold. (2) A general term for the profits or finances of the film industry. A BOX-OFFICE FAILURE or FLOP, or BOMB is a film that has lost money or failed to produce adequate or expected profits for its investors. A BOX OFFICE TRIUMPH is a film that has made a fortune for its producers and investors. *Cleopatra* (1962) is said to have been a box office failure; *The Sound of Music* (1965) is a box office triumph. Box office is sometimes called FRONT OFFICE (which can also mean the studio business office.)

BOYCOTT: A collective refusal to buy, sell, or exhibit films from a specific source: a practice sometimes used by one country against another: e.g., Egypt boycotts films from Israel or films in which Israeli citizens or known sympathizers appear. The public treatment of Chaplin's *Monsieur Verdoux* (1947) and Kubrick's *Spartacus* (1960), scripted by Dalton Trumbo (see HOLLYWOOD TEN) may be cited as examples of informal boycotting. See also CENSORSHIP.

"B" PICTURE: A film intended as a SECOND FEATURE. In the 30s and 40s "B" pictures were often an important and highly remunerative part of a studio's output. They were specifically made as "B" pictures. This is seldom—if ever—studio policy today.

BREAKDOWN: An analysis of a screenplay in order to prepare a cost-analysis of the materials and personnel needed to make the film.

BREAK IT UP: A direction to shoot additional angles that will break up a single or extended shot in a scene.

BRIDGE: Any film material that links two parts (shots, angles, and so on) of the same scene. For example, the close-ups of the English Cross of St. George interpolated during the Agincourt sequence of Olivier's *Henry V*, showing Henry in various locations on the same battlefield. See also SHOTS: BRIDGING SHOT.

BRIGHTNESS RANGE: A maximum and minimum of light intensities of the subject to be filmed. Example: a range of one to 10 means that 10 times as much light is being reflected by the brightest highlights as from the least bright portion of the subject.

BRILLIANCE: The degree of intensity of light reflected by various colors.

BRITISH BOARD OF FILM CENSORS: The censorship authority of the British film industry (established in 1912). The board classifies films for audience suitability. See RATINGS.

BROAD: A panlike light, usually covered with etched, translucent glass. It gives off a soft, over-all illumination. Often used as FILL LIGHT.

BRUTE: See APPARATUS and EQUIPMENT.

BUCKLING: A condition of curling and twisting in film material that has been exposed to heat, that has shrunk, or has been stretched.

BUSBY BERKELEY, TO DO A: To make a lavish, spectacular musical or musical sequence in the style of director-choreographer Busby Berkeley, as exemplified in his films *Dames* (1934) and the *Gold-Diggers* series (1933–1937). Stills illustrating Berkeley's pictorial style may be seen in John Kobal, *Gotta Sing Gotta Dance: A Pictorial History of Film Musicals*, 1970,

"The Shadow Waltz" production number from Mervyn LeRoy's *Gold Diggers of 1933* (Warner Bros., 1933). BUSBY BERKELEY choreographed this spectacular dance routine in this early MUSICAL (see GENRE). Wisconsin Center for Theatre Research, United Artists Collection.

pp. 118–133. A pastiche of Busby Berkeley may be seen in *Singin' in the Rain* (1952); Ken Russell's *The Boy Friend* (1971) is a recent attempt to do a Busby Berkeley.

BUSINESS: A specific action or "turn" by an actor. Also any bit of incidental action by actors or extras to help give a scene reality. For example: a long shot of a cocktail party where guests (extras) are drinking, talking, and snacking.

BUSY BACKGROUND: A background with too much detail. Weakens impact of actors.

BUTT SPLICE: See EDITING: SPLICE.

CALIGARISME: French term for a film mood or style that resembles that of Robert Wiene's German expressionist film, *The Cabinet of Dr. Caligari* (1919).

CAMEO ROLE: (1) A small but outstanding part in a film: e.g., Julie Christie's brief appearance in *Billy Liar* (1963), the cameo role that began her rise to stardom. (2) A role played by a

big-name star giving a guest appearance (see GUEST STAR) as with many roles in *Around the World in 80 Days* (1956).

CAMERA: A device or apparatus for obtaining photographic images on motion picture film. There are essentially five kinds of cameras serving five main functions: (1) ANIMATION CAMERA: This is usually mounted on an animation stand; it photographs objects or scenes for an animated film by shooting from above. Its drive mechanism is adjusted so that it moves the film a single frame at a time. (2) FIELD CAMERA: A relatively portable non-BLIMPED camera for shooting exterior scenes. (3) HAND CAMERA: A battery-operated or spring-driven field camera light enough to be carried in the hand and used for close coverage of action scenes. (4) SINGLE-SYSTEM SOUND CAMERA: Used essentially in 16mm TV-news film work. This kind of camera records synchronous sound and picture on one strip of film in one operation. The sound is recorded optically or by use of magnetic stripe. The *Auricon* is the most widely used camera in this category. (5) STUDIO CAMERA: A large, complex mechanism used primarily in the studio—especially where dialogue is to be recorded. See further: CAMERA SPEED, SOUND CAMERA.

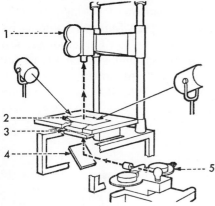

AERIAL-IMAGE ANIMATION PHOTOGRAPHY. Camera, 1, and motion picture projector, 5, are driven in synchronism. Projector produces aerial image in plane of cel, 2, through 45 degree mirror, 4, and large condenser lenses, 3. Optical system of camera picks up aerial image and transfers it to raw stock, thus enabling animated action on cels to be combined with live action on projected film. From *The Focal Encyclopedia.*

MAREY'S PHOTOGRAPHIC RIFLE (1882). 1. Ratchet, positioning areas of sensitized plate in turn behind aperture on release of trigger. 2. Sensitized glass plate showing 12 successive exposures of bird in flight. From *The Focal Encyclopedia.*

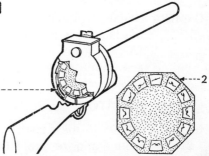

Arriflex: Brand name of a 35mm movie camera produced by the Arnold and Richter Company; colloquially known as an "Arri." Often used as second camera to the MITCHELL, it is widely regarded as the best camera for CINEMA-VERITE and on-location shooting. The cameraman using it is able to watch the scene being shot exactly as it is filmed through the lens. Arnold and Richter also manufacture 16mm Arriflexes: the Arriflex 16S and 16M.

Beaulieu: Brand name of an extremely lightweight, compact 16mm camera manufactured in France; the same company also makes a superior (and expensive) super 8mm camera.

Bell & Howell 70 (Filmo): Brand name of a popular lightweight, reliable 16mm camera, widely used in TV-news film work.

Bolex: Brand name of a popular, lightweight, reliable Swiss-made 16mm camera which provides for automatic threading of the film.

Eclair: Brand name of an extremely versatile movie camera which provides for the film to be threaded in the MAGAZINE— thus allowing the camera to be loaded very quickly. One model of Eclair (the 16/35) can, as its name indicates, be used with either 16mm or 35mm film stock.

Mitchell: Brand name of a 35mm camera, developed in 1919 by the Mitchell Company. Since 1928 Mitchell cameras have been standard equipment in American film studios. "Probably the major reason for the Mitchell's success is its rock-steady registration in the intermittent movement of the camera." (Kenneth H. Roberts and Win Sharples Jr., *A Primer for Film-Making,* 1971).

CAMERA ANGLE: See ANGLES.

CAMERA LOG: See REPORT or LOG SHEET.

CAMERAMAN: See PERSONNEL.

CAMERA NOISE: Noise made during shooting by a camera whose mechanism is not silenced. To avoid this, a SOUND CAMERA is usually employed in making sound movies. This has a soundproof housing or other sound-deadening material called a BLIMP.

CAMERA OPERATOR: See PERSONNEL.

CAMERA SPEED: In the days of silent cinema, cameras were spring-wound and the projectionist turned the projector by hand-

crank; producing the desired speeds was an art. Now driving mechanisms for cameras and projectors are electrically powered, and in certain modern cameras it is possible to vary the amount of film exposed per unit of time. For 16 and 35mm *sound* filming, the standard rate is 24 frames per second; for 8, 16, and 35mm, 16 frames per second is SILENT SPEED. For super-8 silent speed is 18 frames per second. If the filming is done at high camera speeds but projected at regular speed, the movement will appear in *slow motion* (as in the death of Bonnie and Clyde in that film); if the filming is done at slow camera speed but projected at regular speed, the effect of *accelerated* high speed or *fast motion* is created (often with comic effect as in a bedroom scene in *A Clockwork Orange* [1971]). Special or shock effects can be achieved in *stop-motion* photography, in which the camera is stopped while the scene is changed in some way (producing the familiar effect of a photograph "coming to life") or in *reverse motion,* where action depicted is shown in the reverse sequence (e.g., a statue reassembling itself piece by piece as in *October* [1928] or a swimming pool emptying itself of people). *Time-lapse cinematography,* which can show a flower opening in a few seconds, is an extreme form of accelerated or fast motion cinematography. *Frame freezing* involves the repetition of a single frame a number of times so that motion is eliminated altogether: e.g., the closing shot of *The Fellini-Satyricon* (1970), and the final shot of Truffaut's *The 400 Blows* (1959). See also PROJECTION SPEED(S).

CAMERA-STYLO: A term coined by French filmmaker and theorist Alexandre Astruc and used popularly in reference to stylistic features of NEW WAVE films. In his essay on the Caméra-Stylo (in English translation) in Peter Graham, ed., *The New Wave,* 1968), Astruc asserts that "this new age of cinema is the age of the caméra-stylo (the camera-pen)," that the filmmaker now writes his personal philosophy with a camera just as Descartes wrote *his* philosophy with a pen. Cinema has become a language in which to express "any sphere of thought."

CAMERA TEST: (1) The trial filming of an actor or actress to ascertain his or her suitability for the movies in general or for a specific role. (2) Try-out of make-up or costumes by filming them briefly to determine their effectiveness. (3) Try-out of

exposure or development conditions for filming by shooting a small amount of trial film.

CAMERA TRACKS: See APPARATUS and EQUIPMENT.

CAN: A container usually of metal or strong plastic in which a film may be stored or carried around. When a film production is said to be "in the can," it has been shot and edited and is ready for release.

CAPTION: A title or text that precedes a scene or sequence and which explains it, arouses interest or curiosity, or indicates the passage of time. The term was used during the silent period for what is now sometimes called an INSERT TITLE.

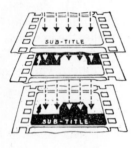

CAPTIONS, credit lines, or the translation of foreign dialogue are usually photographed on a continuous band of transparent film, which is overlaid on the picture negative and printed simultaneously. From *The Focal Encyclopedia.*

CARTOON: See ANIMATION.

CARTRIDGE: A plastic unit containing film or tape that can reproduce sound (and color) pictures of high quality through a standard television receiver. (Similar units are now available for use with film projectors.) Cartridges enable the individual to select, arrange, and show programs using the television set as the projector and screen; a few cartridge systems also provide the capability of making and then playing one's own television "shows." Four of the numerous cartridge systems being currently promoted are:

Videotape/Audiotape: Used in the VIDEOCORDER (a Sony product) to record and play back. A tape system; film is not used.

EVR: Electric Video Recording: a cartridge system using photographic film.

Holographic System: Utilizes HOLOGRAPHY to implant HOLOGRAMS on vinyl tape. It is expected that this system will, in the near future, be used to reproduce 3-D moving images

on giant wall screens that can be installed in private homes. (An RCA product.)

Super 8: TECHNICOLOR 1000: An "endless loop" cartridge system using sprocketless film that can be automatically threaded into an adapted Super-8 home projector. The projected pictures can be shown on giant wall screens. (A product of Bell & Howell, Kodak, Bohn-Benton, MPO, and Jay-Ark.)

CASSETTE: A cartridge or container into which film is loaded prior to insertion into a camera. Insertion of the cartridge into the camera facilitates or simplifies loading the camera. See also CARTRIDGE, VIDEO-CASSETTES.

CAST: The actors and actresses appearing in a film, or a list of these opposite the roles they play in the film.

CASTING DIRECTOR: See PERSONNEL.

CATCHLIGHTS: Reflections of a light source made in the eyes of a subject when filmed close-up.

CELL ANIMATION: See ANIMATION.

CELLS: See CELLULOID.

CELLULOID: (1) The transparent base material which is coated with photo-sensitive emulsion to make movie films. (2) The transparent sheets on which animated pictures are drawn or painted to provide cells for CELL ANIMATION. (3) Used figuratively to signify films or motion pictures—e.g., "celluloid villain."

CEMENT: Adhesive used in splicing film. See ACETONE.

CENSOR: A person engaged in the CENSORSHIP of movies.

CENSORSHIP: The work of a film censor: i.e., the examination of films for the purpose of removing or prohibiting anything in them deemed unsuitable for public viewing by the censor under the code of standards by which he is operating. Censorship may be by PRIOR RESTRAINT or it may be applied after the film has been shown to the public. See further: Richard S. Randall, *Censorship of the Movies,* 1970. See also: BRITISH BOARD OF FILM CENSORS, BOYCOTT, HAYS OFFICE, JOHNSTON OFFICE, MOTION PICTURE PRODUCTION CODE.

CHAMBER FILMS: See GENRE.

CHANGE-OVER: The act of changing from one projector to another, while showing a multireel film, so audience gets impression of a continuous film.

CHANGE-OVER CUE: The signal for projectionist to change from one projector to another. It is made with a series of small spots or other marks in the top, right-hand corner of certain frames near end of the reel.

CHARACTER ACTOR: See ACTING.

CHARLOT: French nickname for Charlie Chaplin (1889–).

CHASE FILM: See GENRE.

CHEAT: An actor *appears* to look at another actor—or at some object, but really "cheats" the angle of his glance to aid the shot's composition. A typical direction is "cheat it out" or "cheat it toward the camera."

CHEATER-CUT: Footage cut in at the beginning of a serial episode (after the first one) to show how the hero or heroine escaped disaster in the previous episode.

CHEAT SHOT: See SPECIAL EFFECTS.

CHILD STAR: A child who has become famous for playing leading roles in popular films. The most outstanding example was Shirley Temple (b. 1928) who for several years in the mid-thirties was the highest-salaried film star in Hollywood.

CHILDREN'S FILM: See GENRE.

CINCH MARKS: Vertical scratches or ABRASIONS that result from pulling the end of the film in an attempt to tighten up a roll of film that has been wound too loosely. The layers of film abrade one another when the film is pulled in this way.

CINEMA-NOIR: See GENRE.

CINEMASCOPE: See PROCESS.

CINEMATOGRAPHE: A combined camera, projector, and printer designed by the brothers Louis and Auguste Lumière and used by them in presenting the world's first public film show, in the Salle au Grand-Café, 14 Boulevard des Capucines, Paris, December 28, 1895.

CINÉMA-VERITÉ: "Technological advances brought about the introduction of light 16mm cameras capable of taking synchronous sound. For the first time, the filmmaker could record the sound and images of people simultaneously without complicated setups, following his picture wherever it went and filming it, if he wished, without a script, directly from life. This method of filming is sometimes called cinéma-verité or direct cinema." (Edward Pincus, *Guide to Filmmaking*, 1969.) Cinéma-verité is thus a style of filmmaking which plays down the technical means of selection (script, apparatus, special lighting, unusual angles, artificial transitions, complex editing, and so on) at the director's disposal and emphasizes instead the circumstantial reality of the scenes recorded—often by a HAND-HELD camera. The actors and/or nonactors who appear in such films must be photographed spontaneously—not after elaborate rehearsal. Jean-Luc Godard is among the most famous directors who have utilized this method.

CINEMIRACLE: See PROCESS.

CINEORAMA: See PROCESS.

CINERAMA: See PROCESS.

CINEX STRIP: A strip of positive film that laboratories send along with the rushes in order to assist the cameraman. Each frame on this strip shows the same scene in a different printer light, ranging from very light to dense. With this strip the cameraman can see immediately how any specific shot would appear if printed in a different printer light from that chosen for printing the rushes.

CIRCARAMA: See PROCESS.

CIRCLE OF CONFUSION: The size of an image point, formed on the film emulsion by a particular lens. When determining the maximum performance of a lens, this is a decisive factor. The smaller the circle, the better the lens.

CIRCUIT THEATRE/CIRCUIT MOVIEHOUSE: A cinema house that belongs to a chain of dealers which generally receives the same movies, either simultaneously or in rotation by district.

CIRLIN REACTOGRAPH: See AUDIENCE RATING.

CLAPBOARD: See APPARATUS and EQUIPMENT.

CLAW: A metal tooth in the camera (or projector) intermittent mechanism. It engages the film perforation and pulls the film through the gate a frame at a time.

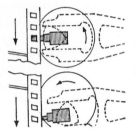

CLAW. Device used in cameras and narrow-gauge projectors. The claw engages perforation, pulls down the film a distance equal to the height of one frame, and then withdraws to the initial position. Double claws are often used so that if a perforation is broken, the next one is engaged. From *The Focal Encyclopedia.*

CLEAN SPEECH: Satisfactory delivery of a speech by an actor as he is being filmed.

CLEAR: Order to an actor to see that nothing is obstructing a clear view of him when the scene in which he appears is being filmed.

CLIFFHANGER: See GENRE: SERIAL.

CLIP (FILM CLIP) (See also PREVIEW): (1) In reference to TV news film this signifies a completed news film story. (2) A relatively small piece of a larger film either shown for its intrinsic interest, to illustrate something else, to advertise a whole film, or a piece of film which is itself incorporated into a longer film—e.g., the brief glimpses of Johnny Weismuller as Tarzan in Karel Reisz's film *Morgan* (1966). The clips represent mental projections of Morgan's self-images.

CLOSE-SHOT: See SHOTS.

CLOSE-UP: See SHOTS.

CLOSE-VIEW: During the silent film period this term was used instead of CLOSE-UP.

CODE NUMBERS: Corresponding numbers printed, during editing, at one foot intervals along the edge of the sound track and the images to be synchronized with it. These numbers provide a simple sync code for use by the editor of the film.

COLD LIGHT: A light that contains very little red value. It produces much less heat than is produced by incandescent lights. The light is produced by mercury-arc-vapor and fluorescent lamps.

COLD READING: An unprepared reading of a part or lines from a screen-play by an actor who is being considered for a role.

COLOR BALANCING (also called COLOR TEMPERATURE): Suitable kind and adequate amount of light for the correct exposure of color films. The higher the temperature of the light, the bluer the light; the lower the temperature, the redder the light.

COLORBLIND FILM: See FILM.

COLOR CINEMATOGRAPHY:

> **Additive Process:** A technique for color-film reproduction that avoids the use of colored pigments. It applies or *adds* the light of the primary colors, red, green, and blue, to the film surface. The additive process is still in use for color television but is no longer employed in making color movies. See also COLOR CINEMATOGRAPHY: SUBTRACTIVE PROCESS.

ADDITIVE COLOR PROCESS. System based on the addition of the light of red, green, blue, on a single surface rather than by the use of colored dyes or pigments within a three-layer recording medium. From *The Focal Encyclopedia*.

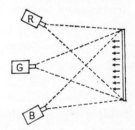

> **Agfacolor:** An integral TRIPACK color-film process for making color movies; first produced in Germany in 1940.

> **Bipack:** Another name for INTEGRAL TRIPACK COLOR FILM: See COLOR CINEMATOGRAPHY: INTEGRAL TRIPACK.

PROCESS CAMERA loaded for BIPACK PRINTING. 1. Unexposed duplicating negative raw stock, wound emulsion in, so that at aperture it prints emulsion-to-emulsion with master positive film in chamber, 2, wound emulsion out, 4, 5. Corresponding take-up chambers. When matte board, 3, facing camera, is white and uniformly illuminated, this set-up functions as a step printer, the films moving forward intermittently frame by frame. If chosen areas of matte board are blackened, there is no exposure and selective printing takes place. From *The Focal Encyclopedia*.

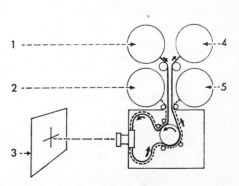

Eastmancolor: A TRIPACK color-film process first produced in the U.S.A. in 1952.

Ektachrome: A TRIPACK reversal film process for making 16mm original films in color from which viewing prints in color may be made.

Ferraniacolor: A color process similar to AGFACOLOR; first produced in Italy in 1953.

Integral Tripack: A three-layer emulsion, each layer of which is photosensitive to a different primary color; also called MONOPACK, BIPACK.

Kinemacolor: The earliest commercially used color system. It involved the use of rotating blue and white filters in front of the camera lens. The system was first introduced by Charles Urban in 1908.

Monopack: Another name for INTEGRAL TRIPACK color film. Called monopack because the three layers of the emulsion are imposed on a single base material.

Sovcolor: A TRIPACK color process similar to AGFACOLOR. Developed in the Soviet Union c. 1948.

Subtractive Process: A method of color reproduction using pigments to *subtract* or filter out from white light each unwanted primary color and then transmitting the primary color(s) required. This is the most frequently used color-film process. See also ADDITIVE PROCESS.

Technicolor: The best-known and formerly most extensively used process of color cinematography. It involves the use of a special camera and the making of three negatives (which register separately the blues, reds, and yellows of the scenes being shot) from which a color print is ultimately processed in a way that resembles color lithography. The process was invented by Herbert T. Kalmus and Daniel F. Comstock, c. 1917. *Technicolor monopack,* first marketed in 1942, was a color system involving only a single negative. Technicolor now uses Eastmancolor film. See also FILTERS, MONOCHROME, MULTILAYER COLOR FILM, and TINTING.

COLOR TEMPERATURE: See COLOR BALANCE.

COMEBACK: An attempt by a former or retired movie star to reestablish his or her career and popularity by appearing in a new movie. Gloria Swanson made a comeback in *Sunset Boulevard* (1950).

COMMENTATIVE SOUND: Source of sound is not visible in the picture, nor has the action implied it to be present. Examples: music, commentary, subjective sounds heard by viewer suggesting they come from mind of the actor.

COMPILATION FILM: See GENRE.

COMPILED MUSIC: See KINOTHEK.

COMPOSER: See PERSONNEL.

COMPOSITE FILM: See GENRE.

COMPOSITE PRINT: A positive print carrying both picture images and a sound track.

COMPOSITION: (1) The arrangement of a scene to be filmed. (2) The arrangement of a scene as it is viewed on the screen.

CONSOLE: The keyboard or controls section of a cinema pipe organ. See further ORGANS.

CONTINUITY GIRL: See PERSONNEL.

CONTACT PRINT: A copy of a film made by overlaying raw footage along the length of a master print in a continuous printer also called a CONTACT PRINTER.

CONTACT PRINTER: See CONTACT PRINT above; also OPTICAL PRINTER, STEP PRINTER.

CONTRASTS: The extent of the difference between light and shade in a picture.

CONTRASTY REPRODUCTION: See FILM: PRODUCTION.

CORE: See APPARATUS and EQUIPMENT.

CORNER INSERT: See SPECIAL EFFECTS.

COSMETICIAN: See PERSONNEL.

COSTUME DRAMA: See GENRE.

COSTUMER: See PERSONNEL: ART DIRECTOR.

COSTUME DESIGNER: See PERSONNEL: ART DIRECTOR.

COUNTER: An indicator on the camera that shows how much film has been exposed, or how much remains to be exposed.

COVERAGE: The number of shots and angles filmed in addition to the shooting of an over-all view of the set or scene.

CRAB DOLLY: See APPARATUS and EQUIPMENT.

CRANE: See APPARATUS and EQUIPMENT.

CRAWLING TITLE: See TITLE.

CREDIT TITLE: See TITLE.

CREEPER-TITLE: British term for CRAWLING TITLE.

CRITICAL FOCUS: The precise distance from the camera to whatever it is filming as shown on the focusing ring of the lens. Called "critical" because it is the point at which the particular lens at the particular aperture is most perfectly in focus.

CROSSCUTTING: A method of interweaving the shots of at least two episodes, actions, or stories during the editing of a film. The purpose of this is to achieve PARALLEL ACTION. D. W. Griffith used crosscutting extensively in *Intolerance* (1916). Crosscutting is also called *intercutting*. See also TRANSITIONS.

CROSS FADE: See TRANSITIONS.

CROSS IN/CROSS OUT: The movement of an actor either in making an entrance into a scene from one side of the frame or in making an exit from a scene from one side of the frame.

CROSSLIGHTING: See LIGHTING.

CROSS MODULATION: A kind of sound distortion characteristic of VARIABLE AREA recording in negative film.

CROSS MODULATION TEST: A means of ascertaining the maximum print density that allows the minimum of sound distortion in negative films with a variable area sound track.

CRAWFOOT: Spiderlike device on the feet of a tripod. Holds tripod legs steady on very slippery floor surfaces.

CUE: The signal for an actor to begin.

CUE SHEETS: Musical compositions—usually prepared set pieces—arranged and timed for the use of musicians providing accompaniment to silent films and supplying appropriate moods. Cue sheets were probably first prepared by Bert Ennis at the Vitagraph Studios, in Flatbush, Brooklyn, New York, in 1910.

CUE TRACK: A sound track, not intended for use in the final production. It is used only to get an exact audio record of the dialogue in the scene. Generally used on exterior location scenes

when wind, automobiles, airplanes, etc., make it impossible to use original sound. The sound used in final production will be postrecorded. See DUB-IN.

CULT MOVIE: A film that becomes the focus of a social group and which exemplifies or inspires the life-style of that group. Recent examples are Dennis Hopper's *Easy Rider* (1969) and Kubrick's *2001: A Space Odyssey* (1969). Walt Disney's *Fantasia* (1940) has become a cult movie for potheads.

CUT BACK: See TRANSITIONS.

CUT IN: An insert or a close-up added to a scene at any place after the scene begins or before it ends.

CUTOUTS: Small, jointed, cut-out shapes or figures used in ANIMATION. They are put into successive positions, each position being filmed in one or two frames. When projected the film conveys the impression that the shapes or figures are moving. See also ANIMATION.

CUTTER: See PERSONNEL.

CUTTING: See EDITING and MONTAGE.

CUTTING ROOM: The place where the film is edited.

CUTTING SYNC. See EDITING: SYNCHRONISM.

DAILIES: See EDITING: RUSHES.

DAY-FOR-NIGHT SHOOTING: Scenes filmed in the daylight but given the quality of night photography either by the use of special camera filters on set or during special processing.

DAY PLAYER: An actor who is hired a day at a time to work on a film.

DEADPAN: Unsmiling or emotionless facial expression. A term frequently used to describe Buster Keaton's face.

DEADPAN. The face of silent comedian Buster Keaton.

DEDICATION: A preliminary title indicating that the film is in honor of or out of respect for a person or institution. Erich Von Stroheim dedicated *Greed* (1923) to his mother; many war films have been dedicated to the specific branch of the armed services on which they focus.

DEDICATION TITLE: See DEDICATION.

DEEP FOCUS (or PAN FOCUS): A focus in which all objects from close foreground to distant background are seen in sharp definition. Though used occasionally by others in earlier films, e.g., by Renoir in *Toni* (1934), deep-focus photography was first used as part of an over-all directorial strategy in *Citizen Kane* (1941). A good recent example of deep-focus occurs in *The Godfather* (1972) in the scene near the end of the film in which Michael's position as new godfather is acknowledged in a room in the background while his wife looks on from the foreground at the end of the hall.

DEEP FOCUS. From Orson Welles' *Citizen Kane* (1941). Welles (as Kane) is in the right foreground; Dorothy Comingore on hearth emphasizes vastness of set. By permission of RKO-Radio Pictures, a Division of RKO General, Inc.

DEFINITION: The degree of clarity or sharpness with which scenes are filmed. See also RESOLUTION.

DE MILLE EPIC: See GENRE.

DEPTH OF FIELD: The range of acceptable sharpness (before and behind the plane of focus) within which an object appears in sharp focus.

DEPTH OF FOCUS: The range behind the lens, at the focal plane within which the film is positioned during exposure and within which a lens can clearly focus both distant and close objects simultaneously. Often confused with DEPTH OF FIELD.

"DEUCES": The slang term for 2000-watt lights.

DEVELOPING: The chemical process that reveals the images on exposed film.

DIAPHRAGM: An adjustable aperture that controls the amount of light that passes through the lens.

DIFFUSION SCREEN: A spun-glass screen used in front of studio light to reduce glare. See also FLAG, GOBO, SCRIM.

DIME SHOW: A movie theatre during the early silent period so called because the price of admission was ten cents. Often such theatres were converted stores or shacks which seldom seated more than 100 persons.

DIRECTOR: See PERSONNEL.

DIRECT PHOTOGRAPHY: The filming of live action.

DIRECTIONAL MICROPHONE: See SOUND.

DISCOVERED: An actor or important element of a scene revealed when the scene opens.

DISCOVERY: A person, hitherto unknown to the public, whose talents or star qualities are suddenly recognized and exploited in a movie. A discovery is sometimes made by a talent scout.

DISSOLVE: See TRANSITIONS.

DISTORTION: (1) A misshaping of the film image, sometimes deliberately, for esthetic, dramatic, or other reasons—as with a very wide-angle lens, when vertical lines tend to bow or bend.

(2) An unnatural alteration in the sound of a film. Good examples of (1) are to be found toward the end of Erno Metzner's remarkable expressionist short film, *Überfall* (1927). S. Kracauer provides an illustration of this in his *From Caligari to Hitler*. A notable example of (2) occurs in the reiterated word "Knife" in Hitchcock's *Blackmail* (1928).

DISTRIBUTOR: The "middle-man" in the film industry. He rents or leases prints of films produced by one or more film companies and arranges the terms of their distribution to EXHIBITORS. From 1930 to 1955 the major Hollywood companies became their own distributors (and exhibitors).

DOCUMENTARY: See GENRE.

DOLLY: See APPARATUS and EQUIPMENT.

DOLLYING: See SHOTS.

DOLLY SHOT: See SHOTS.

DOPE-SHEET: Analysis of film material with an eye to its classification in a film library. See FILM: STOCK FOOTAGE.

DOUBLE: A person who takes the place of a leading actor either to perform a difficult or dangerous action (the work of a *stunt-double*) or to replace the actor photographically when the actor is not available (the work of a *photo-double*). Doubles are often used in far shots for obvious reasons.

DOUBLE EXPOSURE: In making a composite picture the same strip of film is exposed twice. The result is two images, one superimposed on the other.

DOUBLE FEATURE: A film program in which two full-length feature films are shown. See also SINGLE FEATURE, TRIPLE FEATURE.

DOUBLE-SYSTEM RECORDING: See RECORDING SYSTEM.

DRIVE-IN MOVIE: Open-air motion picture theatre—popular in U.S. from 1950s onward—whose patrons watch the films from their cars and are supplied with portable loudspeakers which can be put inside their automobiles for personal volume control.

DRIVE MOTORS: For films using dialogue, it is absolutely essential that the drive motors powering the camera and the recorder run at *exactly* the same speed: they then run "in sync."
(1) The early selsyn interlock system (both camera and re-

corder powered by same motor) is now obsolete and is used in studio shooting only for special effects, essentially rephotography of background projection. It is also used in sound studios to interlock many reproducers, recorders, projectors, and footage counters when final sound dubbing is being accomplished.

(2) The A.C. synchronous motors next came into popularity. This procedure did not require interlock. The camera and the recorder each had its own motor. This system greatly increased mobility, even though it was bulky on location shooting.

(3) The D.C. governor-controlled motors are today fast replacing the old A.C. synchronous system for location shooting. The A.C. synchronous motors are still used for studio shooting by most major studios.

DUB: See SOUND.

DUB-IN: Its general usage today is: the addition of anything (to picture or sound) after the original has been made.

DUBBED VERSION: See SOUND.

DUNNING PROCESS: See SPECIAL EFFECTS.

DUPING: The process of printing (duplicating) a film from a positive print.

DYNAMIC: The visible display of violence, force or physical exertion in a film, as opposed to visual displays of emotion. The term was used during the silent period.

DYNAMIC CUTTING: See MONTAGE.

DYNAMIC FRAME: A technique, invented in 1955 by Glenn Alvey, for masking the projected image size and shape to any ratio that seems appropriate to it. Thus as an actor passes through a narrow passage, the image narrows; it widens as he emerges into the open street. The technique was used c. 1960 to make a short British film, *The Door in the Wall*, based on a story by H. G. Wells. The theoretical origins of the technique may be traced to Eisenstein's article, "The Dynamic Square," *Close-Up*, March and June, 1931.

ÉCLAIR: See CAMERA.

ECHO BOX: A mechanical or electronic device for securing an echo effect.

EDGE NUMBERS (Also called NEGATIVE NUMBERS): An important part of the editing process. Edge numbers are consecutive numbers (one to each foot of film) placed on the edge of the negative during manufacture. The numbers are transferred to the positive during printing. They are used for matching negative to workprint, negative to negative, and for ordering reprints.

EDGE NUMBER. One of a series of numbers, combined with key lettering, printed at intervals of 1 ft. along the edge of most types of negative and duplicating film stock. Also known as footage number. From *The Focal Encyclopedia.*

EDITING or **CUTTING:** The process of assembling a film from its constituent shots and sound track. See also EDGE NUMBERS, EDITOLA, KEM UNIVERSAL EDITING TABLE, LINKAGE, MONTAGE.

Assemble: First process in film editing—collecting together all required shots in consecutive order. Finished product is called the "Rough Cut."

Cut Negative: A film negative prepared for the purpose of making RELEASE PRINTS.

Dailies: See RUSHES, below.

Fine Cut: A stage in the editing process considerably beyond the ROUGH CUT; by this time the film is virtually ready for approval by the director and/or producer.

Outs/Out Takes: SHOTS or TAKES of a shot that have been rejected during editing; are not included in the completed film.

Picture Editing: The highly skilled job of composing the film to be presented from the conglomeration of scenes shot.

Relational Editing: The editing of shots to suggest association of ideas (sometimes associated with two or more actors) in one continuous scene.

Release Prints: A film print prepared for general exhibition after a sample print has been examined or viewed and considered satisfactory for release to public cinemas.

Reversal Print: A film print made on REVERSAL FILM.

Rough Cut: The first stage in editing a WORKPRINT after the film footage has been assembled in roughly the correct order. See also ASSEMBLE, FINE CUT.

Rushes: Film prints which are rushed through the photographic laboratory within 24 hours of the exposure of the negative. Study of the rushes enables the filmmaker to evaluate the progress of the film. Rushes are also called DAILIES.

Splice/Splicing: The joining together of two strips of film by tape or glue so that they form a single strip of film. The place where the joint occurs is called a splice. The main kinds of splice are: (1) Butt splice—the joining of two strips of film that abut without overlapping by fixing an adhesive patch over the place where the two strips meet. (2) Lap splice—the joining of two strips of film by lapping a piece of one over a piece of the other and joining the two strips with film cement. (3) Negative splice—a thin lap splice which conceals any photographic images at the joint or splice. (4) Positive splice—a wide lap splice often used in repairing broken or snapped RELEASE PRINTS. (5) Sound splice: another name for a negative splice. A sound splice is always a butt splice if it is on magnetic film.

Synchronization (abbrev. Sync.): the process, during editing, of establishing a natural time relationship between film image and sound-track. Also called CUTTING SYNC. and PARALLEL SYNC. See also FINAL CUT, IN SYNC., OUT OF SYNC., PRINTING SYNC., PROJECTION SYNC.

Workprint: (1) Picture workprint: a positive print that constitutes the film editor's working material and which he cuts and edits in synchronization with a corresponding sound workprint. (2) Sound workprint: a sound print that the editor cuts and edits in synchronization with a picture workprint.

EDITOLA: See APPARATUS and EQUIPMENT.

EDITOR: See PERSONNEL.

EDUCATIONAL FILM: See GENRE.

EIGHT MILLIMETER (8mm): See GAUGE.

EKTACHROME: See COLOR CINEMATOGRAPHY.

ELECTRIC EYE: A device for automatically setting the correct lens opening. It is a battery-powered light meter in the camera.

ELECTRICIAN: See PERSONNEL: GAFFER.

ELECTRONIC LENS: See LENS.

EMMY AWARDS: The annual awards, in the areas of performance and production, presented by the National Academy of Television Arts and Sciences.

EMPATHY: The identification of the audience (or a member of the audience) with a character in a movie; the sympathetic projection of one's personality into the personality of a character in a film.

EMULSION: Photosensitive layer of chemicals fixed to the film BASE, chemicals record the photographic image that is subsequently fixed in PROCESSING.

EMULSION SPEED: The factor that determines the proper exposure for a particular film, to produce a satisfactory image. The factor is commonly expressed in terms of an ASA number. The higher the number, the "faster" the emulsion speed. The lower the number, the "slower" the emulsion speed. (See also FILM SPEED.)

EPIC: See GENRE.

ESCAPE FILM: See GENRE.

ESCAPIST FILM: Any film that enables one to forget one's personal problems while one is watching it.

ESTABLISHING SHOT: See SHOTS.

ETHNIC FILM: See GENRE.

EVR: See CARTRIDGE.

EXCITER LAMP: The light in a projector that passes through the sound track to a photoelectric cell which activates the amplifier and thereby helps to produce the sound when a sound movie is being shown.

EXHIBITOR: (1) A member of the film industry in charge of arrangements for presenting public film shows. He receives the films by lease or rental from a DISTRIBUTOR. (2) Exhibitor is also a "fancy name" for a movie theatre—i.e., the usual place where movies are exhibited.

EXPLOITATION MOVIE: See GENRE.

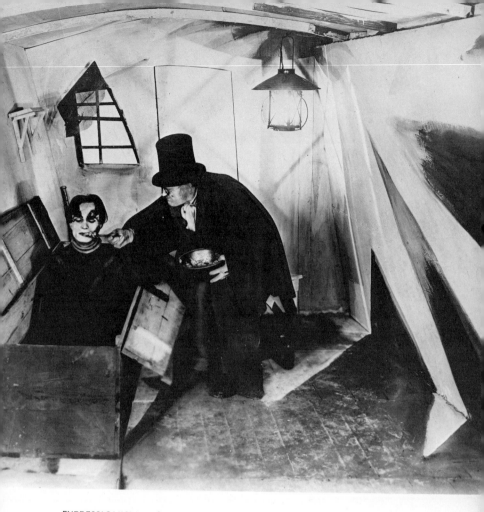

EXPRESSIONISM. Robert Wiene's *The Cabinet of Dr. Caligari* (1919).

EXPRESSIONISM: (1) A style or technique by which the filmmaker, artist, or writer seeks to give inner experiences an objective expression by using stylization, nonobjective symbolism, and stereotyped characterization. (2) A general term to describe the German art cinema of the period 1919–1932, in which, under the influence of literary and artistic expressionism, such films as *The Cabinet of Dr. Caligari*, dir. Robert Wiene (1919), and *Waxworks* (1924), dir. Paul Leni, were made using the style or technique indicated in (1) above. See further: George Huaco, *The Sociology of Film Art*, 1965, and Lotte Eisner, *The Haunted Screen*, 1969.

EXPRESSIVE REALISM: See SOVIET EXPRESSIVE REALISM.

EXPOSURE: The effect of light reaching raw film stock.

EXTERIOR: An out-of-door scene. It may be authentic or simulated: i.e., shot outside the studio, on a studio lot, or even indoors on a set.

EXTRA: A screen performer usually hired by the day to play a minor part, often in a crowd or mob scene. The extra does not speak (or make any kind of vocal reaction in a group of less than five performers) whereas, by contrast, the actor does have a speaking role. When the part is more differentiated, the extra becomes a BIT PLAYER. Slavko Vorkapich's film *The Life and Death of 9413, A Hollywood Extra* (1928) is perhaps the most interesting of cinematic treatments of the experience of being an extra.

EXTREME CLOSE-UP: See SHOTS: BIG CLOSE-UP.

EYELIGHT: See LIGHTING.

FACTUAL FILM: See GENRE: DOCUMENTARY.

FADE: See TRANSITIONS.

FADE-IN/FADE-OUT: See TRANSITIONS.

FAN: (1) A fervent admirer of a movie star, usually but not always young. The mob that disrupted Rudolph Valentino's funeral (1926) and the crowds that pursue Raquel Welsh are examples. (2) Anyone who admires an actor or film genre and spends time and money to see either regularly.

FAN CLUB: A society supported by FAN subscriptions for the purpose of promoting fan interest in a particular movie star. Fan clubs frequently publish newsletters or magazines about the stars they celebrate.

FAN LETTERS: See FAN MAIL.

FAN MAGAZINE: An illustrated publication devoted to gossip and anecdotal articles about the lives, careers, and loves of movie stars. Intended for film FANS and for the perpetuation of their interest in the luminaries of the STAR SYSTEM. Fan magazines have been popular publications since they first appeared in 1913.

FAN MAIL: Letters by FANS intended for and sometimes read by the movie stars to whom they are addressed. They are usually adulatory, ecstatic, or hysterical protestations of love and undying loyalty. Often they are requests for autographed photographs or art stills.

FANTASY FILM: See GENRE.

FAST FILM: Film that is highly sensitive to light; it has a high ASA number—see AMERICAN STANDARD SPEED. This kind of film is most suitable for shooting where there is a restricted amount of light. Also called *high-speed film.*

FAST-MOTION CINEMATOGRAPHY: See CAMERA SPEED.

FEATURE FILM: (1) A fictional-story film as opposed to a documentary. (2) The main film in a program comprising two or more films. Historically it meant a film lasting more than an hour— as opposed to one- or two-reelers. See further MAIN FEATURE, SECOND FEATURE.

FEET PER MINUTE: Reference to the speed of film through the camera or projector. (1) For standard 35mm film: sound speed is 90 feet per minute; silent speed is 60 feet per minute. (2) For 16mm film: sound speed is 36 feet per minute; silent speed is 24 feet per minute.

FEMME FATALE: See ACTING: VAMP.

FERRANIACOLOR: See COLOR CINEMATOGRAPHY.

FICTION FILM: A story film about invented characters and/or invented scenes and situations or about real or historical persons in invented situations or involved with fictional characters. The term is often opposed to FACTUAL or DOCUMENTARY film and is sometimes used synonymously with FEATURE FILM and with THEATRICAL FILM.

FIELD CAMERA: See CAMERA.

FILL LIGHT: See LIGHTING.

FILM: A perforated strip of thin, flexible celluloid (or other base material), coated with a photosensitive EMULSION for recording the photographic images required for cinematography.

Academy Leader: Length of film spliced to the beginning of a reel and used for threading the projector and to calculate the exact starting place of the film's action. The leader often bears the name of the picture and/or other information for the projectionist. See also ACADEMY STANDARDS.

Anti-halation Backing: Opaque backing of film. Prevents reflection from back surface of film base.

Base: See FILM: FILM BASE.

Colorblind Film (Orthochromatic Film): A kind of black-and-white film emulsion that is sensitive to all colors but red. Seldom used except for special effect or in printing black-and-white workprints. See also COLOR CINEMATOGRAPHY.

Dailies: See EDITING: RUSHES.

Dupes/Dupe Negative: The word "dupe" here is an abbreviation of *duplicate*. A dupe or dupe negative is a negative film that is printed from a positive; also called "master dupe negative." From master dupe negatives are printed RELEASE PRINTS. See EDITING.

Eight mm. Film: See GAUGE.

Film Base: The thin, flexible, transparent strip of material on which the photosensitive emulsion is coated. See NITRATE FILM, TRIACETATE FILM.

Film Gauge: See GAUGE.

Film Speed: See SPEED.

Film Stock: Unexposed film; also called *raw stock*.

Film Strip: (1) A length of film bearing visually unrelated or disparate images which are projected in the manner of lantern slides. (2) The name of the first Lumière and Edison films that were 50 to 100 feet in length.

Fine Grain: Refers to the size of the gatherings of particles (grains) of metallic silver composing the film emulsion in slow film. A fine-grain print has a grain size smaller than that of film emulsions used before the mid-1930s.

Fine-Grain Master Positive: The negative track, complete with dubbing, is matched with picture negative, and from these two pieces of film is made a fine-grain master positive.

Frame: Each separate image area on a strip of movie film.

Frame line: The horizontal lines or bands between individual frames which divide the frames from one another. See also IN FRAME, OUT OF FRAME, TO FRAME.

Gauge: See GAUGE.

Grainy: The visibility of particles (grains) of metallic silver on the film image caused by large clusters of grains on the film emulsion. Intentional graininess is evident in the "News on the March" sequence of *Citizen Kane* (1941) where Welles provides the effect of a genuine old newsreel.

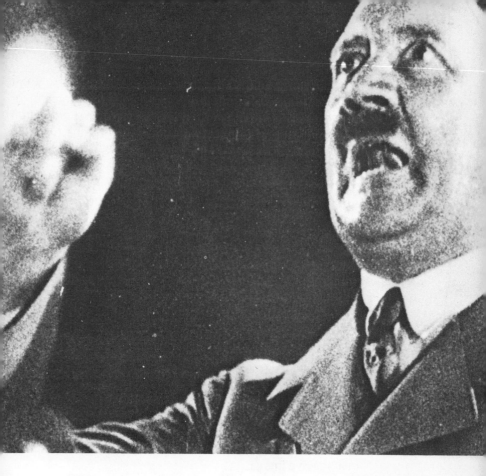

A GRAINY image (see FILM) of Adolf Hitler from the "War for Men's Minds" (1943) episode of *The World in Action (1941–1945) DOCUMENTARY* series (see GENRE). Wisconsin Center for Theatre Research, United Artists Collection.

Head Leader: The LEADER that is printed on (and sometimes spliced on) to a print. It usually provides information for the projectionist that enables him to determine the length of time between the start of the projector and the appearance on the screen of the first frame of the movie. See ACADEMY LEADER.

Internegative: A negative printed directly from a color-reversal original film.

Lavender Print: A special positive print made from an original negative so that duplicate negative prints may be prepared from it; the base or transparent material of such film stock is tinted.

Leader: See FILM: ACADEMY LEADER.

Loop: (1) A slack length of film which provides a certain amount of play while the film is running through the projector or camera; it prevents tearing of the film and allows projection of a single still frame which is not in motion when projected. (2) An endless band of film which, on being run through an appropriate projector, allows the same piece of film and/or sound track to be seen and/or heard repeatedly.

Married Print: A positive print of a film carrying both sound and picture.

Master Dupe Negative: A master negative, made from the fine-grain master positive print. From this master dupe negative, release prints are made that go out for distribution and projection.

Multilayer Color Film: A film base carrying three recording emulsions—one for red, one for blue, one for green. Examples: Ektachrome, Eastman color, Kodachrome, Ansco color, and so on.

Negative: (1) Raw stock before exposure. (2) Raw film stock after exposure but before processing. (3) Exposed films from which positive prints may be made.

Negative Image: A photographic image or picture whose tone values (light and shade) are inverted from their appearance in a positive image.

Nitrate Film: The highly inflammable cellulose nitrate base of raw film stock. From c. 1888 (when it was first produced by George Eastman) until about 1935 (when TRIACETATE FILM began to supplant it), nitrate stock was standard for most film. Nitrate film was abandoned for general use because it deteriorates and is dangerous: it can burn, explode, etc.

Original Negative: This is the film that is run through the camera and recorder during production.

Panchromatic: A film emulsion that is photosensitive to all colors of the spectrum and renders those colors in black and white. Panchromatic film is the standard kind of black-and-white film.

Paper Print: Bromide paper copy of an original negative made for filing with the Library of Congress for copyright purposes. Until 1907, films were not covered by any copyright law in the U.S.A., but printed photographs could be protected legally. Therefore, those early film producers who sought to

copyright their work deposited paper prints of their films in the Library of Congress. In this way, over 3000 paper prints (approximately two million feet of film) accumulated in the Library of Congress. These were restored (reconverted to film stock) in the 1960's by Kemp R. Niver, *see Motion Pictures from the Library of Congress Paper Print Collection 1894–1912,* Berkeley and Los Angeles: University of California Press, 1967.

PAPERING. Inserting markers in a roll of film to indicate to the laboratory the start and end of sections which are to be printed or duplicated. Papers held by clips are no longer used because of the risk of damage to the film. From *The Focal Encyclopedia.*

Perforations: Accurately and regularly spaced holes that are punched on the sides of a film; these holes are engaged by the sprockets that are moved by the camera's driving mechanism during shooting or by the projector's mechanism during projection. By this means the film is moved through the camera or projector. Perforations are also called *sprocket holes.* In 35mm film there are two different kinds of perforation: positive perforations which look rectangular and negative perforations which are roughly oval in shape.

Positive: (1) A photographic print in which the tone values (light and shade) of the images appear as they do in the scene filmed: i.e., dark areas of the scene will appear dark; light areas will appear light. (2) A specific frame or image on a positive print.

Print: A positive photographic film.

Raw Stock: See FILM STOCK.

Reconditioning: The removal of ABRASIONS or SCRATCHES from the emulsion or base surface of film negatives or prints, usually by a secret trade process.

Reproduction: Photographic method of copying color film or of converting the natural world of color into shades or gradations of black and white. If the original tone differences are excessively contrasted in reproduction, the effect is said to

be *contrasty*; if the original tone differences are inadequately shown in the reproduction, the effect is said to be *flat*; if the tone differences are reproduced in a way that seems equivalent to the original colors, the effect is said to be *normal*.

Resolution (also: resolving power): The ability of a film emulsion to record fine detail, or of a lens to reproduce fine detail.

Reticulation: The formation of a wrinkled surface on a film emulsion after processing has taken place. It is caused by temperature changes or chemical reaction.

Reversal Film: Film stock that can be processed so as to produce a positive image from the film that ran through the camera. For example: a positive image can be made from a positive image directly.

Rushes: See EDITING.

Safety Base: Triacetate film—which burns slowly—in contrast to NITRATE FILM which is highly inflammable.

Scratches: Marks or lines scored on the film emulsion or base and often caused by tiny pieces of matter that scratch the film as it runs through the camera or projector. Most scratches appear as vertical lines when the film is projected. A negative scratch is one that originates on the negative—it shows up on the print as a light line—a positive scratch is one that originates on the positive print—it appears as a black line. See also ABRASION, CINCH MARKS, RECONDITIONING.

Secondary Colors: Colors formed by the combination of two primary colors, such as yellow, cyan, and magenta.

Sensitizer: Dye used in the manufacture of photographic emulsions either to increase the speed of an emulsion or to increase its color sensitivity.

Sensitometer: Used in studying the characteristics of a film emulsion.

Separation Negatives: Three negatives, each of which records one of the three primary colors: blue, red, and yellow.

Seventy mm Film: See GAUGE.

Sixteen mm Film: See GAUGE.

Sixty-five mm Film: See GAUGE.

Sound Stock: The film strip on which only the sound is recorded.

Sound Track: The sound that is recorded photographically (or by use of magnetic stripe) on the edge of the release-print sound motion picture film.

Special Effects: Those scenes that do not come within the usual scope of a production cameraman's work. They are scenes such as miniatures and matte shots that are made by production specialists. See SPECIAL EFFECTS, below.

Spots: TV commercials made for an advertiser.

Sprocket Holes: See PERFORATIONS.

Stock: See FILM STOCK.

Stock Footage: Historical or general-application film material preserved in a special library for use when needed, but not prepared for the specific moving picture(s) in which it is used: e.g., many war films contain stock footage of aerial combats which consists of authentic newsreel material. Also called LIBRARY SHOTS. The shots of the Red Army procession in Hitchcock's *Topaz* (1970) are stock footage from newsreels of May Day celebrations in Moscow. See Jay Leyda, *Films Beget Films*, 1964.

Thirty-five mm Film: See GAUGE.

Triacetate Film: Film with a cellulose acetate base; sometimes called *safety film* or SAFETY BASE film. See also NITRATE FILM.

FILM CLIP: See CLIP.

FILM COURSE: A program of instruction in high school, college, or university concerning topics such as film art, film history, film and society, and filmmaking. The American Film Institute publishes an annual *Guide to College Film Courses*.

FILM DIMENSIONS: See GAUGE.

FILM LITERACY: Comprehension of the expressive techniques and conventions of the motion picture medium acquired by the experience of viewing many films. See further Joan Rosengren Forsdale and Louis Forsdale, "Film Literacy," *AV Communication Review*, vol. 18, no. 3 (Fall 1970), p. 263.

FILM-NOIR: See GENRE: CINEMA-NOIR.

FILM SPEED: See SPEED.

FILM STOCK: See FILM.

FILM STRIP: See FILM.

FILM THEORY: (1) An interpretation of the methods and techniques of film as a medium of expression. (2) An explanation of the nature of film as an art form. (3) An analysis of the works and ways of specific elements of filmic expression, e.g., composition, color, sound. Major film theorists include: Eisenstein, Pudovkin, Rudolph Arnheim, Kracauer, André Bazin, and Béla Balázs.

FILTER: (1) A device for removing unwanted frequencies in sound recording. (2) Transparent glass or gelatin of a specific color used in conjunction with a camera lens in order to change the tonal values of the scene being filmed. (3) A means of providing primary-color separation in color photography.

GRADUATED FILTER. Nonuniform type of filter placed in front of a camera lens to give differential effects in various parts of the scene. An example is a sky filter which is yellow at the top shading off to colorless at the bottom. It is designed to increase the density of a black-and-white rendering of blue skies without affecting the rest of the scene. The corresponding filter for color has a neutral density at the top to retain the blue in an overbright sky. From *The Focal Encyclopedia.*

FINAL CUT: The edited film ready for dubbing or postsynchronization.

FINDER: See APPARATUS and EQUIPMENT.

FINE CUT: See EDITING.

FINE GRAIN: See FILM.

FIRST ANSWER PRINT: The first film print sent to the customer who ordered it from the laboratory.

FIRST GENERATION DUPE: A REVERSAL FILM (see FILM) made from an original reversal. It is usually used for making additional prints which are called *second generation dupes.*

FIRST RUN: The initial public exhibition of a film usually in one or two select cinemas in each city at higher prices. The first

run is subsequently followed by GENERAL RELEASE of the film.

FISHPOLE: See APPARATUS and EQUIPMENT.

FIXED-FOCUS LENS: A camera lens that cannot be adjusted for change of focus. It is usually a wide-angle lens with a very large depth of focus.

FLAG: A small GOBO or light-obscuring screen.

FLAPPER: See ACTING.

FLARE: Streaks of light forming a circular pattern on the film—caused by the reflection of a powerful light on the surface of the lens. Sometimes introduced intentionally.

FLASHBACK: The representation of some action or scene previous to the present time sequence in the film. The method is used to show the cause of events or to show remembered scenes or actions (and thus account for psychological conditions). Alain Resnais' *Hiroshima Mon Amour* (1959) builds much of its action out of flashback sequences. On the origin and historical development of the flashback—in the early films of D. W. Griffith—see concluding chapter of Robert M. Henderson, *D. W. Griffith: The Years at Biograph,* 1970.

FLASH PAN: See SHOTS.

FLAT: A piece of film or theatre scenery on a flat frame. In motion pictures a standard flat is four feet wide, ten feet high, and made of three-eighths inch plywood.

FLAT REPRODUCTION: See REPRODUCTION.

FLATNESS OF FIELD: The quality of a lens which produces the sharpness of an image both at the center and the edges of a negative.

FLEA-PIT: A dilapidated and usually archaic cinema showing old films at low prices. Basil Dearden's *The Smallest Show on Earth* (1957) is a comedy about a young couple who inherit a flea-pit.

FLICK: Slang term for a film. The term originated in the early silent period when films (also called "flickers") tended to flicker when they were projected. "Going to the flicks" means "going to the cinema."

FLICKER ALLEY: Nickname of Cecil Court, London W.C.2., England, the business center of the British film industry during the silent film period.

FLIPOVER WIPE: See TRANSITIONS.

FLOOD: See APPARATUS and EQUIPMENT.

FLOOR SECRETARY: British term for a CONTINUITY GIRL. See PERSONNEL.

FLUORESCENT LIGHT: In photography is called *cold light*. Mercury-vapor tubes coated inside so that under certain electrically stimulated chemical reactions they glow.

FOCAL LENGTH: The distance in millimeters from the emulsion surface of the film to the center of the camera lens when the lens is set at "infinity" (focused on a distant object). (2) The point at which rays of light converge to form a sharp image on the film emulsion, after passing through a lens. Telephoto lenses have long focal lengths; wide-angle lenses have short focal lengths.

FOCUS: To adjust the focal distance of a lens so as to produce a clearly defined image on the film or on the screen.

FOCUS DRIFT: The focus of a film gradually shifts during projection of a film.

FOCUS PULL: The changing of focus during a shot so that a different image is brought into sharp focus, allowing the first subject to go "soft."

FOG: A haze over negative or print caused by undesired chemical action of light.

FOG FILTER: A filter placed before the lens to give the effect of fog. It is not too successful, however, because the fog does not swirl or eddy as natural fog would. A more effective "fog" is made by spraying oil through a very fine nozzle. A popular oil for this use is called "Nujol."

FOLLOW FOCUS: To adjust the lens focusing ring so as to keep a moving subject in focus while it is being filmed.

FOLLOW SHOT: See SHOT.

FOOTAGE See FILM: RAW STOCK.

FOOTCANDLE: A measurement of light intensity. One footcandle is the intensity of light falling on a surface that is one foot away from a light source of one candle power.

FOOT LAMBERT: Measurement of screen brightness of a motion picture screen. A good theatre motion picture screen will have at least 10-foot lamberts. One foot lambert reflects a light brightness of one LUMEN per square foot.

FOREGROUND: The part of the scene being filmed that is directly in front of the camera.

FOREGROUND PIECE: Used with a process shot. It is a piece of foliage or some piece of construction between the actor and the camera when a background scene is used on the process screen. See SPECIAL EFFECTS.

FOREIGN RELEASE: A film specially prepared for showing in a country other than the one in which it was made. This usually requires either DUBBING or SUBTITLING.

FORESHORTENING: Abnormal enlargement of the dimensions and distances of persons or objects within the camera's field of view. Distances seem to be compressed with long focal length lenses and to be extended with short focal length lenses. There are striking examples of foreshortening used for esthetic effect in the close-ups of the judges who persecute Joan in Dreyer's *Passion of Joan of Arc* (1928).

FORMALISM: Russian esthetic theory, developed by Shklovsky, Eykhenbaum, and Jakobsen, in which art is considered in terms of techniques and devices to the exclusion of sociological or metaphysical considerations. The theory emerged c. 1914–1918, but was rejected in 1930 as heretical to Soviet thought. Under the Stalin regime charges of creating formalist works were brought against writers, filmmakers, artists, and composers, including Eisenstein, Meyerhold, and Shostakovich. See further Victor Erlich, *Russian Formalism*, 1955.

FORMAT: The size of motion picture film or of the film image. See further ASPECT RATIO.

FORTHCOMING or **COMING ATTRACTIONS:** Ads for films to be shown in future programs. These are sometimes TRAILERS and sometimes advertising slides.

FOUNDATION LIGHT: The general lighting for a scene. It has no character of its own. The other lighting is built upon the foundation light. See LIGHTING.

FOYER: The lobby or entrance hall of a cinema.

FRAME: See FILM.

FRAME, TO: To compose a scene for a film. Also, to adjust the framing device on the projector so that the film frames conform to the aperture provided by the aperture plate, frame lines are thus not visible.

FRAME-FREEZING: See CAMERA SPEED.

FRAME LINE: See FILM.

FRAME LOST: The portions of a picture, on outer edge of frame, that are lost (i.e., not seen) as a result of television transmitting and receiving. The loss is sometimes as much as 10 to 12 percent of the picture.

FRAMES PER FOOT: 16mm film contains 40 frames per foot; 35mm film contains 16 frames per foot.

FREE CINEMA: A movement in England, during the mid and late fifties, signalized by a series of films at the National Film Theatre in London: The work of such young directors as Karel Reisz, Tony Richardson, and Lindsay Anderson. Using documentary techniques, their films featured real persons in plotless enactments of their daily lives. Related to and often paralleling the NEW WAVE in France, NEO-REALISM in Italy, and the NEW AMERICAN CINEMA. See also AVANT-GARDE.

FREE PERSPECTIVE: Background scenery constructed so that its lines converge much more rapidly than normal. This provides a feeling of depth.

FREEZE-FRAME: See CAMERA SPEED.

FRONT LIGHTING: See LIGHTING.

FRONT OFFICE: See BOX OFFICE.

F/STOP: A measurement of the size of the lens opening, indicating the amount of light to be admitted.

FULL-FRAME FOLLOW FOCUS: The cameraman views the scene being filmed through the actual lens that is being used to photograph the scene.

FULL SHOT: See SHOTS.

FULL SUPPORTING PROGRAM: British term for short films shown in addition to the feature films during a particular program. When only one feature film is presented, the term *full supporting program* is a method of making the show look more extensive than it really is.

FUNCTIONAL MUSIC: Another name for *background music:* i.e., music that represents "the close and sympathetic working of the composer with the filmmaker." (Roger Manvell and John Huntley, *The Technique of Film Music*, 1957; see pp. 71–177). Prokofiev's music for Eisenstein's *Alexander Nevsky* (1938) and Sir William Walton's music for Olivier's film *Henry V* (1946) are notable examples of functional music.

GADGET COMEDY: See GENRE.

GAFFER: See PERSONNEL.

GAG COMEDY: See GENRE.

GALVANOMETER: An instrument for determining the direction or intensity of electric currents. In cinematography, galvanometers are used to transform electrical impulses into the movement of light beams in the process of sound recording.

GAMMA INFINITY: The numerical measure of contrast to which an emulsion is developed. The maximum contrast to which a film emulsion can be developed.

GATE (Also called PICTURE GATE or film gate): In a projector or camera this is the hinged retainer of the pressure plate that holds the film on a track in front of the lamp or lens; each frame is momentarily held in the gate while it is illuminated or exposed.

GAUGE: Film width—expressed in millimeters. The most frequently used gauges are 8mm, 16mm, and 35mm. The first two are sometimes called NARROW GAUGES or SUBSTANDARD GAUGES. Gauges wider than 35mm—for example: 42, 56, 65, or 70mm—are known as gauges for large-format systems. (See PROCESSES.)
Super-8 is 8mm film with smaller sprocket holes which allow for a wider frame size. Single-8 is identical to Super-8 in frame size and sprocket holes. Other narrow gauges, now seldom if ever used, are 9.5mm (introduced by Pathé in 1923), 17.5mm, and 28mm (introduced by Pathé in 1899 and

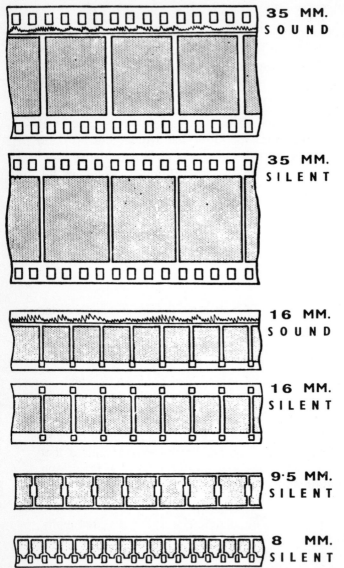

35 MM.
S O U N D

35 MM.
S I L E N T

16 MM.
S O U N D

16 MM.
S I L E N T

9·5 MM.
S I L E N T

8 MM.
S I L E N T

FILM GAUGES. From Roger Manvell, *Film* (Pelican, 1944). Copyright © Roger Manvell, 1944. Reprinted by permission of Penguin Books Ltd.

1912, respectively). 9.5mm was at one time the most popular gauge among amateur filmmakers in Europe. However, 9.5 was never widely used in the U.S. Since 1932, when it was first introduced by Eastman Kodak, 8mm has been the most popular gauge for home moviemakers. But Super-8, introduced by Eastman Kodak in 1965, seems likely to supplant 8mm in popular use.

Eastman Kodak first marketed the Cine Kodak process, using 16mm film, in 1923. Since 1939, when sound on 16mm was first introduced, 16mm has become the most widely used gauge—alternative to 35mm—among professionals. 16mm is commonest for educational and nontheatrical filmshows and much television filming is done in this gauge.

Wide-screen processes have made use of various gauges above 35mm, but only 70mm (first used in the Grandeur wide-screen system, 1929) has been used extensively in the U.S. and other countries. In America and Western Europe, 70mm prints are produced from 65mm negatives; in the U.S.S.R. and Eastern bloc countries they are produced from 70mm negatives. The gauge used for Magnafilm (c. 1929), was 56mm.

GENDAI-GEKI: See GENRE.

GENERAL RELEASE: The release of a film for exhibition in cinemas generally. This usually follows the FIRST RUN or exclusive showing of the film at one or two higher-priced movie theatres in each city.

GENRE: A category, kind, or form of film distinguished by subject matter, theme or techniques. The leading genres are as follows:

Adaptation: A film based on a literary work. See also ADAPTATION, above.

Animal Picture: A film whose focus of interest is an ANIMAL STAR or a story about an animal hero: e.g., *Lassie Come Home* (1943).

Beach Party Movie: One of a series of CULT MOVIES in which a group of young people "live it up," dance to rock music, and make love in a beach setting. The film that established the series was William Asher's *Beach Party* (1963). See also GENRE: SURF-RIDING FILM.

Biography/Biographical Picture: A film life-story of an individual who is usually famous or notorious: e.g., *A Song to Remember* (1945) is a biography of Chopin; *Hitler* (1963) is a biography of the Nazi dictator. See also WARNER BROTHERS BIOGRAPHIES.

Black Comedy: A kind of play, novel, or film characterized by humor that is sadistic, bitter, pessimistic, or sick. A notable example is Kubrick's *Dr. Strangelove* (1963).

Blue Movie: A film that makes its appeal through displays of erotic or pornographic activity; e.g., Russ Meyer's *The Immoral Mr. Teas,* Andy Warhol's *Blue Movie.*

Boxing Pictures: A film whose center of interest is the career of a boxer: e.g., Robert Wise's *The Set-Up* (1949).

Cartoon: An animated film; see ANIMATION.

Chase Film: A serious or comedic film whose story concentrates on a pursuit or that builds to a climax in which pursuit becomes the main action: e.g., Laughton's *The Night of the Hunter* (1955), Reed's *Odd Man Out* (1946), Keaton's *The General* (1926).

Children's Film: A film that is intended primarily for child audiences: e.g., Victor Fleming's *The Wizard of Oz* (1939).

Cinéma- (or **Film-**) **Noir:** Films frequently employing convoluted plots that explore dark passions and motivations against shadowy or misty (often city) backgrounds. Originally inspired by such French films as Carné's *Quai de Brumes* (1938) and *Le Jour se Lève* (1939): many cinéma-noir films were made in Hollywood during the 1940s: e.g., Robert Siodmak's *The Killers* (1946).

James Wong Howe, one of the most famous DIRECTORS OF PHOTOGRAPHY (see PERSONNEL), on skates to shoot a fast-action scene in *Body and Soul* (United Artists, 1947)—a good example of CINEMA NOIR. Wisconsin Center for Theatre Research, United Artists Collection.

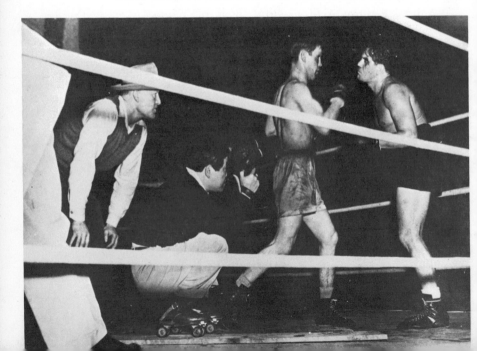

Compilation Film: See GENRE: DOCUMENTARY.

Composite Film: A feature film containing two or more separate stories: e.g., *Quartet* (1949), based on four short stories by W. Somerset Maugham.

Costume Drama: A film that is set in some historical period for which the cast appears dressed in elaborate or colorful costumes: e.g., *Marie Antoinette,* dir. W. S. Van Dyke (1938).

Custard-Pie Comedy: A slapstick film that seeks to provoke laughter by showing characters struck in the face with pies or "gooey" cakes. The term is sometimes used as a synonym for (1) any slapstick comedy; (2) any film by Mack Sennett, although many of his films were not, strictly speaking, custard-pie comedies.

DeMille Epic: A pseudo-biblical spectacular film directed by or in the style of Cecil B. DeMille: e.g., *The Ten Commandments,* dir. DeMille (1956); *King of Kings,* dir. Nicholas Ray (1961).

Documentary: Sometimes called the FACTUAL FILM, the REALIST FILM, or the NONFICTION FILM. Defined thus in 1948 by the World Union of Documentary: "By the documentary film is meant all methods of recording on celluloid any aspect of reality interpreted whether by factual shooting or by sincere and justifiable reconstruction, so as to appeal either to reason or emotion, for the purpose of stimulating the desire for, and the widening of human knowledge and understanding, and of truthfully posing problems and their solutions in the spheres of economics, culture, and human relations." (Paul Rotha, *Documentary Film,* 1966). The term is taken from the French, *documentaire,* which originally meant TRAVELOG. It was first translated and applied in its now more familiar, wider sense by John Grierson in a review of Robert Flaherty's *Moana* (1926) in the *New York Sun,* February 1926. Grierson wrote: "being a visual account of events in the daily life of a Polynesian youth, the film has documentary value." Grierson subsequently defined documentary as "the creative treatment of actuality." In his first important essay, "The First Principles of Documentary," Grierson noticed how the meaning of the term had broadened: "From shimmying exoticisms [i.e., French travel films] it has gone on to include dramatic films like *Moana* (dir. Flaherty), *Earth* (dir. Dovzhenko, 1930), and *Turksib* (dir. Turin, 1928). And in time it will include other kinds as differ-

ent in form and intention from *Moana*, as *Moana* was from *Voyage au Congo* (Allegret and Gide, 1925)." (Forsyth Hardy ed., *Grierson on Documentary*, 1966.) Important landmarks in documentary filmmaking include: Herbert Ponting's *Ninety Degrees South* (1912), Cavalcanti's *Rien Que Les Heures* (1926–1927), Ruttmann's *Berlin* (1927), Grierson's *Drifters* (1929), Ivens' *The Borinage* (1933), Basil Wright's *Song of Ceylon* (1935) and *Night Mail* (1936), *The March of Time* series (beginning 1936), Lorentz' *Plow That Broke the Plains* (1936) and *The River* (1937), Riefenstahl's *Triumph of the Will* (1936), Van Dyke's *The City* (1939), the films of Humphrey Jennings, including *Diary for Timothy* (1945); Paul Rotha's *The World Is Rich* (1946–1947), Sidney Meyers' *The Quiet One* (1949), Resnais' *Night and Fog* (1955), Watkins' *The War Game* (1965), and Frederick Wiseman's *Titticut Follies* (1967).

Important subgenres of documentary include: The PROPA-GANDA DOCUMENTARY (e.g., *Triumph of the Will*) which makes use of film for persuasive ideological, or political purposes; the NATURALIST or ROMANTIC DOCUMENTARY (e.g., Flaherty's *Man of Aran* [1934]) which treats of people in natural landscapes that are often beautiful or spectacular or depicts in epic or highly dramatic terms man's struggle with his natural environment; the NEWSREEL—a recording with or without editorializing or commentary on news or current events (e.g., *Pathé News*); the *News Magazine* (e.g., *The March of Time*) which provides a kind of film essay on a topical news story; the ACTUALITY—a type of newsreel film (sometimes authentic, but often faked) that was in vogue c. 1895–1905; the COMPILATION FILM (e.g., Reed and Kanin's *The True Glory*, 1945) which is made by creatively assembling archive material. On the various kinds of documentary see further: Paul Rotha, *Documentary Film*, London, 1966; Jay Leyda, *Films Beget Films*, 1964; and Lewis Jacobs, *The Documentary Tradition*, 1971.

Educational Film: A film made primarily for teaching purposes or as an aid in teaching a specific subject or course: e.g., *Encyclopaedia Britannica* films.

Epic: A film whose emphasis is on spectacle and a vast supporting cast, usually with a biblical or historical setting: e.g., Henry Koster's *The Robe* (1953), Anthony Mann's *El Cid* (1961).

Escape Film: A film whose story deals primarily with an escape from prison, prison camp, or concentration camp: e.g., Mervyn LeRoy's *Escape* (1940), Wilder's *Stalag 17* (1953), John Sturges' *The Great Escape* (1963).

Ethnic Film: A film that focuses on the life-style(s) or characteristics of races or ethnic groups: e.g., Nicholas Webster's *Gone Are the Days* (also called *Purlie Victorious* [1963]) in which the focus is on a group of blacks; LeRoy's *A Majority of One* (1961) which concerns a Jewish widow's affair with a Japanese widower.

Exploitation Movie: (1) A film that sensationalizes its subject, or attempts deliberately to exploit it rather than make a significant or valuable film. This is done by capitalizing on topical interests. (2) A feature film which includes nudity scenes that are intended to be a major attraction to the audience: e.g., many of the films of Brigitte Bardot.

Factual Film: See GENRE: DOCUMENTARY.

Fantasy Film: (1) A film using trick cinematography to create highly imaginative, illusionistic, or dreamlike scenes: e.g., the films of Georges Méliès. (2) A story film in which dream

Josette Day and Jean Marais in *Beauty and the Beast,* directed by Jean Cocteau, decor by Christian Berard. The Museum of Modern Art/Film Stills Archive. Courtesy Janus Films.

sequences or supernatural elements or events play an important part, whether or not trick cinematography is used: e.g., Cocteau's *Beauty and the Beast* (1946), *Dead of Night*, dir. Cavalcanti, Dearden, Crichton, and Hamer (1945). (3) A story film in which the events are impossible, nonrealistic fantasies—e.g., *Here Comes Mr. Jordan* (1941), *The Horn Blows at Midnight* (1945).

Gadget Comedy: A film in which humor is created by showing fantastic or ludicrous machinery used to perform simple tasks. Gadget comedies are similar in method to the cartoons of Rube Goldberg and W. Heath Robinson. A typical film example is *It's a Gift* (1923), starring Snub Pollard.

Gag Comedy: A film comedy whose humor is created mainly by gags and wisecracks: e.g., the films of the Marx Brothers.

Gangster Film: A film concerned with the activities of organized criminals, often but not always set in the period of Prohibition. Celebrated examples include Howard Hawk's *Scarface* (1932), Wellman's *Public Enemy* (1931), and LeRoy's *Little Caesar* (1930).

James Cagney in Raoul Walsh's *White Heat* (Warner Bros., 1949), one of the best postwar GANGSTER FILMS. Wisconsin Center for Theatre Research, Blum Collection.

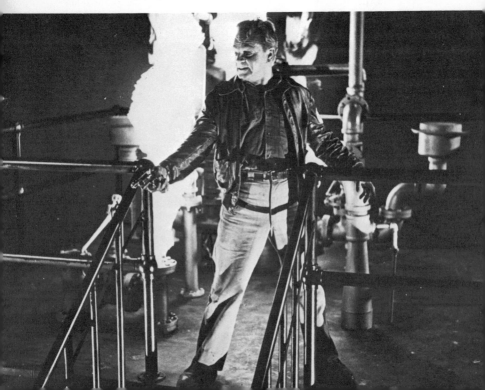

Gendai-Geki: Japanese film with a contemporary setting: i.e., set in 1868 or any time thereafter. The genre is in contrast to JIDAI-GEKI—See GENRE: JIDAI-GEKI. An example of GEN-DAI-GEKI is Kurosawa's film, *High and the Low* (1963).

Historical Film: A film that deals with a historical subject whether factual or fictional: e.g., *Cromwell* (1970) is an historical film that deals with a factual subject; *Captain Horatio Hornblower* (1951) is an historical film that deals with a fictional character involved in quasi-historical events.

Horror Film: A film whose object is to horrify or terrify its audience; the term is a general one that may include other genres such as MONSTER MOVIE, FANTASY FILM, SCIENCE-FICTION FILM. Tod Browning's *Dracula* (1931) is a celebrated horror film.

Horse Opera: Slang term for a Western. See GENRE: WESTERN.

Interest or **Human Interest Picture:** A film showing candid-camera views of ordinary people often engaged in amusing or unusual activities. Jacopetti's *Mondo Cane* (1961) contains much human interest footage.

Jidai-Geki: Japanese film set in a period before 1868, usually a COSTUME DRAMA. Kinugasa's *Gate of Hell* (1953) is an example of Jidai-Geki. See also GENRE: GENDAI-GEKI.

Kammerspiel: See separate entry.

Melodrama: A film whose story presents a conflict between obviously vicious and obviously virtuous characters and in which virtue invariably triumphs; it seeks to produce suspense and/or tears as its end product. The characters are usually stereotyped heroes and villains. Film melodrama was originally a development of nineteenth-century stage melodrama. See further A. N. Vardac, *Stage to Screen*, 1959.

Monster Movie: A film concentrating on the destructive activities of a monster who is usually destroyed before it succeeds in doing its worst. E.g., Cooper and Schoedsack's *King Kong* (1933).

Motorcycle Movie: A film concentrating on the adventures or activities of motorcyclists: e.g., Lazslo Benedek's *The Wild One* (1954), Dennis Hopper's *Easy Rider* (1969).

Musical: A film whose focus of interest is its music (usually light or popular music rather than classical music). In such films, when there is a story, it is often constructed around musical

sequences or serves to introduce them. Initial attempts at making musicals occurred during the silent period, when music was sometimes provided by phonograph records or by live performers concealed behind the screen. However, the genre was actually established with the coming of sound in 1926–1927, and with such series as the GOLD DIGGERS and the musicals of Fred Astaire the musical became one of Hollywood's perennially popular genres. See further BUSBY BERKELEY MUSICAL. See also Tom Vallance, *The American Musical,* 1970; Douglas McVay, *The Musical Film,* 1967; John Kobal, *Gotta Sing Gotta Dance: A Pictorial History of Film Musicals,* 1970.

Nature Film: A film whose focus of interest is wildlife in its natural habitat: e.g., Disney's *The Living Desert* (1953).

Newsreel: See GENRE: DOCUMENTARY.

Parody: An imitation, and distortion, of a more serious film for humorous effect: e.g., *Two Wagons, Both Covered* (1924), Will Rogers' parody of James Cruze's *The Covered Wagon* (1923); Chaplin's *Burlesque on Carmen* (1916), a parody of *Carmen* (1915), and the recent *De Duv* which parodies Ingmar Bergman's style and themes.

Porno Movie: A Blue Movie: See GENRE: BLUE MOVIE.

Prison Movie: A film, like *Big House* (1930), in which the action takes place in a prison.

Psychological Melodrama: A MELODRAMA that is concerned with the mental disorders of one or more of its main characters. Hitchcock's *Spellbound* (1945) is an example of the genre.

Record Film: A motion picture that is simply a film record of an actual event: e.g., *The Inauguration of President* [Theodore] *Roosevelt* (1905), which does not editorialize on the film material. See DOCUMENTARY and also SEMIDOCUMENTARY.

Religious Film: (1) A film based on a Bible story. (2) A film about the life of a saint or a person entirely preoccupied with religious activities and/or religious dogma. An example of (1) is DeMille's *Samson and Delilah* (1949); an example of (2) is Robert Bresson's *Diary of a Country Priest* (1950).

Romance: A love story: e.g., Gregory Ratoff's *Escape to Happiness,* also called *Intermezzo* (1939).

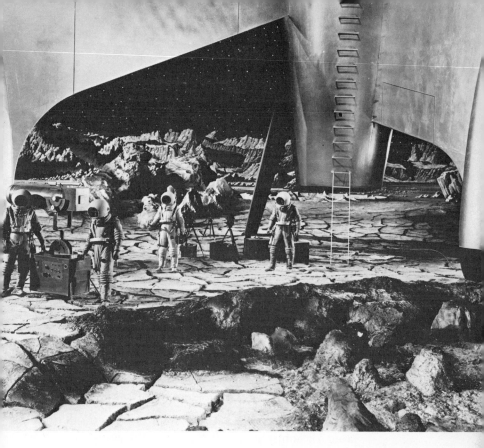

From Irving Pichel's *Destination Moon* (Eagle-Lion, 1950), an important SCIENCE-FICTION film predicting realistically what space flight would be like through the use of SPECIAL EFFECTS, SETS (see APPARATUS and EQUIPMENT) and PROPS (see STUDIO). Wisconsin Center for Theatre Research, United Artists Collection.

Science-Fiction Film: A story film in which scientific fantasies, possibilities, or speculations are visualized: e.g., Byron Haskin's *The War of the World* (1953), Kubrick's *2001: A Space Odyssey* (1968).

Screwball Comedy: A film comedy whose humor is created mainly out of developing ludicrous situations involving zany or absurdly exaggerated characters: e.g., Howard Hawks' *Twentieth Century* (1934), and, more recently, Peter Bogdanovich's *What's Up, Doc?* (1972).

Semidocumentary: A fiction film using the narrative techniques of DOCUMENTARY, frequently emphasizing process and shot in authentic rather than studio-fabricated locations. E.g., Rossellini's *Open City* (1945), Dassin's *The Naked City* (1948), Henry Hathaway's *The House on 92nd Street* (1945).

Serial: A film story told in a series of episodes each of which is intended to be shown separately. Each episode may be a completed unit (like the individual chapters of the Pearl White serial, *The Perils of Pauline* [1914]) or a CLIFFHANGER —in which a dangerous or apparently disastrous event is left unresolved until the next episode (e.g., Buster Crabbe in *Flash Gordon* [1936]). *What Happened to Mary?* (1912) was the first American serial; it starred Mary Fuller. Pearl White, Helen Holmes, and Ruth Roland became the queens of the silent serial. Buster Crabbe, Tom Tyler, and Johnny Mack Brown were popular heroes of sound serials during the 30s and 40s. The making of serials was discontinued in the 50s. See further Kalton C. Lahue, *Continued Next Week*, 1964, and Alan G. Barbour, *Days of Thrills and Adventure*, 1970. See also CHEATER CUT.

Sexploitation Movie: A film whose main appeal or exploitable content is its scenes, sequences, or themes of an erotic or sexual nature: e.g., Mac Ahlberg's *I, A Woman* (1966).

Short-Footage Film: See GENRE: COURT-METRAGE.

Silhouette Film: See ANIMATION: SILHOUETTE ANIMATION.

Situation Comedy: A film whose humor is created out of a ludicrous or amusing situation rather than out of gags or wisecracks: e.g., Allan Dwan's *Brewster's Millions* (1945), Cukor's *Adam's Rib* (1949).

Skin Flick: A film whose main appeal is its displays of nudity— usually, but not always, female. It is not necessarily pornographic. Marilyn Monroe's *Apple Knockers and the Coke* (pre-1948) was a skin flick in which she appeared in the nude playing suggestively with apples and a Coke bottle.

Slapstick Comedy: A film whose humor is created mainly by scenes showing displays of comic violence or knockabout farce. Laurel and Hardy's *Two Tars*, dir. James Parrott (1928) is a "classic" slapstick comedy; so are many of the films of Mack Sennett. See also GENRE: CUSTARD-PIE COMEDY.

Soap Opera: A radio or television serial drama of a sentimental and/or melodramatic nature; it is so called because many serials of this kind are sponsored by soap or detergent manufacturers: e.g., the television serial, *Secret Storm* (CBS). The term is often used as a synonym for a WEEPIE or TEAR-JERKER.

Social-Conscience Picture: A factual or fiction film whose subject or main theme is intended to arouse public concern for some injustice or social disorder: e.g., Mervyn LeRoy's *They Won't Forget* (1937)—a denunciation of lynching and lynch mobs—and many of Stanley Kramer's films e.g., *Judgment at Nuremberg* (1961).

Social Drama: A film focusing on themes of general social concern or on individuals whose lives exert or exerted wide public influence: e.g., Larry Peerce's *One Potato, Two Potato* (1964)—a study of interracial marriage; Dieterle's *The Life of Emile Zola* (1937), which concentrates for the most part on the Dreyfus case.

Spectacle: A motion picture that focuses on scenic or action displays on a grand scale—casts of thousands performing in spectacular locations or amid grandiose scenery e.g., Mervyn LeRoy's *Quo Vadis* (1951). See also GENRE: EPIC, DeMILLE EPIC.

Spoof: A parody or mockery of another film or film genre. See GENRE: PARODY.

Spy Film: A film about espionage: e.g., George Fitzmaurice's *Mata Hari* (1932) starring Greta Garbo; Joseph Mankiewicz's *Five Fingers* (1952); the James Bond series.

Stag Film: Any SKIN FLICK or BLUE MOVIE intended for or shown to an exclusively male audience. Delbert Mann's *The Bachelor Party* (1957) has a sequence in which a group of middle-aged men watch a stag movie.

Surf-Riding Film: One of a series of CULT MOVIES in which a group of young people "live it up," dance to rock music, and make love in the intervals between their surf-riding activities. The prototype for the series was Harry Spaulding's *Surf Party* (1964). The outstanding example of the genre is Bruce Brown's *The Endless Summer* (1966). See also GENRE: BEACH-PARTY MOVIE.

Swashbuckler: A film that glorifies the exploits and prowess of a super-hero whose athletic performance is often as remarkable as his fighting skill. Many of the films of Douglas Fairbanks, Sr. (e.g., *The Black Pirate* [1926]) and Errol Flynn (e.g., *Captain Blood* [1935]) were swashbucklers.

Tear-Jerker: See WEEPIE, SOAP OPERA.

Thriller: A film whose story focuses on detection, mystery, crime, or horror: e.g., Robert Siodmak's *The Spiral Staircase* (1946), Hitchcock's *Psycho* (1960). See also GENRE: WHODUNNIT.

Travelog: A nonfiction film showing scenery and life in foreign and/or unusual places and usually emphasizing travel-guide (or attractive) features: e.g., almost any film sponsored by a tourist bureau. See also GENRE: DOCUMENTARY.

Trick Film: A film whose main interest is to be found in special effects or camera tricks: e.g., most of the films of Georges Méliès.

Two-Reel Comedy: A comedy film with a showing time of twenty minutes to half an hour (approximately 2000 feet of 35mm film). Two reels became the standard length for the short comedy film between 1914 and 1930. The making of two-reel comedies was discontinued in the 1940s. See further Kalton C. Lahue, *World of Laughter*, 1966. Many of Charlie Chaplin's films for Keystone (1914), Essanay (1915), and Mutual (1916–1917) companies were two-reel comedies: e.g., *The Tramp* (1915).

Underground Film: Defined by Sheldon Renan as "a film conceived and made essentially by one person, and is essentially

UNDERGRC
FILM. Stan
hage's *Dog
Man* (1961–
Through su
position ba
pears to be en
from baby's
Courtesy Ant
Film Arc
Library.

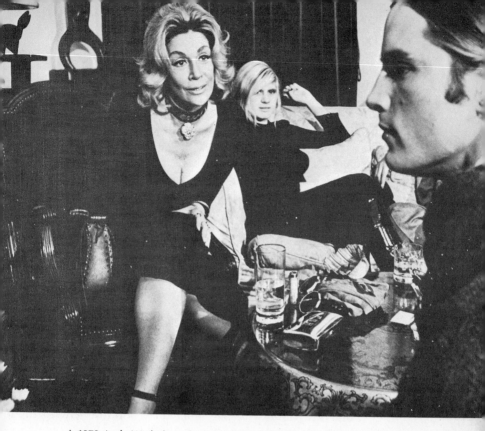

A 1972 Andy Warhol production, *Heat*, with Silvia Miles, Andrea Feldman, and Joe Dallesandro. The film is by Paul Morrissey. A Syn-Frank Enterprises, Inc., presentation distributed by Levitt-Pickman Film Corporation.

a *personal statement* by that person. It is a film that dissents radically in form, or in technique, or in content, or perhaps in all three. It is usually made for very little money . . . and its exhibition is outside commercial film channels." (Renan, *An Introduction to the American Underground Film*, 1967.) See also: Parker Tyler, *Underground Film*, 1969, and Gregory Battcock, *The New American Cinema*, 1967; Kenneth Anger's *Scorpio Rising* (1963) is a widely shown underground film.

Underwater Movie: A feature film in which dramatically important scenes occur under the water: e.g., scenes involving frogmen, divers, or submarines: e.g., Lloyd Bacon's *The Frogmen* (1951), Dick Powell's *The Enemy Below* (1957), Peter Gimbel's *Blue Water, White Death* (1971).

War Film: A film in which the main action or one or more important sequences involve warfare: e.g., Lewis Milestone's *All Quiet on the Western Front* (1930), which like many war films is antiwar in intention.

Warner Brothers Biography: A film in a series about the lives of the great and famous, produced by Warner Brothers in the 1930s and 1940s. Paul Muni starred in several of the most memorable films in the series: e.g., William Dieterle's *The Story of Louis Pasteur* (1935), *The Life of Emile Zola* (1937), and *Juarez* (1939). Dieterle's *Dr. Ehrlich's Magic Bullet* (1940), starring Edward G. Robinson, is perhaps the finest of the Warner Brothers biographies and the least affected by the formula nature of many of these films.

Weepie: A sentimental or emotionally charged film which usually makes a deliberate appeal to women. A typical example is George Seaton's *Little Boy Lost* (1953) in which Bing Crosby, trying to find his own son, becomes involved with a little boy from an orphanage. More recently, *Love Story* (1970) is a weepie aimed at provoking tears from both sexes. A weepie is sometimes called a TEAR-JERKER.

Western: A film set in that part of the American West, Southwest, or Mexico which can, in some sense or other, be considered a frontier. It is usually concerned either with conflicts between law and the establishment of civilization or the natural lawlessness of the individual and the environment. Edwin S. Porter's *The Great Train Robbery* (1903) is generally considered to have been the first Western. On the Western tradition and its variations see George N. Fenin and William K. Everson, *The Western from Silents to Cinerama*, 1962; Jim Kitses, *Horizons West,* 1969; and John Cawelti, *The Six-Gun Mystique*, n.d.

Whodunnit: A mystery-thriller in which the main action centers on the solution or unraveling of a crime: e.g., Howard Hawks' *The Big Sleep* (1946).

GLASS SHOT: See SPECIAL EFFECTS.

GLICK: See SAMMY GLICK.

GOBO: A black screen, made of black opaque cloth on a metal frame used to obscure the light from studio lamps. See also DIFFUSION SCREEN, FLAG, SCRIM.

GOLD DIGGERS: A series of Hollywood musicals with formula plots about staging a show—usually in New York. Prior to the Warner Brothers' series there was a silent film, *The Gold Diggers* (1923), based on a play by Avery Hopwood. *Gold*

Diggers of Broadway (1929) was the first Gold Diggers musical. However, the series is generally considered to begin with *Gold Diggers of 1933*, dir. Mervyn LeRoy, with memorable dance routines and sequences by Busby Berkeley. There followed four other Gold Diggers films, terminating with *Gold Diggers of 1937*. These were the work of various directors, including Berkeley and Lloyd Bacon, but the spectacular dance sequences were in each case the work of Busby Berkeley.

GOLDWYN GIRLS: The "chorus" of pretty girls seen in many films produced by the Goldwyn Studios in the forties. They are in evidence, for example, in *Up in Arms* (1944), Danny Kaye's first feature.

GOLDWYNISM: Type of ludicrous saying attributed to film producer Samuel Goldwyn. It is usually a malapropism or an amusing garbling of English. Well-known examples are: "He ran like wildflowers" (i.e., wildfire), "Include me out," "A verbal agreement isn't worth the paper it is printed on."

GRADATION: The range of densities, from highlights to shadows in a film emulsion.

GRAIN: When the silver particles in an emulsion become so large that they are noticeable and objectionable.

GRAINY: See FILM.

G RATING: See RATING.

GRAY SCALE: A series of densities, from white to black, measured in definite steps.

GREENS MEN: The prop men who handle the trees and foliage on a set.

GRIDS: Beams, usually steel, attached to the ceiling of a studio. The various lights are hung from these beams.

GRIP: See PERSONNEL.

GROUND NOISE (also called "surface noise"): The noise inherent in the sound track of the film itself. It is most noticeable when no action is occurring.

GUEST STAR: A movie star (or well-known personality) who makes an appearance (often called a CAMEO appearance, usually a very brief one, in a film in which another movie star plays the

lead. The guest star "lends" himself or is invited to appear in the film. This guest appearance is a procedure that may serve to make the film more attractive to the public or it may be a means of giving strong support to the leading star of the film. Cecil B. DeMille, the director of many movie epics, makes an appearance as guest star in Billy Wilder's *Sunset Boulevard* (1950). On a television series the guest will usually take a leading role.

HALATION: An unwanted reflection or spreading of light on a negative. It gives the impression of a halo around highlights. See also ANTIHALATION BACKING, FILM.

HALF TONES: The middle tones of an emulsion that lie between shadows and highlights.

HAND-HELD CAMERA: See CAMERA: HAND CAMERA.

HARDLIGHT: See LIGHTING.

HAYS OFFICE: Popular name of the Motion Picture Producers and Distributors Association of America, Inc., when it was headed by Will H. Hays during the period 1922–1945. The Association was the film industry's censorship bureau. See also JOHNSTON OFFICE; MOTION PICTURE PRODUCTION CODE.

HAZE LENS: See LENS.

"H" CERTIFICATE: A certificate indicating that the film to which it is applied is horrific in nature and may not be seen by children under sixteen. This certificate was formerly bestowed on certain films by the British Board of Film Censors. It is no longer used in classifying films. See also "A."

HEAD: See SHOTS.

HEAVY: See ACTING.

HIGH-KEY LIGHTING: See LIGHTING.

HIGHLIGHTING: See LIGHTING.

HIGH SPEED CINEMATOGRAPHY: See CAMERA SPEED.

HIGH-SPEED FILM: See FAST FILM.

HISTORICAL FILM: See GENRE.

HOLD FRAME: See FREEZE-FRAME.

HOLLYWOOD CODE: See MOTION PICTURE PRODUCTION CODE.

HOLLYWOOD TEN: A group of directors, producers, and screenwriters who in 1947 would not reveal to the House Un-American Activities Committee whether or not they were Communists or Communist sympathizers. As a result they were jailed and on their release from prison were BLACKLISTED by the film studios. The ten members of the group were Dalton Trumbo, Edward Dmytryck, John Howard Lawson, Ring Lardner, Jr., Alvah Bessie, Lester Cole, Albert Maltz, Herbert Biberman, Adrian Scott, and Sam Ornitz. (See further: Gordon Kahn, *Hollywood on Trial*, 1948 and Dalton Trumbo, *Additional Dialogue*, 1970.) Trumbo, director of *Johnny Got His Gun* (1971) (based on his own novel) is the author of numerous screenplays, including *Thirty Seconds over Tokyo* (1944); Dmytryck has directed many films including *Give Us This Day* (1949) and *Crossfire* (1947); Ring Lardner, Jr. was screenwriter of *Cross of Lorraine* (1943) and recently of *M*A*S*H**; Lester Cole's screenplays include *Blood on the Sun* (1945); Albert Maltz, author of the novel, *The Cross and the Arrow*, wrote the screenplays of *This Gun for Hire* (1942) and *Moscow Strikes Back* (1942); Herbert Biberman's screenplays include *The Master Race* (1944); Adrian Scott produced *So Well Remembered* (1947) and *Crossfire* (1947); Sam Ornitz's screenplays include *Three Faces West* (1940).

HOLOGRAM: See HOLOGRAPHY.

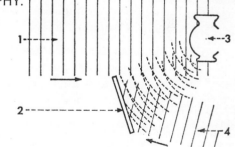

'ORMATION OF HOLOGRAM. 1. 〈eam of coherent light from laser 〈trikes object, 3. Complex system 〈f wavefronts originating from object strikes the emulsion surface, 2. 〈econd coherent light beam, 4, 〈alled reference beam, from same 〈ser, is directed on to emulsion. 〈rom *The Focal Encyclopedia*.

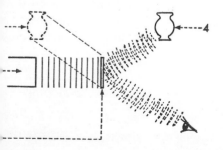

RECONSTRUCTION OF HOLOGRAM. Laser, 2, emits coherent light beam which strikes developed emulsion of hologram, 3. Light, diffracted by interference pattern on hologram, results in virtual image, 1, seen by eye of spectator, and real image, 4. Other methods of reconstruction are possible. From *The Focal Encyclopedia*.

HOLOGRAPHY: A technique for recording three-dimensional images on tape or film. "In holography, the light source of a LASER is split into two beams, one of which is directed at the subject and reflected onto a photographic plate; the other beam is sent directly to the plate. The first beam has a changed character, having been reflected from the subject and interferes with the second direct beam. It is this interference that is photographically recorded in the form of a hologram." Peter Guber, "The New Ballgame: The Cartridge Revolution," *Cinema* 6, no. 1 (1970), p. 22. See Gene Youngblood, *Expanded Cinema*, 1970. See also CARTRIDGE.

HOPKINS ELECTRIC TELEVOTING MACHINE: See AUDIENCE RATING

HORROR FILM: See GENRE.

HORSE OPERA: See GENRE.

HOT BACKGROUND: Background light on a set is too strong for general purposes. It is often used for special effects such as silhouettes. See LIGHTING.

HOT SPOT: See LIGHTING.

HUMAN INTEREST PICTURE: See GENRE.

HYPERFOCAL DISTANCE: The distance from the lens to the nearest plane of sharp focus when the lens is focused at infinity.

HYPO: The common term for the chemical agent used to "fix" or "set" the photographic image on the film emulsion.

IMAGE: (1) Photographic picture as it appears projected on the screen. (2) Photographic picture as it appears on the film itself. (3) A metaphor for something—e.g., Yossarian (in *Catch-22* [1970] is an image of modern man.

IMAGINARY LINE: A make-believe line that approximates the proscenium of a theatre. In filming, the imaginary line represents a limitation for the camera: it must not move beyond it (or must not do so in such a way as to confuse the audience geographically). Also called the *180-degree line* or sometimes the *stage line*.

IMBIBITION: In making color prints, the chemical process of dye transfer in the "washoff relief" method of developing.

IMPACT: Increasing the number of cuts, decreasing the length of scenes, using violent changes of angles, and disregarding

composition for the purpose of intensifying the excitement of a scene.

INCANDESCENT LIGHT: A light usually rich in red values, such as is caused by the burning of an arc between two electrodes. The light gives off considerable heat.

INCIDENTAL MUSIC: Strictly speaking this refers to music that supports or helps create the mood for an important action or incident in a movie: e.g., Miklos Rozsa's music to accompany Van Gogh's fits of insanity in Minnelli's *Lust for Life* (1956). However, the term is sometimes used, erroneously, as a synonym for FUNCTIONAL MUSIC.

INCIDENT LIGHT: The light falling on a subject from all angles. See LIGHTING.

INDEPENDENT PRODUCTION: A film that is produced without the financial backing of an established film studio. *Thunder Over Mexico* (1934) was an independent production, sponsored by Upton Sinclair and a small group, The Mexican Film Trust, and cut from the footage Eisenstein shot for *Que Viva Mexico!* Notable examples of later independent productions are John Cassavetes' *Shadows* (1960) and *Faces* (1968), and Howard Smith's *Marjoe* (1971).

INDEPENDENTS: During 1909–1915 these were the film companies who opposed the attempts of the MOTION PICTURE PATENTS COMPANY to regulate and control film production and exhibition in the U.S.A. Leading Independent companies were Fox, I.M.P., Rex, Nestor, Thanhouser, Bison, Keystone, and Mutual. The Independents formed protective organizations, the most important of which was Carl Laemmle's Motion Picture Distributing and Sales Company. Laemmle's organization was, in Lewis Jacobs' words, "prepared to sell and ship bootleg products of any independent producer. It collected fees and deducted a percentage from its members' receipts for a common defense fund in the battle against the trust." See further chapter 6 of Lewis Jacobs' *The Rise of the American Film*, 1939, and John Drinkwater, *The Life and Adventures of Carl Laemmle*, 1931. See also MOTION PICTURE PATENTS COMPANY.

IN FRAME: The FRAME LINES between two frames are not visible when the film is projected.

A motif from Sergei Eisenstein's *Que Viva Mexico!* from which footage was cut for the independent production *Thunder Over Mexico* (1934). Courtesy Estate of Upton Sinclair.

INSERT: See TITLE.

IN SYNC: The achievement and/or maintenance of SYNCHRONISM between picture and sound track.

INTEGRAL TRIPACK: See COLOR CINEMATOGRAPHY.

INTERCUT: See CROSSCUTTING.

INTERLOCK: State of satisfactory synchronization of sound and picture

INTEREST PICTURE: See GENRE.

INTERIOR: A scene filmed in a studio, on a stage, or inside a building

INTERMITTENT MOVEMENT: See MALTESE-CROSS MOVEMENT.

INTERMODULATION: A harmonic distortion produced when an overloaded sound system is fed with tones of differing frequencies.

INTERNEGATIVE: A DUPE negative of a color film made from an original color master negative.

INTERPOSITIVE: A master positive color film struck from an original color negative after it has been edited and an ANSWER PRINT made from it.

IRIS: An adjustable aperture on a camera; its purpose is to control or alter the amount of light reaching the film. It is called an iris because its function is similar to that of the iris of the eye.

IRIS-IN/IRIS-OUT: See TRANSITIONS.

IRIS WIPE: See TRANSITIONS.

ITALIAN NEO-REALISM: See NEO-REALISM.

JIDAI-GEKI: See GENRE.

JOHNSTON OFFICE: Popular name of the Motion Picture Producers and Distributors Association of America, Inc., when it was headed by Eric A. Johnston, during the period 1945–1963. The Association was the film industry's censorship bureau. See also HAYS OFFICE; MOTION PICTURE PRODUCTION CODE.

JOIN: See EDITING: SPLICING.

JUICER: British term for an ELECTRICIAN or GAFFER who works in a film studio. See PERSONNEL: GAFFER.

JUMP CUT: See TRANSITIONS.

JUVENILE: See ACTING.

KAMMERSPIEL: A genre of German cinema of the 1920s and early 1930s which developed out of and in partial reaction to the German EXPRESSIONIST movement in cinema. The Kammerspiel "departs from the expressionist parent stem in that, unlike pure expressionism, these films [such as Murnau's *The Last Laugh* (1924)] go in for psychological characterization and surface naturalism." See further George Huaco, *The Sociology of Film Art,* 1965, Part I.

KEM UNIVERSAL EDITING TABLE: See APPARATUS and EQUIPMENT.

KEY LIGHTING: See LIGHTING.

KEYSTONE KOPS: Zany, ludicrous policemen in the SLAPSTICK films of Mack Sennett.

KILOWATT (K or Kw): One thousand watts of electricity.

KINEMACOLOR: See COLOR CINEMATOGRAPHY.

KINESCOPE: (1) A motion picture film recording of material originally shot with television cameras; (2) the trade name used by RCA to identify their TV cathode-ray tubes, used for picture

reproduction; (3) a drastically abridged movie shown on television; (4) a made-for-television film that fits neatly into the time SLOTS.

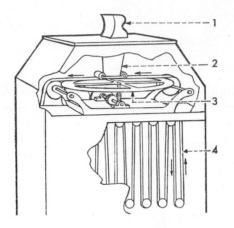

EDISON'S KINETOSCOPE (1893). Machine for viewing by a single person, looking down on the film image through aperture, 1. A 56-ft. continuous band of film was pulled with a steady motion through a reservoir chamber, 4, and passed beneath a magnifier in the tube, 2. A revolving disc, 3, had a perforated rim which, in this model, was interposed between the film and the light source (not shown), thus very briefly illuminating each frame, so that it appeared to be stationary. From *The Focal Encyclopedia.*

KINESCOPE CONVERSION: The "normal" speed for sound motion pictures is 24 frames per second. The "normal" speed for TV pictures is 30 frames per second. To make them compatible, six frames must be "added" to a film when it is shown on TV. This is done mechanically in the projection process.

KINETOSCOPE: The invention of W. K. L. Dickson, Edison's assistant. It was a device for showing and viewing motion pictures and was exhibited in 1894, approximately one year before the commercial beginnings of the cinematograph. Gordon Hendricks describes the Kinetoscope as a "peep-hole picture machine" which "stood on the floor to a height of four feet. Through an eye-piece on the top a customer could, upon application of the coin of the realm, cause the machine to whirr briskly and show motion pictures of dancing girls, performing animals, etc." See Gordon Hendricks, *The Kinetoscope*, 1966.

KINETOPHONE: A combination of the Kinetoscope with the Edison phonograph, intended to provide moving pictures with sound accompaniment. See Gordon Hendricks, op. cit.

KINOBIBLIOTHEK: See KINOTHEK.

KINO-EYE GROUP: A group of avant-garde filmmakers in the U.S.S.R. Organized in 1919 and led by Dziga-Vertov (Denis Kaufman), the group made twenty-three revolutionary-style newsreels on principles expressed in a manifesto by Dziga-Vertov. Dziga's most memorable film is his *Man with the Movie Camera* (1928). See further Dziga-Vertov, "Kinoks -Revolution," in Harry M. Geduld, ed., *Film Makers on Film Making*, 1967, pp. 79–105.

KINOTHEK: A published collection of mood music for accompanying silent films. (The term was an abridgement of Kinobibliothek, cinema library.) The first published collection of this kind was Giuseppe Becce's *Kinothek*, 1919. See further Kurt London, *Film Music*, 1936, Part Two, section D.

KLEIG LIGHT: Common term used for powerful spotlights specifically designed for motion picture or television usage. The lights are manufactured by Kleigl Brothers.

KODACHROME: A TRIPACK color reversal film process first introduced in 1935. Now used mainly in 8mm, Super-8, and some 16mm filming.

LAP DISSOLVE: See TRANSITIONS: Dissolve.

LAP-SPLICE: See EDITING: SPLICE.

LASER: An acronym formed from the initial letters of the words: light amplification by stimulated emission of radiation. Lasers are low-noise microwave amplifiers that are effective in visible or almost visible areas of the spectrum. See HOLOGRAPHY.

LATENT IMAGE: The invisible image in an emulsion that has been formed by exposure to light. The image becomes visible by the process of development in certain chemicals.

LATERNA MAGIKA: See PROCESSES.

LATITUDE: This refers both to exposure latitude and development latitude. When referring to the former, it means the quality of an emulsion which allows variation in exposure without damaging image quality. When referring to the latter, it

means variation in the suggested developing time without noticeable differences in density or contrast.

LAVENDER PRINT: See FILM.

LAZARSFELD-STANTON PROGRAM ANALYZER: See AUDIENCE RATING.

LEAD: See ACTING.

LEADER: See FILM: ACADEMY LEADER.

LENS: An optical system consisting of a refracting medium of a transparent material (usually glass), a LENS BARREL, and a focusing ring which concentrates, disperses, or changes the direction of light rays to form an image.

Anamorphic Lens: A lens designed to produce a wide-screen image. The photographic image is "squeezed" into the width of the normal limits of a motion picture frame during filming, then "unsqueezed" during projection.

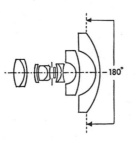

FISH-EYE LENS. Lens in which retrofocus construction has been utilized to give maximum possible field of view. At an aperture of about f8, the limiting field of 180 degrees (i.e., a whole hemisphere) can be reached. The portrayal of so wide a field on a flat film surface is necessarily distorted, but fish-eye lenses usually contribute further distortions, some of which may in future be significantly reduced with the aid of parabolic surfaces. From *The Focal Encyclopedia.*

Anastigmat Lens: A lens—corrected for anastigmatism—that is used to photograph vertical and horizontal lines with equal definition and brightness.

Angle of View: The angle formed by plotting two lines from the center of a lens, as shown on the negative, to the two distant corners of the negative.

Apochromatic Lens: A lens that focuses the light rays of all color on the same plane.

Electronic Lens: Lens that replaces light rays by electron rays which form an image under the influence of magnetic fields.

Haze Lens: Colloquial term for soft-focus gauzing of the lens, sometimes used when shooting close-ups of female stars, particularly those who are older than they like to appear. See also SOFT FOCUS.

Lens Aperture: See APERTURE, DIAPHRAGM, IRIS.

Lens Barrel: A cylindrical-shaped mounting for the camera or projector lens. It usually has a focusing mechanism and an IRIS.

Lens Hood: A cover or shield situated at the front of the camera or the lens barrel; it can be used to exclude unwanted light from passing through the lens—often to reduce lens glare.

Lens Turret: A revolving mount fixed at the front of a camera and providing two or more lenses which may be switched into position for the purpose of filming.

Long-Focus Lens: (1) A lens used to film a distant scene or object. (2) A lens used to magnify the object being filmed. Long-focus lenses have focal lengths above the normal. See also below: TELEPHOTO LENS.

Objective: A lens through which the cameraman looks to see the image of the object which the camera lens is recording on film.

Optical Lens: A photographic lens as distinct from an electronic lens.

Resolving Power: The ability of a lens to reproduce fine detail. The term applies in the same manner to a film emulsion.

Sharpness: Relates to the edges of the photographed image on the motion picture negative.

SHARPNESS AND RESOLUTION. Micro-densitometer traces across the photographic images of a point source formed by a lens focused (A) for maximum resolution and (B) for maximum sharpness. From *The Focal Encyclopedia*.

Short-Focus Lens: A lens whose focal length is shorter than normal and which gives a wide field of view. Also called a WIDE-ANGLE LENS.

Telephoto Lens: A lens of greater-than-normal focal length. See also LONG-FOCUS LENS above.

Wide-Angle Lens: A lens of shorter-than-normal focal length. See SHORT-FOCUS LENS above.

Zoom Lens: A lens with variable focal lengths. It is used to create the effect of camera movement toward or away from a scene without actually moving the camera.

LIBRARY SHOT: See FILM: STOCK FOOTAGE.

LIGHTING: The illumination of scenes to be filmed—those filmed indoors as well as those shot at night or in natural light—is described in terms of the direction from which the light comes relative to the scene: *front-, back-, top-, cross-lighting* being the obvious ones. *Highlighting,* however, involves intensification rather than direction, and a *hot spot* is the extreme intensification of highlighting. The *key light* is the chief light used in illuminating what is being filmed. *High-key lighting* is a method of lighting in which the key light provides most of the illumination of the scene: it results in a minimum of contrast and brilliant illumination. *Low-key lighting* is a method of lighting in which the key light provides much less illumination than other light falling on the scene (natural or artificial): it results in shadow effects which are often of dramatic importance. *Fill light* is a weak light which is used to balance the shadows on the darker side of what is being filmed. *Eyelight* is a light situated near the camera and used to create a sparkle in the eyes of the person being filmed. *Hard-light* is an arc lamp used to give the effect of sunlight.

LIGHTING RATIOS: The reflectance ratio of the subject, as determined by the physical nature of the subject itself compared to the lighting contrast ratio. The lighting contrast will be determined by the subject contrast.

LIGHT FLARE: An overexposure in one part of a scene. It is caused by improper placement of lights.

LIGHT LEVEL: The over-all light on a scene, ordinarily measured in foot candles.

LIGHT METER: An instrument used to measure the amount of light on a scene. It also may be used to measure the amount of reflected light from the subjects being photographed.

LINKAGE: The theory of Soviet filmmaker, V. I. Pudovkin, that film images should be organically connected or "linked" in the cutting or editing process to provide the desired psychological influence on audiences, rather than brought into collision as in Eisenstein's view of MONTAGE. See further V. I. Pudovkin, *Film Technique and Film Acting,* New York, 1949.

BACK LIGHTING. Concluding shot from Ingmar Bergman's *The Seventh Seal* (1956). Courtesy Janus Films.

In his essay, "The Cinematographic Principle and the Ideogram," in *Film Form,* Eisenstein notices the differences between Pudovkin's view and his own: "In front of me lies a crumpled yellowed sheet of paper. On it is a mysterious note:

'Linkage—P' and 'Collision—E'

This is a substantial trace of a heated bout on the subject of montage between P (Pudovkin) and E (myself). . . . A graduate of the Kuleshov school, he loudly defends an understanding of montage as a *linkage* of pieces. Into a chain. Again, "bricks." Bricks, arranged in series to *expound* an idea. I confronted him with my viewpoint on montage as a *collision.* A view that from the collision of two given factors *arises* a concept. From my point of view, linkage is merely a possible *special* case."

LIP SYNC: See SOUND.

LIVE SOUND: The recorded sound that includes dialogue and other noises recorded during the actual shooting.

BACK LIGHTING. Light source opposite the camera and behind the subject. Face is in shadow and outline of head is clearly defined.

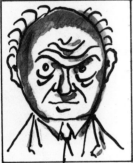

FRONT LIGHTING. Light source placed so that it is pointing directly at subject. Face almost entirely out of shadow.

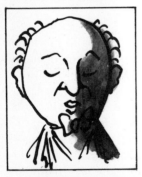

SIDE LIGHTING. Light source from left. Right side falls into shadow.

SIDE LIGHTING. Light source from right. Left side falls into shadow.

SIDE LIGHTING from both sides. Narrow shadow area where contour of subject separates light from different light source.

TOP LIGHTING. Shadows particularly striking on neck, beneath nose, in eye sockets.

LIGHTING FROM BELOW SUBJECT. Shadows opposite those in TOP LIGHTING.

LIGHTING EQUALLY DIFFUSED.

Derived from the earlier vaudeville form known as LIVING PICTURES, "historical facsimiles" such as this one of the surrender at Appomattox from Griffith's *The Birth of a Nation* (Epoch, 1915) were popular in early film spectaculars. Wisconsin Center for Theatre Research, Blum Collection.

LIVING FILM: A term used to describe a scene, and sometimes an entire motion picture, that seems as if by magic to "come alive" with deep and penetrating emotion.

LIVING PICTURES: A late nineteenth-century vaudeville act consisting of a tableau of live performers posing motionless in an elaborate setting, often reproducing a famous painting. This did not involve film in any way, but references to *living pictures* are sometimes confused by film historians with early references to motion pictures, perhaps because Griffith created a variation in *The Birth of a Nation* (1915): "historical facsimiles."

LIVING SCREEN: A term for the performance of live actors on stage in combination with projected pictures (still photographs and/or films). See also LATERNA MAGIKA.

LOADING SPOOL: A kind of light-tight reel on which 8mm, 16mm, or 35mm film stock is wound before it can be loaded into the camera in daylight. Longer film loads must be darkroom loaded.

LOCATION: A place other than the studio where a film can be partly or entirely shot. Location shooting can provide the filmmaker with authentic backgrounds, but it often allows less control than can be achieved in studio shooting. Very few feature films made today are shot in studios.

LOCATION SITE: The geographical area where a motion picture will be shot. Considerations must be given to the dramatic elements of the script, the weather, the amount of extraneous sounds such as railroads, airplanes, and so on.

LOG: A written account of the details and activities involved in making a film—maintained while the film work is in progress. Separate logs may be kept for each important aspect of the film's production.

LONG-FOCUS LENS: See LENS.

LONG PLAY: A film story in more than one reel. The term was used during the silent period. See SHORT PLAY.

LONG SHOT: See SHOTS.

LOOP: See FILM.

LOOPING: The re-creation of dialogue by an actor. This is done on a sound stage in synchronization with the film in order to substitute for unsatisfactory sound recording during original shooting. The shot may run over and over on the projector in a *continuous loop* to expedite the attempt to get the lines exactly to the director's liking.

LOT: (1) The land beside a film studio on which exterior sets may be erected or where out-of-doors shooting may take place. (2) A term used synonymously with studio: i.e. "We're shooting on the lot today" means that filming is going on at the studio rather than on location.

LOVE INTEREST: Film-story material about love relationships, usually of a romantic rather than an erotic or pornographic nature.

LUMEN: A measurement of light. One lumen is equal to the amount of light falling on a one-foot-square surface which is one foot away from a light source of one candle power.

MAGAZINE: A light-proof film container which attaches to a camera. The film magazine has two compartments: one holds unexposed raw stock that is fed into the camera for exposure; the other compartment holds the film after it is exposed but undeveloped. The exposed film is sealed and put into a film can for dispatch to the photographic laboratory where it can be opened for processing under controlled conditions. Also an integral part of many cameras and processing machines.

MAGIKA LATERNA: See PROCESSES.

MAGNETIC RECORDING: See SOUND.

MAGNETIC SOUND: See SOUND.

MAIN FEATURE: In a program comprising two or more feature films, this is rated or advertised as the most interesting, attractive, or important picture. See SECOND FEATURE.

MAKE-UP MAN: See PERSONNEL: COSMETICIAN.

MAKE-UP ARTIST: See PERSONNEL: COSMETICIAN.

MALTESE-CROSS MOVEMENT: A mechanism in a camera or projector that provides for the intermittent (stop-and-go) movement of the film: i.e., it allows each frame to be viewed while it is briefly in a stationary position and then replaces it with the next frame. The *pull-down claw* is another mechanism serving the same purpose.

MARCH OF TIME: A successful series of two-reel DOCUMENTARY films dealing with topical matters; produced 1934–1951 by Louis de Rochemont in collaboration with *Time* magazine. The style of these films and their blatant commentaries are parodied by Orson Welles at the beginning of his *Citizen Kane* (1941).

MARQUEE: A structure that projects over the movie theatre entrance; it is used to advertise or announce details of the films being shown.

MASK: (1) A shield, usually placed in a matte box before the camera lens, to block out some portion of the camera's field of view. It is generally used in making trick films, and the end product is accomplished by use of an OPTICAL PRINTER. (2) During the silent era, the mask was a shield used over the lens to alter the shape of the screen image—as in shots in Griffith's *Intolerance* (1916).

MASTER DUPE NEGATIVE: See DUPE NEGATIVE.

MASTER SHOT: See SHOTS.

MATCH CUT: See TRANSITIONS.

MATCHING ACTION: A procedure in CUTTING a film. It involves, first, the selection of two strips of film which show an overlapping action, and second, the choice of the place where the cutting and splicing will be most satisfactory so that the film's action seems continuous to the viewer.

MATTE: See SPECIAL EFFECTS, TRAVELING MATTE.

McGUFFIN: Alfred Hitchcock's term for the riddle, object, or information that triggers the plot; it is what everyone is after in a thriller: e.g., the secret formula, the military plans. A microfilm of chemical formulae is the McGuffin in Sam Fuller's *Pick-Up on South Street* (1953); in Hitchcock's *The 39 Steps* (1935) the spies are hunting for the formula of an airplane engine. See also WEENIE.

MEDIA: See MEDIUM.

MEDIUM: (1) Material or form used for communication or for artistic expression or delineation. (2) The techniques or methods of expression in any given form. MEDIA (plural of medium): film, television, theatre, and music are media.

MEDIUM IS THE MESSAGE: The famous epigram of Marshall McLuhan which capsulates the dominant theme in his controversial book, *Understanding Media: The Extensions of Man*, 1964. "The phrase first suggests that each medium develops an audience of people whose love for that medium is greater than their concern for its content. . . . Second, the 'message' of a medium is the impact of its forms upon society. . . . Third, the aphorism suggests that the medium itself—its form—shapes its limitations and possibilities for the communication of content." Richard Kostelanetz, "Understanding McLuhan (in part)," in Harry H. Crosby and George R. Bond, *The McLuhan Explosion*, 1968.

MEDIUM SHOT: See SHOTS.

MELODRAMA: See GENRE.

METHOD ACTING: An acting style that originated with Constantin Stanislavsky and the Moscow Art Theatre. Essentially it involves the actor becoming (totally identifying with) a char-

acter rather than merely playing a role. See C. Stanislavsky, *My Life in Art* and *Stanislavsky Produces Othello*. On the introduction of Method acting into the American theatre, see Harold Clurman, *The Fervent Years*. Marlon Brando was among the first exponents of Method acting in films—see especially his performance in Elia Kazan's *A Streetcar Named Desire* (1950).

METTEUR-EN-SCÈNE: Person responsible for the MISE-EN-SCÈNE: often synonymous with DIRECTOR.

MICKEY MOUSE: Walt Disney's most famous cartoon character, who first appeared in *Plane Crazy* (1927). The character is known in France as Michel Souris or Mickey Sans Culotte, in Italy as Topolino, in Spain as Miguel Ratoncito, in Sweden as Musse Pig, in Japan as Miki Kuchi, in Greece as Mikel Mus, in Brazil as Camondongo Mickey, in Argentina as El Raton Mickey, and in the Central American countries as El Raton Miguelito. See Richard Schickel, *The Disney Version*, 1968.

MINIATURE: See SPECIAL EFFECTS.

MISE-EN-SCÈNE: A complex term generally used in reference to the staging of a play in considering as a whole the settings, the movements of the actors in relation to the settings, lighting, and so forth. Many film theorists, including Bazin and Panofsky, consider mise-en-scène the true source of film. The term can also be used in reference to similar considerations in film production.

MIST PHOTOGRAPHY: The filming of scenes swathed in mist or fog usually for atmospheric purposes. Mist photography is to be seen in Ford's *The Informer* (1935) and in Robert Stevenson's *Jane Eyre* (1944) when Jane first encounters Mr. Rochester riding his horse across the Yorkshire moors. In most studio-made films, mist and fog are artificially produced by a mist-making machine.

MITCHELL: See CAMERA.

MIX: See TRANSITIONS.

MIXER: See PERSONNEL.

MODEL SHOT: See SPECIAL EFFECTS.

MODULATION NOISE (also called BEHIND-SIGNAL NOISE): A harmonic distortion discernible on unmodulated sound tracks.

MOGUL: A movie tycoon; a major film producer. Darryl F. Zanuck and Adolph Zukor are well-known examples.

MOLLER: An organ designed and constructed for use in cinemas. It was a product of the Moller Organ Co., Hagerstown, Md.

MONOCHROME: Signifies that the only tonal gradation in the film is one of shading (light and dark) and not of color.

MONOPACK: See COLOR CINEMATOGRAPHY.

MONSTER MOVIE: See GENRE.

MONTAGE: A term coined from the French word *monter* (to assemble) applied to the process of cutting, assembling, arranging, or editing of shots. However, the term has been interpreted differently by Soviet filmmakers on the one hand and by commercial (Western) filmmakers on the other. For Eisenstein, montage was the fundamental creative process in filmmaking. It meant for him the methods used to combine shots of apparently unrelated material so as to generate new, meaningful relationships within the minds of the audience. This concept of montage was influenced by Marxian dialectic, Pavlovian psychological theory, and the Hegelian triadic process of thesis-antithesis-synthesis. Eisenstein's method of montage is sometimes known as *dynamic cutting*. He also distinguished subcategories of montage (e.g., rhythmic montage, tonal montage) in his essay, "Methods of Montage" in *Film Form*. Among commercial filmmakers, *montage* is a term often used to describe a sequence using rapid SUPERIMPOSITIONS, JUMP-CUTS, and DISSOLVES in order to create a kind of kaleidoscopic effect to leave audiences with a particular emotional experience: e.g., Ray Milland's rapid tour of taverns in the course of getting drunk in Billy Wilder's *The Lost Weekend* (1945). See also LINKAGE, EDITING, VORKAPICH.

MOSAIC: The sensitive surface in an electronic camera tube, used in TV work, on which a picture image is focused.

MOTIF: A term that originated in music, in a film it usually refers to a situation, pictorial detail, word, phrase, or idea that is reiterated—often for the purpose of giving unity to the film by relating the repeated element to various, apparently disparate parts of the story. The mysterious monolith in Kubrick's *2001: A Space Odyssey* (1968) is a motif that helps to unify

MOTIF from Sergei Eisenstein's *Que Viva Mexico!* Courtesy estate of Upton Sinclair.

the separate sections of the film. Glass, especially broken glass, is a motif in Penn's *Bonnie and Clyde* (1967). Circular figures (plates, hats, wheels, etc.) constitute an important motif in Eisenstein's *Potemkin* (1926).

MOTION PICTURE PATENTS COMPANY: An organization formed by a number of pioneer American film companies with the objective of monopolizing filmmaking in the U.S.A. The company was established on January 1, 1909, and comprised: Edison, Biograph, Essanay, Vitagraph, Selig, Lubin, Kalem, Méliès and Pathé (the U.S. branches only) and George Kleine (a distributor)—film-related companies that agreed to pool their patents to film apparatus, and so on, and to issue licenses for film manufacture. The organization, known as the TRUST, was dissolved in 1915 by order of the Supreme Court on the rather obvious grounds that it constituted a monopoly—albeit a totally ineffective one because of the successful activities of the INDEPENDENTS.

MOTION PICTURE PRODUCTION CODE: A statement of censorship principles adopted by the American film industry on March 31, 1930, but not enforced until 1934 when American Catholic bishops who had formed the Legion of Decency announced that they would advise a boycott of Hollywood films by Catholic audiences unless there was an improve-

ment in moral standards represented on the screen. The Code was revised in 1956 and 1966. Its principles were widely enforced until the 1960s. For a full statement of the Code see Murray Schumach, *The Face on the Cutting Room Floor,* 1964, pp. 279–292. See also HAYS OFFICE; JOHNSTON OFFICE; PRODUCTION CODE OFFICE.

MOTORCYCLE MOVIE: See GENRE.

MOVIE PALACE: See PICTURE PALACE.

MOVIETONE: (1) A sound-on-film system developed by Theodore W. Case and E. I. Sponable and sponsored and exploited in the late 1920s by William Fox. (2) Fox Movietone News—the first regular sound newsreel series, beginning in 1927, produced by William Fox and using the Movietone sound system. See further Upton Sinclair, *Upton Sinclair Presents William Fox,* 1933, and Glendon Allvine, *The Greatest Fox of Them All,* 1969.

MOVIOLA: See APPARATUS and EQUIPMENT.

MPAA: See ABBREVIATIONS.

MULTILAYER COLOR FILM: See FILM.

MUSICAL: See GENRE.

MUSIC and EFFECTS TRACK: See SOUND.

MUTE NEGATIVE: British term for the negative picture of a sound film minus its sound track. Also called an ACTION NEGATIVE.

MUTOGRAPH: A camera used in making MUTOSCOPE pictures. It was designed by Henry Norton Marvin.

MUTOSCOPE: A hand-cranked motion picture viewing machine designed in the late 1890s by Henry Norton Marvin and W. K. L. Dickson. In effect it was similar to the KINETOSCOPE, but it worked by flashing picture cards in front of the viewer instead of showing films. Still popular in amusement park arcades.

NARRATOR: The off-camera voice that guides the audience through the action by supplying information or commenting on the significance of events. When the voice neutrally explains or informs (typical in documentary film) it is usually identified as a *narrator;* when the voice interprets and judges, it is called a *commentator.* In documentary as well as art film,

though, the voice may assume the importance of a major actor as in *The Hour of the Furnaces* (1970), *Tom Jones* (1963), and *A Clockwork Orange* (1971).

NARROW GAUGE: See GAUGE.

NATIONAL ACADEMY OF TELEVISION ARTS AND SCIENCES: An organization composed of performers, producers, and executives in the television industry who are devoted to the improvement of television.

NATURALISM: (1) Slice-of-life portrayal; the technique of presenting a detached, objective, and "scientifically correct" picture of life—should be referred to as REALISM in order to avoid confusion with (2) a view of man as a creature controlled or determined by his heredity and environment; naturalistic elements of this kind are found in William Wyler's *Dead End* (1937) and Buñuel's *Los Olvidados* (1950). See NEO-REALISM.

NATURALIST DOCUMENTARY: See GENRE: DOCUMENTARY.

NATURE FILM: See GENRE.

NEGATIVE: See FILM.

NEGATIVE CUTTING (Matching): The exact frame-by-frame cutting of the original negative to match the edited positive print. Since the negative cannot be replaced, the matching must be precisely done. All subsequent prints of the film will derive from the resulting negative.

NEGATIVE IMAGE: See FILM: NEGATIVE.

NEGATIVE NUMBERS: See EDGE NUMBERS.

NEGATIVE SCRATCH: See FILM: SCRATCHES.

NEGATIVE SPLICE: See EDITING: SPLICE.

NEO-REALISM: A major movement in Italian cinema which flourished c. 1944 through 1952. It originated under the influence of SOVIET EXPRESSIVE REALISM and literary NATURALISM (especially of the American writers, Hemingway, Steinbeck, and Faulkner) and as a reaction against the artificialities and propaganda of Italian Fascist cinema. The major directors of the movement were Rossellini, de Santis, de Sica, and Visconti. The movement was seriously countered by the passing of the ANDREOTTI LAW of 1949. See further

George A. Huaco, *The Sociology of Film Art,* 1965, Part 3: Italian Neo-Realism.

NEW AMERICAN CINEMA: Often used interchangeably with *underground* or *experimental film,* this term derives from the New American Cinema Group, an organization founded September 28, 1960, by a varied group of filmmakers and producers (including Lionel Rogosin, Peter Bogdanovich, Jonas Mekas, Shirley Clarke, and Robert Frank) whose interests included experimental, avant-garde, *and* commercial film. As a study of the Group's published statements indicates, the term designates a broad movement of rebellion against the constraints on subject matter, treatment, social and philosophic attitudes, and methods of financing and distributing film. For a full statement of belief and program and for a discussion of some of the main directors and films identified with the New American Cinema, see P. Adams Sitney, ed., *Film Culture Reader,* 1970, pp. 71–118.

NEWS FILM PHOTOGRAPHY: Today, the term refers to 16mm motion picture film, shot with a silent or single-system sound camera, for news programs on television. Before television, the "newsreel" consisted of a 10- or 20-minute news-film program, shot on 35mm film, and shown in theaters. With the advent of television, such films virtually ceased being shown as part of a film program.

NEWSREEL: See GENRE: DOCUMENTARY.

NEW WAVE: French cinema of the late fifties and sixties, and associated with such contrasting directors as Godard, Resnais, Truffaut, and Malle. Alexandre Astruc was a leading theoretician of the movement which was in no way coherent or united by any manifestos but whose divergent concepts often found expression in the pages of the journal *Cahiers du Cinéma.* See Roy Armes, *French Cinema Since 1946,* Raymond Durgnat, *Nouvelle Vague: The First Decade,* 1963.

NICKELODEON: In 1905 the Pittsburgh store-theatre of John and Harry Davis opened and, because it offered some amenities and provided piano accompaniments for the movies they showed, charged a nickel admission. The name, first used in connection with the Davises' theatre, quickly caught on and was soon applied indiscriminately to any inexpensive movie house.

NITRATE: See FILM.

NONDIRECTIONAL MICROPHONE: See SOUND.

NONFICTION FILM: See GENRE: DOCUMENTARY.

NONTHEATRICAL: A class of distribution which applies chiefly to clubs, service organizations, educational institutions, and film societies typically at a fixed fee rather than at a percentage of admission receipts. Also applies to films made for education, industry, business, medicine, and the like.

NORMAL REPRODUCTION: See REPRODUCTION.

NOUVELLE VAGUE: See NEW WAVE.

NUDIE: A skin flick. See GENRE: SKIN FLICK.

NUMBER BOARD: See APPARATUS and EQUIPMENT, CLAPPER BOARD.

OBJECTIVE: See LENS.

OLDIE: An old film. The term is often used nostalgically. The exact significance of "old" will vary with the age and/or film experience of the person using the term.

ON LOCATION: See LOCATION.

OPACITY: Resistance of a material to the transmission of any kind of light.

OPTICAL EFFECTS: Common special effects, often called opticals, prepared in the course of processing exposed film. For example, fades, dissolves, mixes, wipes, hold-frames can be created by the optical printer.

OPTICAL LENS: See LENS.

OPTICAL PRINTER: A film printer (see CONTACT PRINT) that transfers the printing image to the unexposed film via an optical system. Optical printers are widely used for SPECIAL EFFECTS and for blow-ups and reductions. See also CONTACT PRINTER, STEP PRINTER.

OPTICAL (or PHOTOGRAPHIC) **SOUND RECORDER:** SEE SOUND.

OPTICAL VIEW FINDER: See LENS: OBJECTIVE.

ORGANS: These began to be installed in cinemas from c. 1912 onward, and were widely used throughout the silent period

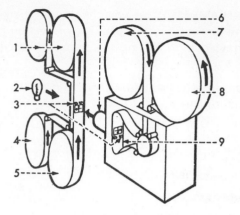

OPTICAL PRINTER LAYOUT. Process camera *(right)* faces printer head *(left)* through copying lens, 6, often in separate support to give adjustable magnification. Because of image reversal in lens, movement of film in printer is normally upwards from feed chambers, 4, 5, to take-up chambers, 1. Big registration pin, 3, is thus on opposite sides in printer and camera, where 9 is guided edge of film. Light source, 2, provides exposure. Camera feed chambers, 7, and take-up chamber, 8, are in orthodox positions. Camera is shown copying bipack master positives in printer for a traveling-matte shot. From *The Focal Encyclopedia.*

for providing musical accompaniment to films. They continued to be popular as a means of providing interlude music right through to the late forties, and thus large cinemas erected after 1927 were sometimes supplied with large and elaborate pipe organs. See further CONSOLE, MOLLER, WURLITZER.

ORIGINAL NEGATIVE: See FILM.

ORTHOCHROMATIC: See FILM: COLORBLIND FILM.

OSCAR: The gold-plated statuettes (initially 13½ inches tall, 6 pounds, 12 ounces in weight; now 8½ pounds) awarded each year by vote of the membership of the Academy of Motion Picture Arts and Sciences to honor high achievement in the several arts and sciences involved in making motion pictures. The first awards were made on May 16, 1929, but the name Oscar was not introduced until 1931, reputedly by Margaret Herrick, then a librarian at the Academy, later its executive director, who exclaimed on first seeing the statuette that it looked like her Uncle Oscar. See Natalie Fredrik, *Hollywood and the Academy Awards,* 1969.

OUT OF FRAME: The FRAME LINES between two frames become visible when the film is projected. This is a projection fault that can be corrected by adjusting the framing device on the projector.

OUT OF SYNC.: Failure to establish and/or maintain SYNCHRONISM between picture and sound track.

OUTS: See EDITING.

OUT-TAKES: See EDITING.

OVERLAP DIALOGUE: See SOUND.

OVERLAPPING CONVERSATION: The simultaneous speaking of lines by two or more characters in a film. The first conscious and significant use of this naturalistic sound technique is generally attributed to Orson Welles, who used it in the Mercury Radio Theatre and especially in his films *Citizen Kane* (1941) and *The Magnificent Ambersons* (1942) as a kind of aural extension of *DEEP FOCUS* composition.

OVERPLAYING: The actor overprojects. A rather common occurrence when stage actors go before motion picture cameras.

OVERSHOOTING: When a director wants to make sure he has the exact shot he needs, he may shoot much more film than is necessary for the scene. Generally used for time- (and money-) saving purposes.

PACE: The subjective experience of the relative speed with which a film "moves" or its action develops. The pace of a film is culturally conditioned, and the psychology of audiences varies not only from country to country but also from generation to generation. Thus, many German, Scandinavian, and Indian films will seem slow to American audiences and many American silent films will seem slow to the present generation. American cartoons or a film like *Bullitt* (1968) will be almost frenetically unintelligible to many non-American or older viewers. The elements which contribute to the psychological sense of pace are enormous in number and complexity of relationship. Editing, sound, color, camera angle and movement, lines, masses, lighting, shot-length, and dramatic content all enter. Further discussions may be found in Ralph Stephenson and J. R. Debrix, *The Cinema as Art*, 1969; Ivor Montagu, *Film World*, 1964, and in Roy Huss and Norman Silverstein, *The Film Experience*, 1968.

PAN: See SHOTS.

PANCHROMATIC: See FILM.

PANTHEON DIRECTORS: Fourteen directors selected by film critic Andrew Sarris as those filmmakers "who have transcended their technical problems with a personal vision of the world." His list is as follows: Chaplin, Flaherty, Ford, D. W. Griffith, Hawks, Hitchcock, Keaton, Lang, Lubitsch, Murnau, Ophuls, Renoir, Von Sternberg, Welles. See Andrew Sarris, *The American Cinema: Directors and Directions 1929–1968,* 1968. See also AUTEUR THEORY.

PAPER PRINT: See FILM.

PARALLEL ACTION: A method of narrative construction by which two stories of two separate pieces of action are presented simultaneously by depicting first a piece of one story (or action), then a piece of another, then continuing to alternate in this manner. Also called PARALLEL DEVELOPMENT. The last two reels of D. W. Griffith's *Intolerance* (1916) provide outstanding examples of the use of parallel action. See also CROSS CUTTING.

PARALLEL DEVELOPMENT: See PARALLEL ACTION.

PARALLELS: Large platforms, built high in the air, for the purpose of mounting a camera, to get a desired high-angle shot.

PARALLEL SYNC.: See EDITING: SYNCHRONISM.

PARODY: See GENRE.

PARODY FILM: See GENRE.

PATHÉ: (1) Pathé Frères, an important French film company established by silent film pioneer Charles Pathé, and associated with several important directors, including Ferdinand Zecca. The company issued the first regular newsreels—in 1910—and the name Pathé is still connected with regular newsreel production (Warner-Pathé newsreels). In the 1920s, Pathé became a major distributor of Roach and Sennett comedies. (2) Brand name of a camera manufactured by the Pathé company. It was the most popularly used movie camera before 1916, but was superseded in the 1920s by the MITCHELL.

PENNY GAFF: Contemptuous term for a movie theatre in Great Britain during the early silent period. Equivalent of DIME SHOW.

PERFORATIONS: See FILM.

PERSISTENCE OF VISION: The characteristic of human eyesight which makes it possible to see a succession of still photographs projected at certain speeds as images in motion. The retina retains a visual impression of any image presented to it for a fraction of a second longer than the time taken for the presentation. If a second image (the content of a frame) is presented within 1/24 to 1/10th of a second after the first, persistence of vision will eliminate any flicker or discontinuity between the two images.

PERSONNEL:

Art Director: Ordinarily, the person responsible for designing and overseeing the construction of sets for a studio film. Cecil Beaton, *My Fair Lady* (1964), designed the sets and also the details of interiors, costumes, and so forth, so that he was responsible for the over-all visual style of the film. The art director also is instrumental on location shooting in adapting "natural" sets and blending them with studio footage. The *set decorator* (or designer) provides the decor for sets—the furniture, draperies, furnishings, decorations for interiors. In films like Kubrick's *2001: A Space Odyssey*, (1968) or his *A Clockwork Orange* (1971), interior design is obviously extremely important and the set decorator will work especially closely with the director. The *costume designer* develops appropriate clothing for films requiring original designs, while a *wardrobe manager* or *costumer* will select, after studying the script, the right clothes from the enormous stock kept by most large studios.

Assistant Director: A company's first assistant director is really the assistant to the producer; his job is to maintain time schedules and budgets. The second assistant director is responsible for directing the movement of the EXTRAS (see also ATMOSPHERE). Spectacle films often require the services of a third, fourth, fifth (or more) assistant director, each of whom supervises extras.

Best Boy: The Gaffer's assistant; see PERSONNEL: GAFFER.

Cameraman: Person responsible for overseeing lighting and operating the camera used in shooting the film. See DIRECTOR OF PHOTOGRAPHY, below.

Casting Director: A studio official in charge of the selection of actors for a film production and sometimes responsible for

working out details of their contracts. If a STUDIO is not producing the film, the casting director works directly for the PRODUCER.

Choreographer or Dance Director: In musicals and ballets the person who plans and rehearses solo and ensemble dance routines.

Cinematographer: See PERSONNEL: DIRECTOR OF PHOTOGRAPHY.

Composer: The person primarily responsible for developing the music—original or adapted—appropriate to the film's mood and action. He may work with the director during the shooting of the film or compose a score after the film is shot and edited. Often a *music editor* or *cutter* will work with a composer; this relationship roughly parallels that of film editor to director.

Continuity Girl: The person responsible for making certain that there are no discrepancies in details from shot to shot. She records the details of each shot in order to facilitate editing. Also known as a *script girl, script supervisor.*

Cosmetician (also called MAKE-UP ARTIST or MAKE-UP MAN): The person (almost always male) responsible for making up the characters (human and animal) in most films. Responsibilities range from the application of ordinary and familiar beauty aids to the creation of special effects of face and figure in characters such as Frankenstein's monster, the hunchbacks in the versions of the *Hunchback of Notre Dame,* the transformations of Fredric March in *Dr. Jekyll and Mr. Hyde* (1932) or Orson Welles in *Citizen Kane* (1941). See also SPECIAL EFFECTS.

Cutter or Editor: A technician who is responsible (usually) for the important but more mechanical labor of editing the film. The job includes the trimming and splicing of the pieces of film that have to be assembled. Certain editors also play a central role in selecting shots and determining length and arrangement. See MONTAGE.

Director: The person who interprets the screenplay in order to give practical realization to it by "orchestrating" the activities of actors and technicians while the film is being made. The director is often the most creative force in filmmaking and it is usually his talents that give a film its distinctive qualities.

Director of Photography (also called CINEMATOGRAPHER): Person who plans the shots to be filmed in consultation with the DIRECTOR.

Editor: See CUTTER.

Gaffer: The chief electrician or chief *juicer* whose duties involve the lighting of the studio sets according to directions he receives from the cameraman or director of photography.

Gopher: Person sent on errands or given minor jobs: *"Go for* the tea." *"Go for* some cigarettes."

Grips: Persons responsible for the maintenance of and adjustments to equipment, sets, and props used.

Herder: Second assistant director whose primary job it is to handle all the extras on a set.

Juicer: See GAFFER.

Make-up Man: See COSMETICIAN.

Mixer or Rerecordist: (1) Chief technician in a sound-recording unit. He is in charge of all matters pertaining to the sound recording of the picture. (2) The person responsible for mixing or combining several separate sound tracks into one sound track.

Producer: The person finally responsible for the making, shaping, and outcome of a film. He is in charge of business activities involved in the film's production and carries responsibility for the commercial success or failure of the picture.

Production Unit Manager: Person in charge of making advance preparations for the production unit; this often involves choosing or finding the appropriate location and anticipating and solving any problems—from supplies to legal complications—likely to delay the unit when it arrives on location.

Script Girl: See CONTINUITY GIRL.

Script Supervisor: See CONTINUITY GIRL.

production shot on sound stage (see STUDIO) during the shooting of *Citizen Kane* (RKO, 1941) showing a CONTINUITY GIRL left rear, DIRECTOR OF PHOTOGRAPHY Gregg Toland, DIRECTOR Orson Welles in wheelchair, GRIPS, and several pieces of APPARATUS and EQUIPMENT including a SELF-BLIMPED REFLEX CAMERA. By permission of RKO-Radio Pictures, a Division of RKO General, Inc.

Second-Unit Director: Director of location sequences that involve spectacular action, "casts of thousands," stunt men, and so on, but not the main actors in the picture. Second-unit work frequently provides the most exciting action sequences in the movies.

Special Effects Men: The highly skilled and often extremely creative technician-artists whose magical effects vary from blowing up trains and bridges—*Lawrence of Arabia* (1962) or *The Bridge on the River Kwai* (1957)—to the invention of monsters like King Kong which have established themselves at virtually a mythic level in contemporary culture. Some special effects men specialize in mechanical effects; others deal exclusively with optical special effects. See also SPECIAL EFFECTS.

Stuntmen (or **Stuntwomen**)**:** Those persons who serve as doubles for leading actors and actresses in performing physical actions of a particularly hazardous kind. Other stunt specialists include rifle and bow-and-arrow marksmen, horse riders, car drivers, and flyers. For some films, a *stunt coordinator* will be responsible for the several kinds of people and equipment called for.

Technical Adviser: A subject-matter specialist who is hired to advise the director on details of the film.

Unit Manager: The person responsible for the business affairs of a film production unit while it is working *on location*.

Writer: The writer for the movies typically provides the verbal blueprint for the dramatic action of a film either by creating it *de novo* or by adapting material already written in another form. He works closely with the producer and the director and sometimes the actors, and the degree of control he has over the final form his work assumes varies greatly. See also SCRIPT.

For a lively, popular account in detail of movie personnel including many not listed above, see Theodore Taylor, *People Who Make Movies*, 1967.

PERSPECTIVE: The creating of an illusion of three dimensions on a flat surface. Of particular importance in a film like *Last Year at Marienbad* (1961).

PG RATING: See RATING.

PICTURE GATE: The opening behind the lens, in a projector or camera, across which the film passes.

PICTURE PALACE: (1) A grandiose and often highly ornate and very big cinema theatre. See the illustrations in Ben M. Hall, *The Best Remaining Seats,* 1961. (2) A grandiose or hyperbolic term for an unexceptional cinema house. Also called *Movie Palace.* Most "picture palaces"—whether or not deserving of the name—were erected prior to 1948.

PICTURE DUPLICATE NEGATIVE: See FILM: DUPES.

PICTURE IMAGE: The likeness of any object, obtained by photographic processes, on any film emulsion.

PICTURE NEGATIVE: See FILM.

PICTURE RELEASE NEGATIVE: A cut and edited picture negative used in the printing of release prints.

PILOT PRINTS: See PROCESSES.

PIRATED PRINT: A copy of a film made illegally without the permission of the copyright holder or legal distributor.

PIXILLATION: A technique of animation using live-action shots of real people in real locations to achieve the effect of having actors jump, jerk, or twitch as if they were pixillated. There are three ways of obtaining this effect: (1) editing single frames from live-action shots and omitting intervening film material, (2) posing actors as if they were puppets and taking single-frame photographs of each pose, and (3) snapping one frame at a time during normal action. The Yugoslav film *Justice* (1962) by Ante Bajaja is an example of the first kind of pixillation; Norman McLaren's Canadian film, *Neighbors* (1952) is an example of the second kind. Examples of the third kind are not generally known.

PLANE: The *image plane* refers to the emulsion surface of the film. The more common use of this term, however, involves relative placement of characters and decor in the depth-spatial composition of a shot. The arrangement and emphasis given to the various planes of depth can often have important thematic consequences. In *Citizen Kane* (1941) the scene in the New Salem, Colorado, cabin—one long shot—uses character placement at different planes to establish important emotional and thematic relationships.

PLANOSCOPIC REPRODUCTION: See PSEUDOSTEREOSCOPIC.

WARREN BEATTY
FAYE DUNAWAY

They're young... they're in love

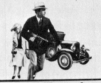

...and they kill people.

BONNIE and CLYDE

MICHAEL J. POLLARD · GENE HACKMAN · ESTELLE PARSONS

Written by DAVID NEWMAN and ROBERT BENTON · Music by Charles Strouse · Produced by WARREN BEATTY · Directed by ARTHUR PENN

TECHNICOLOR® FROM WARNER BROS.-SEVEN ARTS

POSTER: This poster to advertise *Bonnie and Clyde* (1967) reproduces the shattered-glass MOTIF used in the film. Directed by Arthur Penn, the film was written by David Newman and Robert Benton, produced by Warren Beatty, released by Warner Bros.—Seven Arts. Reprinted by permission of Warner Bros.

PLAYBACK: See SOUND. The term used to denote the immediate re-production of recorded sound (and, more recently, images, especially on videotape). The same term is also used to describe a technique employed in musicals or films featuring music and dance. The music and singing are almost always recorded or *prescored* in the sound studio under controlled acoustical conditions, and then played back while the actions are performed on the set. Later, the sound track and the actions are synchronized.

POLITIQUE DES AUTEURS: See AUTEUR THEORY.

PORNO MOVIE: See GENRE.

POSITIVE: See FILM.

POSITIVE SCRATCH: See FILM: SCRATCHES.

POSITIVE SPLICE: See EDITING: SPLICE.

POSTER: Advertising used for displays at theatres, in stores, etc.

POSTSYNCHRONIZATION: See SOUND: DUBBING.

PRATFALL: Strictly speaking this is a term for a comedian's fall on his "prat" or ass, but it has come to mean any fall executed for comic effect, and especially those falls associated with the classic routines of Chaplin, Keaton, Laurel and Hardy, Abbott and Costello, the Three Stooges, and other such physical film comedians.

PRAXINOSCOPE: See PROCESSES.

PRESCORE: See SOUND or PLAYBACK.

PRESSBOOK: The collection of advertising and promotional materials prepared for distributors of films. Pressbooks contain both visual material—production stills, drawings, posters, and so forth—as well as ideas for publicizing the film through contests, lobby displays, tie-ins with restaurants (King Kong sandwiches) and other businesses, and various, often bizarre, promotional activities. They often contain, incidentally, interesting material on the production of the film, also paper mat cuts for newspaper advertisements of various kinds and sizes.

11 WAYS TO TELL STROLLERS

CURIO EXHIBIT ON TRUCK

If you've got the equipment for a floating bally, this one ought to 'rouse plenty of comment. Idea is to post both sides of your truck with film's posters and erect a small platform. On platform you display a bunch of curios (which you can borrow) of the period and locale in an attractive layout. Truck doesn't roam streets continually but stops at busy corners. After folks have their peek, they're handed show's heralds. If you care, you can attract many more lookers by installing your P. A. system with usher to spiel while your plug makes the rounds.

SOLDIER ATOP MARQUEE

Even if you don't dress your lobby like a military station or erect a frontier Indian fort in the marquee, you'll get good results by decking out one of your ushers in uniform as worn in picture and having him march back and forth atop of marquee with a gun on his shoulder. At night a spotlight can be flashed on him to heighten the effect. Illustration shows how guard looks.

If you can spare another usher, let him dress the same way and have him wander 'round town passing out heralds. Copy on back gives show additional plug.

BUGLERS PERFORM

Get local bugle and drum corps like the V.F.W., American Legion or Boy Scout outfits to line up in military formation in front of house and give the usual array of calls including the one for the charge. It shouldn't be too hard to persuade them — in return for ducats, of course.

UNIFORM GROUPS

Contact the uniformed groups in your city to act as sponsors of benefit performances for charity in their own organizations. They'll march to the theatre in a body and give you a street bally you couldn't buy. It's good for a newspaper story, too. Among the groups are the American Legion, Veterans of Foreign Wars, Elks' Marching Clubs, Boy and Girl Scouts, National Guards, certain Masonic orders, etc.

PARADE OF LANCERS

Eight uniformed lancers mounted on white horses, their lances resting in their boots and each flying a banner titled, 'Charge of the Light Brigade,' will make a bally that will stop every pedestrian. Of course you'll have to fit this suggestion to your budget. You can't always get white horses, either. But one mounted lancer or a regiment—it's a great stunt to attract attention. Of course, if one of the men can blow a bugle, too, you've got something even better.

PLAY WAR SONG

For your opening you'll probably go to town with ballys and there's nothing more effective than martial music. Military bands can be contacted—the American Legion band will probably make a tie-up with you — and there are always fife and drum corps available. Don't forget the Boy Scout trumpeters — they'll do the trick, too.

COACH AS BALLY

If there is a Victorian coach in your vicinity that you could borrow, you have a street bally made to order for the picture. Plant a sweet-looking girl inside and have it driven around town, bannered, of course, with copy inviting folks to look inside and see over where the "Charge" was made. You can always park the bally in front of your house to attract passers-by.

AUTO PARADE AS PLUG

An auto parade of new model cars using film's title as the lead line should fit in very nicely with your bally ideas. Contact auto dealers to co-op with you in running this parade night of opening with sparklers, and other fire-works enhancing the effect. Cars carry banner copy along these lines: "*Buick Leads 'The Charge of the Light Brigade'*." At least one dealer will tie in with you, but if you can't find one, a parade of car owners is easily organized by the judicious use of ducats and your sign painter can do the rest. Since the cars will be traveling at a slow pace, it should be easy for your ushers to distribute heralds and throwaways along the route.

SLIDE ON WALL

If you haven't used your ballyopticon in a long time, simply slip your stills into it and play them on wall of building opposite. Or, if you prefer, get magic lantern and use regular slide instead of stills.

SNIPING ROAD

In plugging your show it would be wise to snipe poles and fences of all roads leading into town with copy saying: "15 Miles to 'The Charge of the Light Brigade' at the Strand Theatre, Parkville."

INDIAN FORT ON FLOAT

Dress up a truck as a frontier fort and you have an inexpensive effective street bally. Your artist can make up from beaverboard painted in the dull gray military color. With pennants and a British flag flying from the turret and guns stacked in middle it makes a big flash. While truck is patrolling the streets at a fairly slow rate of speed, your ushers can again be busy handing out heralds and throwaways. If you're anxious to have still more flash, get a few fellows in uniform on the float, having them fire fake bullets as truck moves along the street. Or would band or P.A. system giving out martial music provide the same effect?

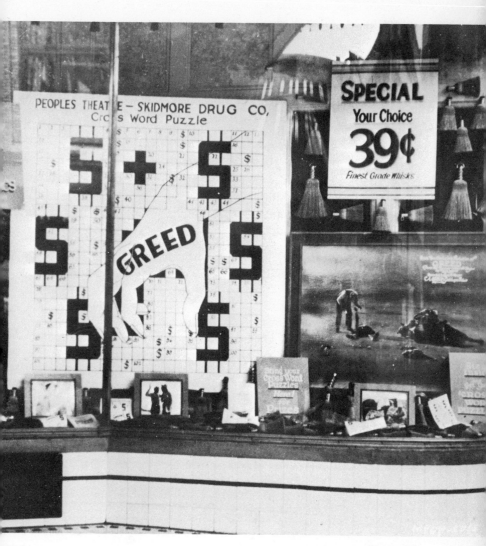

This window display which may have been suggested by a PRESSBOOK shows an attempt to promote various products "tied in" to a film. *Greed* (MGM, 1924) was based on the Frank Norris novel *McTeague*. Wisconsin Center for Theatre Research, Leibowitz Collection.

A typical page from a PRESSBOOK, this one is for *The Charge of the Light Brigade* (Warner Bros., 1936), Wisconsin Center for Theatre Research, United Artists Collection.

PRESSURE PLATE: The highly polished plate in a camera, a projector, or optical printer which presses on the back (base side) of the film in order to keep the emulsion surface in the focal plane of the lens.

PREVIEW: A preview or *trailer* is a short film consisting of excerpts from a feature to be shown at some future date and designed to stimulate interest in the film.

A *sneak preview* is a minimally and anonymously advertised, usually surprise showing of a film prior to its general release or announced premiere. The purpose of such showings is to test audience reactions to a film prior to its general exhibition. Cuts and changes of various kinds may be made on the basis of these test reactions. Frank Capra claims to have cut the entire first reel of *Lost Horizon* (1937), while more recently Stanley Kubrick decided to cut more than 20 minutes from *2001: A Space Odyssey* (1968) after it was previewed.

PRINT: See FILM.

PRINTER: See APPARATUS and EQUIPMENT.

PRINTER'S SYNC.: See PROJECTION SYNCHRONISM.

PRINTING: See PROCESSING.

PRIOR RESTRAINT: The prerogative of government or police officials to censor or ban the showing of a film before it can be exhibited to the public. This method of CENSORSHIP was introduced in the U.S.A. by a New York City board in 1909, and has since been extensively and frequently applied. See further: Richard S. Randall, *Censorship of the Movies,* 1970.

PRISON MOVIE: See GENRE.

PROCESSES: Any of the usually patented systems developed to record and display moving-picture performances. Some of the best known include:

Cinemascope: Has been described as "seamless Cinerama." A wide-screen system similar to Cinerama but without the defect of joining lines between the projected images.

Cineorama: An early, extreme form of multifilm, wide-screen presentation covering 360 degrees on a cylindrical screen. The process used ten projectors which showed what had been recorded by ten linked cameras. First demonstrated in 1897,

it was closed down after a single showing because the projector arc lamps were a fire hazard. See CIRCARAMA.

Cinerama: A wide-screen system using multiple camera processes and originally requiring a battery of six projectors and a special, complex screen consisting of 1110 vertical slats. The system now requires only one projector and one camera. Cinerama was first shown publicly in 1952 and began the Hollywood scramble to promote wide-screen systems.

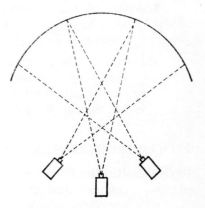

CINERAMA. In its original form, images of three separate films in three projectors were thrown on a deeply curved screen. Audience was seated between projectors and screen. From *The Focal Encyclopedia.*

Circarama: A multiscreen system using several projectors to show a series of panels on a cylindrical screen within which the audience is seated. The Russian equivalent is called *Kino-panorama.*

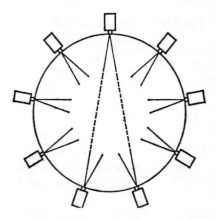

CIRCARAMA. Nine projectors arranged round the outer wall of a cylindrical screen, with lenses in narrow slots dividing screen into segments, are used to cover full 360 degrees. Audience is in central area of auditorium. From *The Focal Encyclopedia.*

Laterna Magika: A presentation combining live stage action with projected still and motion pictures. Developed in the 1950s as a distinctive and popular form by the Czechs.

Panavision: A wide-screen system dependent on the use of variable prismatic anamorphic lenses. Panavision lenses are often used in conjunction with showing 65mm film.

Technirama: A wide-screen system developed by the Technicolor Company. It uses a 70mm original-negative process and a mirror-prism anamorphic lens in shooting the picture.

Todd-AO: A wide-screen system using 65mm film. It was developed by Dr. Brian O'Brien and exploited by Michael Todd and the American Optical Company.

Vistavision: A wide-screen system providing films that can be shown on conventional cinema projectors. The image is photographed horizontally on the film negative and in this way can be nearly double the width of images photographed vertically.

PROCESS PROJECTION: See SPECIAL EFFECTS.

PROCESSING: See DEVELOPING. The equipment used in the various chemical and physical operations involved in the developing, fixing, hardening, washing, bleaching, and drying required to produce negative or positive images from an exposed strip of film bearing latent images. The equipment used in commercial labs is now extremely complex, expensive, and sophisticated. See D. J. Corbett, *Motion Picture and Television Processing Techniques*, 1967, for further information.

PRODUCER: See PERSONNEL.

PRODUCTION-CODE OFFICE: In response to the public criticism of Hollywood scandals in the early 1920s, and to head off possible federal censorship, the Motion Picture Producers and Distributors of America (now Motion Picture Association of America) was established in 1922 with Will H. Hays as its first president (the office held today by Jack Valenti). A set of standards was established and producers were encouraged to submit their scripts and finished films for voluntary prerelease examination. In 1930 the Production Code was developed as an advisory document, and in 1934 pressure from the Legion of Decency (formed by American Catholic

bishops) resulted in the formation of the Production Code Office with power to levy a fine of $25,000 on any member who sold, distributed, or exhibited any film which did not bear the PCO's seal of approval.

Particularly as the result of an antitrust decree of 1948—which forced producers to divest themselves of theatres—the absolute power of the PCO has steadily declined. Over the years, the Code has undergone amendment and fundamental changes to bring it in line with what the 1966 version describes as "the mores, the culture, the moral sense and the expectations of our society." The result in recent years has been to make available to writers and directors a much broader spectrum of language, subject matter, and point of view. For a history and analyses of the several forms film censorship has taken and the various rating systems used to classify films see Richard S. Randall, *Censorship of the Movies,* 1970.

PROJECTION BOOTH: The small room, usually at the back of the viewing room or theatre, which contains the projector and other equipment and controls affecting the lighting and sound of the film as well as other elements of the auditorium environment. In a *rear projection* auditorium the operator and equipment are located in the space immediately behind the viewing screen, which in that case is translucent rather than reflecting. Rear projection facilities can provide a better quality picture, but several difficult requirements must be met if the quality is to be enhanced. See *Focal Encyclopedia* entries under *Cinema Theatre* and *Rear Projection* for detailed descriptions.

PROJECTION SPEED(S): The rate at which a strip of film passes through the projector during the showing of a film. Projection speed for silent film is approximately 16 frames per second while most sound films must be shown at 24 frames per second. It should be noted, however, that silent firms were originally made for showing at variable speeds on hand-cranked machines. See further CAMERA SPEED, SILENT SPEED. If the film is not projected at the same speed at which it has been recorded, distortions of motion will occur. These are most obvious when motion is speeded up unintentionally as seen in the result of faulty projection of silent films.

PROJECTIONIST: The technician responsible for projecting films. If he is unskilled or inattentive to sound, light, focus control, and the like the viewing experience can be very unsatisfactory.

PROJECTOR(S): The device by which film images are illuminated and made viewable, usually on a screen. Projectors are classified as sound or silent and as to the gauge(s) of film they accommodate.

PROJECTION SYNCHRONISM: The establishment of a natural time relationship between picture and soundtrack in film being projected. Also called *printing sync.*

PROPS: See STUDIO.

PROTECTION PRINT: See FILM.

PSEUDOSTEREOSCOPIC: A *planoscopic reproduction* system is one in which only a single camera and projector are used, thus sacrificing the representational features of binocular vision. Though most films we see are planoscopic, the illusion of depth is retained and the images on the screen appear as more than flickering shadows without substance or dimensionality.

PSYCHOLOGICAL MELODRAMA: See GENRE.

PUNCH: See APPARATUS and EQUIPMENT.

PUPPET ANIMATION: See ANIMATION.

PURILIA: A fictional country in which the fantasies and formulas of Hollywood films are everyday occurrences. The name was coined by Elmer Rice in his novel, *A Voyage to Purilia,* 1930.

PUSH-OVER WIPE: See TRANSITIONS.

QUARTZ LIGHT: A general term applied to lights using a halogen gas (generated from such elements as iodine, chlorine, bromine, etc.) sealed in a lamp. Advantages: the lamp does not blacken and correct color temperatures are maintained.

PROJECTION OF SOUND FILM. From Roger Manvell, *Film* (Pelican, 1944). Copyright © Roger Manvell 1944. Reprinted by permission of Penguin Books Ltd.

PROJECTION OF SOUND FILM

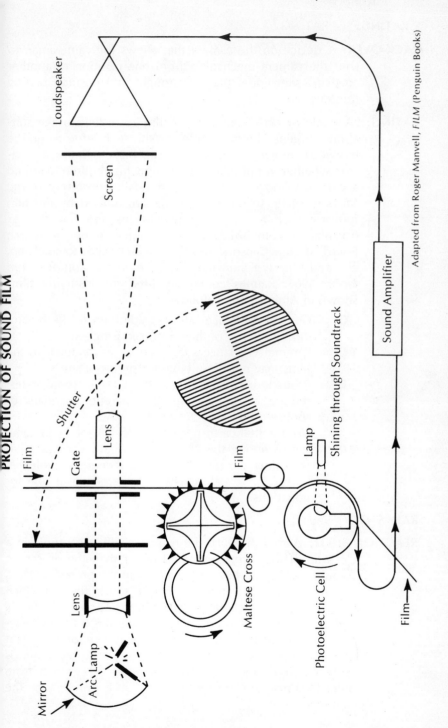

Adapted from Roger Manvell, *FILM* (Penguin Books)

R RATING: See RATING.

RACK-OVER: A device on the camera that allows the cameraman to shift the camera mechanism from one position to another so that a viewfinder may be brought into position behind the lens.

RATING: "A grade or classification for a film according to age suitability or general moral content. With such information the individual moviegoer or parent can make a rational decision whether or not to attend or allow his children to attend a particular movie." (Richard S. Randall, *Censorship of the Movies,* 1970). In the U.S. ratings are offered by the film industry itself and by various religious and nonreligious organizations. In Britain they are provided by the British Board of Film Censors. See further Richard S. Randall, op. cit., and Murray Schumach, *The Face on the Cutting Room Floor,* 1964. Ratings commonly used in classifying films shown in America are as follows:

> **G** = General Audience. All ages admitted to the theatre during the run of the advertised program.
>
> **PG** = Parental Guidance suggested. Some material in the films may not be suitable for preteenagers.
>
> **R** = Restricted. Persons under 18 (or 17 in some states) require accompanying adult parent, guardian, or spouse if they wish to see this show.
>
> **X** = No admittance to persons under 18 (or 17 in some states) during this show. This usually indicates that the films concerned contain scenes of violence, horror, or sexual activity considered unsuitable for nonadults.

RAW STOCK: See FILM.

REACTION SHOT: A shot in which the response (often captured in a close-up of the face) is pictured rather than the off-screen stimulus, which we have usually seen in the preceding shot. Reaction shots are frequently seen in sound films in which the shot reveals a character's response to another speaker, and so on. In *King Kong* (1933) we see the horrified reaction of the main actors to the appearance of the giant gorilla before we see the gorilla himself. The technique is quite common and helps to distinguish screen arts from older theatrical arts, where the attention is primarily on the stimulus.

REALISM: A style or technique of presenting, as objectively as possible, observed ordinary, circumstantial details of man and his world; contrasts with NATURALISM which views man as a creature of deterministic influences. Erich Von Stroheim's *Greed* (1923) is perhaps the most famous example of feature film realism. See also NEO-REALISM, SOVIET EXPRESSIVE REALISM.

REALIST FILM: See GENRE: DOCUMENTARY.

RECONDITIONING: See FILM.

RECORD FILM: See GENRE.

RECORDER: See APPARATUS and EQUIPMENT.

RECORDING: See SOUND.

RECORDING SYSTEM: See APPARATUS and EQUIPMENT.

REDRESSING: A SET, so constructed, that merely by changing the props (re-dressed) it may be used for two or more sets in the same film.

REDUCTION PRINT: The printing of a copy of finished film on a smaller-gauge stock, as from 35mm to 16mm or 8mm. Most commercial features are shot in 70mm or 35mm and reduced for nontheatrical prints to 16mm. Most feature films are shot in 35mm, a few in 70mm and 16mm. Some, released in 70mm, are actually blown-up from 35mm to 70mm, and some from 16mm to 35mm.

REEDITED FOR TELEVISION: Used in reference to a film that has been abridged, cut down, or lengthened from its original length to enable it to be shown within a television time SLOT.

REEL: See APPARATUS and EQUIPMENT.

REEL CHANGE: The process of changing from one reel of film to the next during a film show. Usually this requires switching from a reel that has just been shown on one projector to a reel that is to be shown on another. If only one projector is being used, it means taking off the reel that has already been shown and loading a new reel on the projector.

REFLECTOR: See APPARATUS and EQUIPMENT.

REFLEX CAMERA: A camera that has an optical system which allows the cameraman to "view-find" his scene, through the actual taking lens, while the camera is in operation.

RELATIONAL EDITING: See EDITING.

RELEASE: A finished film that has been approved and distributed for public exhibition. The term *foreign release* is used to designate approved distribution outside the country of origin, which of course may vary from the domestic-release date. A *rerelease* occurs one or more times after the original runs have exhausted public interest, usually after a period of several years. A film like *Gone With the Wind* (1939) is re-released about every five years.

RELEASE NEGATIVE: See EDITING.

RELEASE PRINT: See EDITING.

RELIGIOUS FILM: See GENRE.

REPORT or **LOG SHEET** (also called CAMERA LOG): This form is ordinarily kept by the assistant to the cameraman and includes data on each set-up and take plus all the technical information which may be needed by the processing laboratory or the cutting room.

REPRINTS: See EDITING.

REPRODUCTION: See FILM.

RESOLUTION: The relative quality of the detail in an image which results from the capability of the optical system and photographic process. The power of resolution is usually described in terms of the number of lines that can be distinctly separated per millimeter. The higher the power of resolution, the finer the definition or sharpness of detail.

REVEALED: See DISCOVERED.

REVERSAL FILM: See FILM.

REVERSAL ORIGINAL: See FILM.

REVERSE-ANGLE: See SHOTS.

REVERSE-MOTION CINEMATOGRAPHY: See CAMERA SPEED.

RIFLE SPOT: See APPARATUS and EQUIPMENT.

A publicity portrait of Marlene Dietrich from William Dieterle's *Kismet* (MGM, 1944). RESOLUTION and KEY LIGHTING reveal her features, hair, and clothing in sharp relief. Wisconsin Center for Theatre Research, Blum Collection.

RIGGING: See APPARATUS and EQUIPMENT.

ROMANCE: See GENRE.

ROMANTIC DOCUMENTARY: See GENRE: DOCUMENTARY.

ROUGH CUT: See EDITING.

RUSHES: See EDITING.

SAFETY BASE: See FILM.

SAND DANCE: A variation on the SOFT-SHOE DANCE that gives the sound of scraping sand under soft shoes.

SCENARIO: See SCRIPT.

SCENE: An ambiguous term which is used either to describe a particular tableau or view or more commonly to characterize the smallest dramatic or narrative block in a film. A scene is usually composed of several shots, but in *Citizen Kane* (1941) units of several minutes' duration are made up of a single shot in which the camera keeps running while it and the actors are moving to provide variety of angle and relationship to actors and decor. The scene is unified by the appearance of the same characters and setting closely related in time; the next largest unit is the *sequence*. A scene in films is typically shorter and less distinctively differentiated than a scene in a play; the distinction between sequence and act is similar. Many writers use scene and shot interchangeably. The CLAPBOARD bears the word "scene," which in that case is understood to be synonymous with SHOT.

SCENERY DOCK: The place where scenery is stored when it is not being used.

SCHMALTZ: Sentimentality or excessive emotional displays. Alan Crosland's *The Jazz Singer* (1927) is heavily laden with schmaltz. The term is actually Yiddish for chicken-fat.

SCHWERIN SYSTEM: See AUDIENCE RATING.

SCIENCE-FICTION FILM: See GENRE.

SCOOP: A light that provides a general over-all light rather than a spotlight.

SCRATCHES: See FILM.

SCREEN(S): A screen is the specially constructed surface upon which the projected images become visible, either by virtue of the screen's reflecting capacity or its translucency (in rear projection systems). The front surface of screens is their most important feature and these are treated in various ways by spraying mixtures including oxides (*matte*) glass (*beaded*), and aluminum (*metallic*). Translucent screens are typically made of plastic. Most screens are perforated to allow effective transmission of sound from the speakers located behind them.

SCRIM: (1) A translucent shade used to diffuse, reduce, or soften illumination on a set. See also DIFFUSION SCREEN, FLAG,

GOBO. (2) A translucent material made of lightly woven cotton, often used as drapery on a set.

SCRIPT: Script is the general term applied to the various forms taken by written prescriptions for the characters and action of a film used in its production. In its earliest or simplest form, a script may be a *synopsis* in which the essential ideas and structure for the film are offered in condensed form. This term is later expanded after several *story conferences* from *step outline* to *treatment* to a *rough draft screenplay* or *scenario*. At a late stage in its evolution the screenplay or scenario is broken down to include shots, and sometimes technical information, and is usually then called a *shooting script*. When the film has been edited and is ready for release, a *cutting-continuity script* is prepared which serves to describe the number, kind, and duration of shots, the kind of transitions, the exact dialogue and sound effects, and the like. The shooting script is the verbal blueprint, though directors practice various degrees of improvisation on the set. The nature of the evolution of an "idea" into a film and cutting-continuity script depends on a great many variables, but particularly on the screenwriter and the director—and the relationship between them. Scripts of various kinds— from the poetic, nontechnical ones of Ingmar Bergman and Sergei Eisenstein to the fairly technical cutting-continuity of *Citizen Kane* (1941)—are increasingly becoming available, especially from Simon and Schuster, Grove Press, Appleton-Century-Crofts, Grossman, and Viking. See Clifford McCarty, *Published Screenplays: A Checklist,* 1971, and Lewis Herman, *A Practical Manual of Screen Playwriting for Theater and Television Films*, 1952.

SCRIPT GIRL: See PERSONNEL: CONTINUITY GIRL.

SCRIPT SUPERVISOR: See PERSONNEL: CONTINUITY GIRL.

SECOND FEATURE: In a program comprising two feature films, this is rated or advertised as the lesser in interest or importance of the two pictures. See MAIN FEATURE.

SECOND-GENERATION DUPES: See FIRST-GENERATION DUPE.

SELF-BLIMPED: A self-blimped camera is a camera that runs silently: i.e., emits no noise that can be a nuisance to the sound engineers.

SEMIOLOGY: See CRITICISM.

SEMIOLOGY OF THE CINEMA: The study of film as a system of signs, involving a fundamental consideration of the senses in which film may be considered a language. Semiology is a very recent development of film esthetics and involves many of the tools of linguistics. Leading semiologists are Christian Metz, Roland Barthes, Umberto Eco, and film director Pier Paolo Pasolini. See further Peter Wollen, *Signs and Meaning in the Cinema,* 1969.

SENIOR (also called "A FIVE"): A 5000-watt light.

SENSITIZER: Dyes used in manufacturing photographic emulsions.

SENSITOMETER: A piece of equipment used in studying the characteristics of an emulsion.

SEPARATION NEGATIVES: See COLOR.

SEQUENCE: See SCENE.

SERIAL: See GENRE.

SET: See APPARATUS and EQUIPMENT.

SET-UP: The placing of the camera in a specific position from which a shot will be made. There is a new set-up each time the camera is placed in a different position for another shot. Because of the lighting problems for each shot, a film's shooting schedule is so arranged that the scenes with the same set-ups (regardless of their place in the script) are all shot at one time.

SEVENTY MM: See GAUGE.

SEX SYMBOL: Any actor or, more commonly, actress, who by virtue of some features of face, figure, or manner is, with varying explicitness, erotically or romantically stimulating to film audiences and whose appearance in a film itself guarantees a measure of box-office success. Among the male stars who have exercised this appeal are Rudolph Valentino, Clark Gable, John Garfield, Errol Flynn, Rock Hudson, Cary Grant, Marlon Brando, Gregory Peck; among the female, Theda Bara, Clara Bow, Greta Garbo, Mae West, Marlene Dietrich, Betty Grable, Gina Lollobrigida, Sophia Loren, Brigitte Bardot, Lana Turner, Marilyn Monroe, and Raquel Welch.

SEXPLOITATION MOVIE: See GENRE.

Rudolph Valentino and Agnes Ayres in George Melford's *The Sheik* (1921).

Theda Bara, the first VAMP (c. 1917).

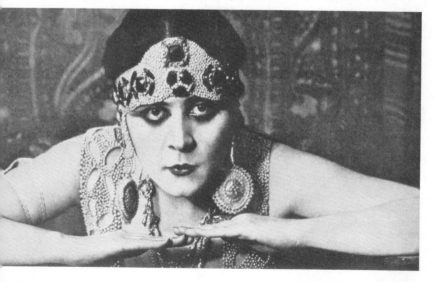

Following page: Brigitte Bardot. These three stills are from the Picture collection, New York Public Library.

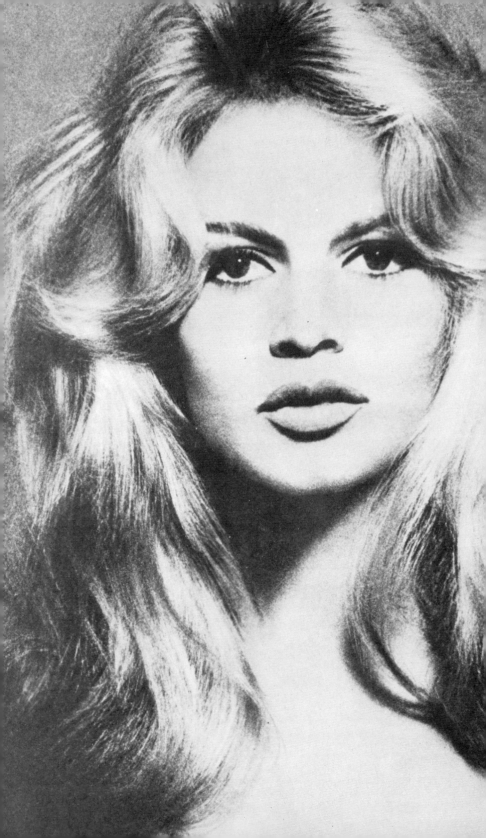

SHADOW PLAY: Perhaps the earliest form of moving pictures were shadows cast by firelight on cave walls. The shadow play or shadow show, at any rate, is thousands of years old, having apparently originated in the Orient. Popular in Europe and America since the eighteenth century, the plays are performed by flat, jointed puppet figures on a translucent cloth or paper screen which is illuminated from behind. See further Olive Blackham, *Shadow Puppets*, 1960, Henry Bursill, *Hand Shadows*, 1967, and C. W. Ceram, *Archaeology of the Cinema*, n.d.

SHARPNESS: See LENS.

SHOOTING: The term derives, apparently, from one of the earliest devices for recording movement photographically, Professor E. J. Marey's twelve-picture photographic rifle, invented in the early 1880s. It now is used to describe the recording on film of action to be considered for use in the finished film. Typically, each scene is shot, simultaneously or consecutively, by several cameras placed in different positions relative to the action.

SHOOTING RATIO: The amount of film shot for a motion picture in relation to that finally used in the film. A ratio of 5:1 to 10:1 is not uncommon, though some directors, like Ford, operate on a 2:1 ratio.

SHOOTING SCRIPT: See SCRIPT.

SHORT FOCUS LENS: See LENS.

SHORT-FOOTAGE FILM: See GENRE: COURT-METRAGE.

SHORT PLAY: A film story in one reel. The term was used during the silent period. See LONG PLAY.

SHOTS: A shot is a section of a film that has been exposed without interruption by a single running of the camera. Within a single shot there is no temporal or spatial discontinuity, but between shots anything is possible. This control over space and time gives film its *plasticity*. Shots are categorized by: (1) the *distance* between the camera and the object being filmed; (2) the *angle* of the camera in relation to the object; and (3) the *content*, nature, or subject matter of what is being filmed.
The following constitute the most common shots:

LONG SHOT. Subject of shot seen in full length.

MEDIUM SHOT. Subject seen from knee length upwards.

CLOSE SHOT. Subject seen from shoulders upwards.

CLOSE-UP. Subject's head occupies entire screen, concentration only on significant detail.

Big or Extreme Close-up: A very large close-up of subject or object. As related to a human subject: a shot of part of the face only.

Bridging: A shot used to cover any break in continuity or jump in time.

Close: Not quite as near to its subjects as a *close-up*. With a human subject, the close-shot reveals the person from the shoulders upward and also includes glimpses of one or two other details, such as part of the setting or a prop. Often used as synonym for CLOSE-UP.

CLOSE SHOT from Sergei Eisenstein's *Que Viva Mexico!* Lilly Library's Sinclair Archives. Courtesy estate of Upton Sinclair.

Close-up: The camera is very close to the subject, so that when the image is projected most of the screen will be taken up with revealing a face and its expression, a hand, or foot, or some relatively small part of a larger whole.

Dolly, Follow, Tracking, or Trucking: The camera is in motion on a dolly or truck; it can move in closer to the subject or follow it as it moves.

Establishing or Master Shot: A shot that includes all the important action of a specific scene. This is often a LONG SHOT. The same scene is usually explored with closer shots and from a variety of different angles after the master shot has been presented.

Extreme Close-up: See BIG SHOT above.

Full: A close MEDIUM SHOT.

Head or Eye Level: Camera positioned at eye level of subject.

High Angle: Camera positioned above subject. There are numerous examples in Henry Hathaway's *Fourteen Hours* (1951), a film about a man attempting suicide from a skyscraper ledge.

HIGH-ANGLE SHOT from *Que Viva Mexico!* Courtesy Estate of Upton Sinclair.

A production still of Gibson Gowland and Joan Crawford showing the camera set-up for a LOW-ANGLE SHOT in Lucien Hubbard's *Rose-Marie* (MGM, 1928). The lower illustration shows the results of such shooting. Though Gibson Gowland is also featured in this still, the moment depicted occurs at the end of Von Stroheim's *Greed* (MGM, 1924). Wisconsin Center for Theatre Research, Blum and Leibowitz Collections.

Insert: A shot of a static object, such as a book, letter, sign, clock or building. This material can be inserted during editing. In *Citizen Kane* (1941) the extreme close-up of the typewriter printing out Charles Kane's completion of Jed Leland's dramatic notice is an insert shot.

Long: The camera is or seems to be at a great distance from the subject being filmed. Many battle scenes in *The Birth of a Nation* (1915) are in long shot.

Low-Angle: Camera positioned below subject; a common shot in Dreyer's *Passion of Joan of Arc* (1927).

Medium: The camera is nearer to the subject than if it were taking a long shot, but further from it than if it were taking a close-shot. A human subject in medium shot is generally shown from the knees upward.

Moving: Produced when the camera moves toward or away from a fixed object, with a moving object, at the same or different rate of speed (DOLLY, TRACKING, or TRUCKING), upward or downward with respect to the object (BOOM or CRANE). MOVING shots can also be achieved by rotating the camera on its axis horizontally or vertically (PAN or TILT).

Pan: The camera moves along a horizontal plane. With a FLASH, SWISH, or BLUR PAN the camera is moved very rapidly along the horizontal plane so that the filmed action appears on screen as a blurred movement; the most famous example is the breakfast scene in *Citizen Kane* (1941). A REVELATION PAN shot is one that ends in the revelation of some startling or unexpected detail or action—e.g. a body or a hidden danger.

PAN. Pivotal movement of the camera in a horizontal plane. Sometimes the term is used generally to describe movements of the camera in any plane. From *The Focal Encyclopedia.*

Reaction: A shot that shows the reaction of a person to something or someone usually seen in the previous shot.

Three: Close-shot of three persons.

Tight Two: Shows the heads and shoulders of two persons.

Tilt: The camera moves up or down (from its axis) along a vertical plane.

Two: Close-shot of two persons.

Zoom: A shot taken with a zoom lens (i.e., a lens that makes it possible to move toward or away from the subject without moving the camera). A good example of the functional use of this shot occurs in *Battle of Algiers* (1966), when the protagonist witnesses from his cell a guillotining in the prison courtyard; the camera zooms in on his face as the guillotine

falls and a revolutionary is born out of a petty criminal by the impact of the event.

SHUTTER: The mechanism in a camera or projector that places an opaque surface between the lens and film gate as a new frame of film is being moved into position in the film gate.

SHUTTLE: A movable part in the camera or projector that carries the claws which engage the film sprockets to move a new film frame into position.

SILENT SPEED: 16 frames per second; 60 feet per minute for 35mm film, and 24 feet per minute for 16mm film, are currently regarded as the correct projection rates for silent movies when shown with today's projectors. However, it is questionable whether they were always shown at these speeds during the silent period. See further: James Card, "Silent Film Speed," *Image*, Rochester, N.Y., George Eastman House, Vol. 4 (1955), 55–56.

SILHOUETTE ANIMATION: See ANIMATION.

SILHOUETTE FILM: See GENRE.

SINGLE FEATURE: A program in which only one full-length film is shown. See also DOUBLE FEATURE, TRIPLE FEATURE.

SINGLE-FRAME MECHANISM: The mechanism that makes ANIMATION possible, allowing the exposure of a single frame of film at a time.

SINGLE-SYSTEM RECORDING: See RECORDING SYSTEM.

SITUATION COMEDY: See GENRE.

SIXTEEN MM: See GAUGE.

SKIN FLICK: See GENRE.

SLAPSTICK COMEDY: See GENRE.

SLATE or **SLATE BOARD:** See APPARATUS and EQUIPMENT: CLAPPER BOARD.

SLEEPER: (1) A film that receives little or no critical attention at its PREMIERE or FIRST RUN, but which is subsequently "discovered" by critics or FILM BUFFS to be a picture of significance. A recent example is Jodorowsky's allegorical Western, *El Topo* (1970). (2) An unheralded film that becomes a big hit and makes a lot of money: e.g., Delbert Mann's *Marty* (1955).

SLOT: A period of time within which a film or commercial is shown on television. Films that do not fit exactly into the time slots are usually RE-EDITED FOR TELEVISION.

SLOW-MOTION CINEMATOGRAPHY: See CAMERA SPEED.

SLUG or **BUILD-UP:** A length of *leader* (blank film) inserted in a *workprint* to replace damaged or missing footage.

SNEAK PREVIEW: See PREVIEW.

SOAP OPERA: See GENRE.

SOCIAL-CONSCIENCE PICTURE: See GENRE.

SOCIAL DRAMA: See GENRE.

SOCIETY OF MOTION PICTURE AND TELEVISION ENGINEERS: An organization of professionals interested in the technical aspects of motion picture and television production.

SOFT: A term used to describe "low contrast" in film negatives and prints.

SOFT-EDGE WIPE: See TRANSITIONS.

SOFT FOCUS: The blurred or hazy effect achieved by shooting slightly out of focus or through gauze, vaseline, or a similar medium.

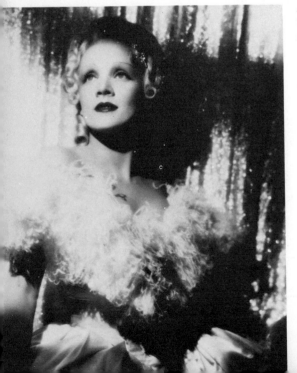

A publicity portrait of Marlene Dietrich for von Sternberg's *Scarlet Empress* (Paramount, 1934) in SOFT FOCUS. Wisconsin Center for Theatre Research, Blum Collection.

Associated with romantic films, both silent and sound, the effect can also be used to blur an actress's real age. Elizabeth Taylor often appears in soft focus in George Stevens' *A Place in the Sun* (1951).

SOFT LITE: See APPARATUS and EQUIPMENT.

SOFT-SHOE DANCE: A kind of TAP DANCE performed without metal taps on the shoes—seen in many MUSICALS. See also SAND DANCE.

SOUND:

Asynchronism: Sound used in counterpoint with the visual image (the opposite of synchronism, in which the sound provided naturally or realistically belongs with the images shown on the screen).

Audio: Common name for the sound portion of a film or television transmission.

Directional Microphone: A microphone that picks up sounds from a specific direction, and rejects sounds from other directions.

Double-System Sound: The system now used in all 35mm work, and on "high-quality" 16mm work. With this system, the recorder and the camera are two separate units, run simultaneously by synchronous motors. The sound is recorded on one film (or tape) as the picture is recorded in the camera. The advantages of double-system recording are better sound quality, plus ease and flexibility in editing.

Dubbing: (1) The replacing of dialogue or commentary in one language by dialogue or commentary in another. (2) The mixing of all the required sounds (music, dialogue, noises, and so on) on one sound track. (3) Any postfilming recording of dialogue.

Nondirectional Microphone: A microphone that picks up sounds from a wide, circular area.

Optical (or Photographic) Sound Recorder: Apparatus used to record sound photographically. In the optical sound recorder a beam of light is directed onto a light-sensitive film and moved past it at a constant speed. The modulations in light correspond to the varying qualities of the original sound. The variations appear on the sound track either as varying densities (degrees of opacity) or as waves covering different

areas on the track. When the film is projected, the VARIABLE DENSITIES or VARIABLE AREAS are electronically converted and amplified. Though magnetic recording has largely displaced optical recording during shooting, most 16mm and 35mm release prints carry optical sound tracks. Magnetic sound recording offers operational and technical advantages (high fidelity), but relatively few theatres have added magnetic-track replay systems to projectors designed for photographic sound tracks.

Overlap Dialogue: Dialogue that is continued over to a shot where it does not naturally belong. Frequently used in conjunction with REACTION SHOTS.

Postsynchronization: The recording of sound material (music, dialogue, and so forth) in order to synchronize it with a picture that has already been shot.

Sound Camera: A camera (usually SELF-BLIMPED) whose mechanism runs silently to avoid making CAMERA NOISE. It is the type of camera used in shooting sound movies when pictures and sound are being recorded simultaneously.

Sound Displacement: The difference in position, on a strip of film, between the picture and its accompanying sound. With 35mm film, the sound is 20 frames ahead of the picture. With 16mm optical sound, the sound is 26 frames ahead of the picture. With 16mm magnetic stripe sound, the sound is 28 frames ahead of picture. This is caused by the construction peculiarities of the projectors.

Sound Effects Library: Studios store on disk or tape a wide variety of natural and artificially created sounds ranging from the noise of traffic and machines to the cries of insects and animals, from gunfire to ocean surf, from volcanic eruptions and storms to instruments and singing.

Sound Gate: The mechanism on a camera or projector where the sound is either recorded or reproduced. With optical sound this is done by an exposure lamp photographing sound waves (camera); or by the action of a varying light falling on a photoelectric cell (projector).

Sound Heads: In a tape recorder, these record, erase, and replace sounds; in a professional machine, each function is served by a separate head.

Sound Perspective: Making sure that the sound quality relates directly to its synchronized picture. For example, the sound

of an actor talking in long shot would be different from that of an actor talking in close-up.

Sound Reader: A device used in EDITING to permit the editor to "read" (listen to) the recorded sounds on the sound track.

Sound Speed: The correct projection rate for 16 and 35mm sound films is 24 frames per second. See Edward Pincus, *Guide to Filmmaking*, 1969, pp. 167–170, for tables providing running times and formats of 8mm, Super-8, and 16mm silent and sound films.

Sound Stage: A studio building where indoor shooting takes place, and which is acoustically isolated and controlled to permit effective, clean recording, especially of dialogue.

SOUND STAGE in a film studio showing cameraman, director, sound crew, boom, mobile crane, lighting. The film being shot is Richard Quine's *My Sister Eileen* (1955) starring Janet Leigh, who is seen on the set confronting Bob Fosse. Courtesy Columbia Pictures Corp., copyright 1954.

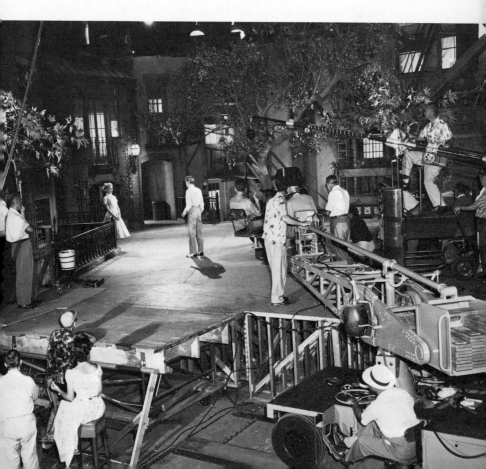

Sound Track: The narrow band on one side of the strip of film which carries the recorded sounds accompanying the images. Sound tracks vary as to type and quality; for STEREOPHONIC SOUND recording a number of bands are used. See also OPTICAL (or PHOTOGRAPHIC) SOUND RECORDER.

DUPLEX SOUND TRACK. Type of symmetrical variable-area optical sound track on film, recognizable by the fact that in the negative the central axis and surrounding modulated area are opaque; in the equally common bilateral type of track they are transparent. From *The Focal Encyclopedia.*

Sound Truck: A mobile unit equipped with the apparatus and equipment necessary for synchronous sound filming, a room for loading film, and an independent electrical power system.

Sound Workprint: See EDITING: WORKPRINT.

Stereophonic Sound: Sound so reproduced that it comes, as in reality, from more than one direction. Stereophony, which removes the limitations of monaural recording and reproduction, involves the use of more than one microphone at a time on the set during recording and the use of two or more loudspeakers simultaneously when the film is being shown. The loudspeakers must be placed so that sounds coming from them combine as constituent elements of a single but total sound experience. It has become usual to provide stereophonic sound with wide screen and 3D filmshows.

Synchronization: See EDITING.

Variable-Area Sound Track: A sound track which appears to move along the film in a wavy shape.

Variable-Density Sound Track: A sound track which appears to move along the film in bands of varying density.

Vitaphone: A sound-on-disk system developed at the Bell Telephone Laboratories to provide synchronized sound to accompany the VISUALS. The disks were 13–17 inches in diameter and could carry the sound for an entire reel of film. Warner Brothers, who had earlier taken over the old Vitagraph (film) Company, acquired this patented system, gave it the name Vitaphone, and released shorts and Alan

Crosland's *Don Juan* (with synchronized music) as Vitaphone films in 1926; they released *The Jazz Singer* (also Vitaphone) the following year. Within a few years, the sound-on-film systems developed by RCA and Western Electric drove out Vitaphone and other sound-on-disk systems. The name Vitaphone now refers to a sound-on-film process.

Voice-Over: The voice of the narrator speaking while the VISUALS and other sound continue; e.g., the voice of the Chorus (Leslie Banks) heard while the screen shows the English and French camps before Agincourt—in Olivier's *Henry V* (1944).

SOVCOLOR: See COLOR CINEMATOGRAPHY.

SOVIET EXPRESSIVE REALISM: Style associated with the leading Russian filmmakers during the period 1925–1930. "The Soviet expressive realists were almost exclusively concerned with dynamic editing or montage." See further George Huaco, *The Sociology of Film Art*, 1965; see also LINKAGE, MONTAGE.

SPECIAL EFFECTS: Generally, those visual scenes which are "too costly, too difficult, too time-consuming, too dangerous or simply

A still from *The Thief of Bagdad* (United Artists, 1940) showing Rex Ingram and Sabu in one of the "miracles" possible through SPECIAL EFFECTS. Wisconsin Center for Theatre Research, United Artists Collection.

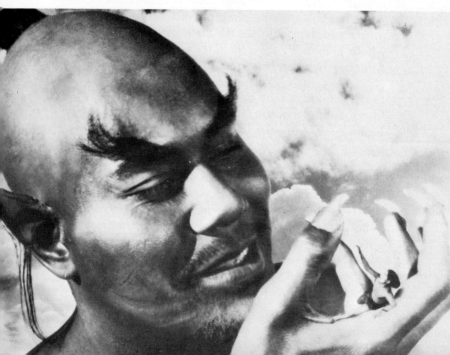

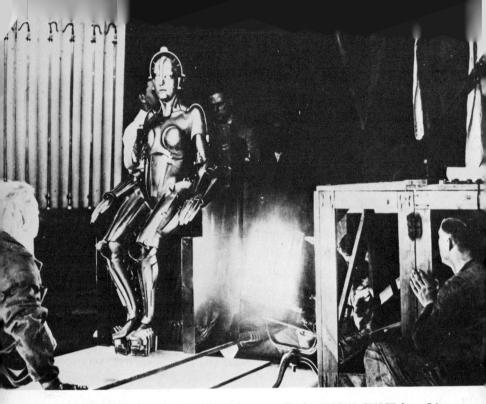

Animation of a robot. A production still of a SPECIAL EFFECT from Fritz Lang's *Metropolis* (Ufa, 1926-1927). Wisconsin Center for Theatre Research, Hamilton Collection.

impossible to achieve with conventional photographic techniques" (Raymond Fielding, *Focal Encyclopedia* . . . p. 723). These range from the simplest distortions of images with prisms and mirrors to the destruction of cities, armadas, and whole planets to the creation of invisible men and flying carpets. There are essentially three classes of techniques: (1) in-the-camera, (2) laboratory processes, and (3) combination techniques. For detailed descriptions of all of these listed below, consult Raymond Fielding's masterful *The Techniques of Special Effects Cinematography*, 1968.

Some of the more common techniques in each category:

IN-THE-CAMERA:

Accelerated-Motion: Movement on the screen appears to be quicker than it is in reality. This effect is achieved by filming action at a slow speed and then projecting it at regular speed. The technique is the opposite of that used in SLOW-MOTION CINEMA PHOTOGRAPHY. Comparable effects can be achieved by varying projection speed.

Cheat Shot: A shot that excludes part of a scene from observation so that the viewer is led to believe that what appears on screen is different from what it really is. For example, the shot of an actor hanging by his fingertips from a window ledge which is only a very short distance from the ground, although the camera does not reveal that fact.

Image Replacement: The addition or substitution of pictorial detail, e.g., the depiction of a character in front of famous buildings. First, a library or stock shot might show the entire building from a distance; the actors, in conversation, however, would appear only against the background of the portion of the building constructed on the sound stage.

Glass Shot: A shot of a setting which is partly constructed in full size and partly depicted (painted or photographed) on a small sheet of transparent glass. The glass is so placed before

GLASS SHOT. Trick shot in which part of the scene is a painting on glass which is photographed at the same time as the main action seen through the clear portion of the glass; very spectacular scenes can thus be shown without the need for the whole of the set structure to be built in the studio. From *The Focal Encyclopedia*.

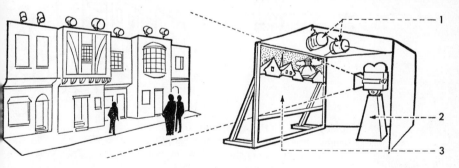

GLASS SHOT OR PAINTED MATTE. Sheet of optical glass is erected in a stout frame, 3, far enough from the camera for focus to be held on the glass surface and the set beyond. Camera is mounted on solid base, 2, to avoid vibration. On the glass, the top line of the set is drawn; artist paints in architecture above the line. Glass above roof tops may be left clear and film of red sky afterwards inserted in composite. The whole assembly is enclosed by black velvet. The painting is illuminated to a suitable balance with the built set by lights, 1, hung clear of the reflective angle of the glass with the camera. From *The Focal Encyclopedia*.

the camera that the picture on it will appear to be a part of the full-size construction which is visible through the unpainted areas of the glass. This technique is used in *Butch Cassidy and The Sun-Dance Kid* (1969) and explained in the documentary film about its making.

Mirror Shots: See SCHUFFTAN PROCESS.

Model or Miniature Shots: Small-scale models filmed in such a way as to provide the illusion that they are full-scale objects (e.g., model dinosaurs filmed so that they look like 100-foot monsters).

Schufftan Process: A variation on the *glass shot* which makes use of mirror reflections in filming composites of partially constructed full-size sets and miniatures that "complete" them.

SCHUFFTAN SHOT. Camera, 4, picks up full-scale live-action component, 5, reflected off silvered area of mirror, 3. Simultaneously, the camera photographs through clear area of mirror either art work, miniatures or (as shown) a rear-projected image, 2, from projector, 1. From *The Focal Encyclopedia*.

SCHUFFTAN SHOT. Set is built to a limited height of two floors, 1, in which script calls for a fire in the upper storeys, built in model form, 3, on rostrum draped in black velvet. Interposed at 45 degrees to the faces of set and model is a sheet of optical mirror, 2. Viewing the whole through the camera lens, 4, silver from the lower back of the mirror is scraped away until through the clear glass so formed the set is seen to join reflected image of model in top half, where silver has been left intact. From *The Focal Encyclopedia*.

Slow-Motion Cinema Photography: Movement on screen appears to be slower than it is in reality. This effect is achieved by filming action at fast speed and projecting it at regular speed. The technique used is opposite to that used for ACCELER-ATED-MOTION PHOTOGRAPHY.

Split-Screen (Matte) Shots: These require two or more exposures of the film. During the first an opaque plate or matte obscures preselected portions of the negative; during the second exposure, the matte is exchanged for another matte which screens out the already exposed portion of the film

MATTE AND COUNTER-MATTE: COMPOSITE IMAGE. (a) Matte with positioning holes to provide peg-bar registration, outlined so as to mask unwanted detail in dark area (*right*). (b) Counter-matte of opposite tonality, similarly registered, and outlined to permit printing-in of wanted detail from another locale in transparent area (*right*). (c) Composite image combines live foreground action with derived scene in background. From *The Focal Encyclopedia.*

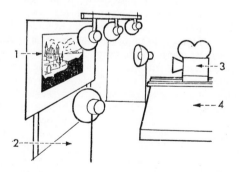

PHOTOGRAPHY OF IN-THE-CAMERA MATTE SHOTS. Stand, 1, holds art work, with lower half, representing area occupied by live action, matted out in black. Cement floor, 2, rigidly supports camera, 3, mounted on solid base, 4, surmounted by lathe bed in which movement is completely free from shake or play. Absence of relative movement between camera and art work is essential for success. From *The Focal Encyclopedia.*

and allows exposure of the balance of the frame. When the film is processed, the two separately shot portions of the frame are seen as one image.

Stop-Action Cinema Photography: The technique of filming intermittently, at spaced intervals in the development of an action or scene. A frequent method used in trick-action scenes, as, for example, in some of the films of Méliès. The method is also used to "speed up" action that would take too long to show in its entirety: as, for example, the scenes of Chaplin clearing away huge mounds of snow in *The Gold Rush* (1925).

LABORATORY PROCESSES:

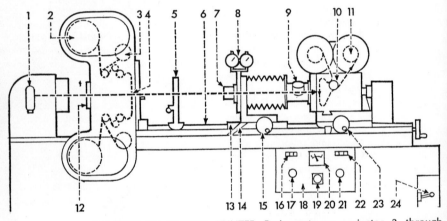

ELEMENTS OF OPTICAL PRINTER. Basic parts are projector, 2, through which film moves intermittently, and synchronized camera, 10, which photographs frame in projector aperture onto film wound up in chamber, 11. Projection lamp, 1, focuses beam of light on film in aperture, 4. Movable masks may also be placed in the beam, 5, and traversed or rotated with micrometer accuracy. Matte rolls, 3, may also be run in bipack. Camera lens, 7, supported on rigid base, 13, may be moved off center by vertical and horizontal vernier adjustment, read on gauges, 8. Change of magnification is achieved by moving lens and/or camera by handwheels, 15, 23, or by motor drive actuated by lever, 24. Lens focusing is automatic by arm, 14, acting on cam between lathe-bed rails, 6, on which movable units, 5, 7, 10, travel with extreme precision. Reflex viewing aperture, 9, is for exact setting-up before shooting. Electrical controls are operated from panel, 18; light output of lamp is read on exposure meter, 12, and is set by rheostat, 21, and voltage is read on meter, 20. Printer functions are selected by knob, 17, which links or separates printer and projector, reverses motion, introduces skip-frame or double-frame printing, etc. Control, 19, enables driving motor to be speeded up to wind film forward and back to predetermined frame, with counter for projector, 16, and camera, 22. From *The Focal Encyclopedia*.

These include BIPACK CONTACT MATTE PRINTING, OP-
TICAL PRINTING (FADES, DISSOLVES, WIPES, SUPERIMPO-
SITIONS, TRAVELING MATTE, FLIPSHOTS, and a variety of
DISTORTIONS in size, number, and texture of images), and
AERIAL-IMAGE PRINTING.

DUNNING PROCESS. Early method for the combination of separately
photographed foreground and background action. The foreground action
was lighted with yellow light only in front of a uniform strongly illu-
minated blue backing. Panchromatic negative film was used in the camera
as the rear component of a BIPACK in which the front film was a
positive yellow dye image of the background scene. This yellow dye
image was exposed on the negative by the blue light from the backing
areas but the yellow light from the foreground passed through it and
recorded an image of the foreground action at the same time. From *The
Focal Encyclopedia.*

In the TRAVELING MATTE process, backgrounds and fore-
grounds which have been shot separately are combined, as
in the Dunning Process, developed in the 1920s. AERIAL-
IMAGE PRINTING makes it possible to combine live-action
with painted or still photographs at relatively low cost.

AERIAL IMAGE PROJEC-
TOR. Device for combin-
ing filmed live action
with animation by means
of an aerial image pro-
jected into the plane of
the cel beneath the ros-
trum camera. 1. Camera.
2. Cel. 3. Condenser
lenses. 4. Mirror. 5. Pro-
jector. From *The Focal
Encyclopedia.*

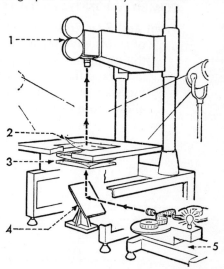

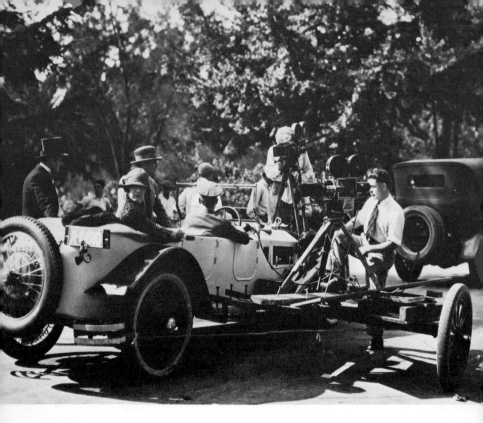

A production still showing how automobile action shots are photographed when REAR PROJECTION techniques (see SPECIAL EFFECTS) are not desired. Wisconsin Center for Theatre Research, Leibowitz Collection.

COMBINATION TECHNIQUES:

Front and Rear Projection makes it possible to combine images of actors with moving backgrounds, shot elsewhere, through the projection of the previously shot background (e.g., the landscape from a moving vehicle) while the players are being shot on the sound stage in a "vehicle" constructed to allow more controlled and convenient filming.

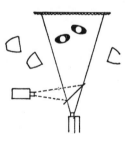

FRONT PROJECTION. Projector (*left*) and camera (*bottom*) are optically aligned so that foreground characters are shadowless when seen against projected image (*top*). From *The Focal Encyclopedia*.

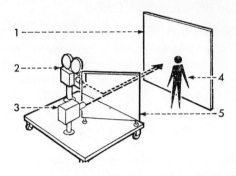

FRONT-PROJECTION PROCESS. Background image is projected by projector, 2, on highly reflective screen, 1, in front of which action, 4, takes place. Camera, 3, shoots through pellicle or semireflecting mirror, 5, which also turns projector beam through right angles. Principle: shadows are eliminated because the reflected background image is projected directly along the camera's optical axis, so that the actor's shadow on the screen is precisely masked by his body. Hence, camera panning and movement are normally not practicable. From *The Focal Encyclopedia.*

SPECTACLE: See GENRE.

SPEED: (1) the extent of the sensitivity to light of a film emulsion; (2) the extent of which light is admitted by the camera lens; (3) the correct rate at which the camera is supposed to run. See AMERICAN STANDARD SPEED, CAMERA SPEED, EMULSION SPEED, SILENT SPEED, SOUND SPEED, (4) the response to the director's saying "Roll 'em!" When the sound tape is up to the correct speed, then the director calls, "Action!"

SPLICE: See EDITING.

SPLICER: See APPARATUS and EQUIPMENT.

SPLICING: See EDITING: SPLICE.

SPLICING MACHINE: See APPARATUS and EQUIPMENT.

SPLIT FOCUS: A method of focusing used when it is necessary to have two objects—one near to the camera and the other far from camera—in acceptable focus in the same shot.

SPLIT REEL: (1) A film subject occupying less than one reel. The term was used during the silent period; (2) a specialized reel used in editing. The reel screws apart in two pieces, so that the

roll of film may be "lifted" from the reel and placed in a film can for filing purposes; (3) a reel that comes apart so that core-wound film may be inserted.

SPLIT SCREEN: The appearance of two or more shots on discrete portions of the screen at the same time, usually by optically printing the different images on the same frame. Introduced by Griffith in *The Birth of a Nation* (1915), elaborate use of this technique was made in *Woodstock* (1969) and a number of other late-sixties films. The technique is also popular in TV, particularly on a show's opening credits (e.g. *Mannix*).

SPOOF: See GENRE.

SPOTLAMP: See APPARATUS and EQUIPMENT.

SPRING DRIVE: A mechanical drive for cameras used primarily in news film photography where the recording of sound is not necessary. The ordinary length of a continuous shot that may be made with a spring-drive camera is 30 to 45 seconds.

SPROCKET HOLES: See FILM.

SPROCKET WHEEL: A drumlike wheel containing a number of teeth spaced to engage the sprocket holes in the edges of the film. The teeth are used in moving the film through a camera or projector.

STAG FILM: See GENRE.

SPY FILM: See GENRE.

STAND-IN: See ACTING.

STAR: An actor or actress who has become famous for playing leading roles in popular films. The first movie star to be known by name was Florence Lawrence (1886–1938), "The Biograph Girl." See also ANIMAL STAR, CHILD STAR, STAR SYSTEM.

STAR SYSTEM: In the early years of film in America, actors and actresses appeared anonymously, the major producers correctly reasoning that unknown players could demand less salary than those the public called for by name. By about 1915, though, the development of the system of highly paid public favorites was establishing itself, and by 1917 "Little Mary" Pickford and Charlie Chaplin were demanding contracts calling for $1,000,000 and more.

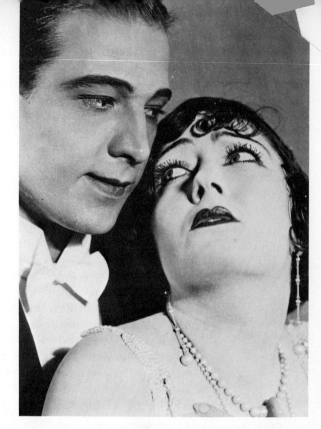

STAR SYSTEM. Rudolph
Valentino and Gloria
Swanson—two of the
brightest stars in Holly-
wood's galaxy during
the silent era.

From that time on the great stars (and the fan magazines
and publicists that celebrated them) were a permanent fea-
ture of the film industry: one might say dominant feature,
for performers in the Silent Era such as Richard Barthelmess,
Douglas Fairbanks, Lillian Gish, William S. Hart, Buster
Keaton, and Gloria Swanson—all creators of basic screen
types—were more important to a film's box-office appeal
than its story, director, or technical competence.

Since the advent of sound in the late twenties, the exotically
remote, archetypal, and purely romantic fantasy characteris-
tics of stars have given way to a more humanly immediate,
individual, and realistic image. In the past forty years scores
of stars have emerged in the American firmament, and in
recent years leading performers in other national cinemas
have become significant emotional and economic forces in
American life and films. Even in a fragmented and antiheroic
time, movie stars have not lost their appeal. They do not,
however, seem as durable and capable of that "infinite vari-
ety" they once seemed to possess. See further Richard
Schickel, The Stars, 1962, and Alexander Walker, Stardom,
1970.

STEP PRINTER: A film printer (see CONTACT PRINT) which prints the film a frame at a time—similar to the way a film moves through a camera or projector. See also CONTACT PRINTER, OPTICAL PRINTER.

STEREOPHONIC: See SOUND.

STEREOSCOPY: In general, the techniques and apparatus developed to provide for viewers a sense of depth equivalent to the dimensionality characteristic of binocular vision. In stereoscopic cinema, separate left- and right-eye images must be recorded and successfully presented to viewers. This necessitates either special glasses familiar to 3-D film viewers in the early 1950s or special screens that achieve the integration required for stereoscopic effects. On the whole, HOLOGRAPHY seems to offer brighter prospects for three-dimensional movies in the future. See *Focal Encyclopedia* and Gene Youngblood, *Expanded Cinema*, 1970. James L. Limbacher in *Four Aspects of the Film,* 1968, provides a factual history of stereoscopic film. Ezra Goodman in *The Fifty-year Decline and Fall of Hollywood,* 1961, chronicles the 3-D "boom" of the 1950s. See also HOLOGRAPHY.

STOCK: See FILM: FILM STOCK.

STOCK CHARACTER: See ACTING.

STOCK PART: See ACTING.

STOCK ROLE: See ACTING.

STOCK or LIBRARY SHOTS: Motion picture scenes usually obtained from film libraries for background scenes. They are used primarily in process shots or background inserts.

STOP: See CAMERA SPEED.

STOP FRAME: Another name for a FREEZE FRAME.

STOP-MOTION CINEMATOGRAPHY: See CAMERA SPEED.

STOCK or Library shot. Bombs just released from planes over settled area. Copyright 1944 Paramount Pictures, Inc. Courtesy Paramount Pictures, Inc.

STORYBOARD: See SCRIPT.

A sequence of still photographs or sketches which provides, in something like comic-strip form, an outline of the essential action of a film or any of its parts. Especially important in animated films, storyboards are also used in the process of developing details of visual presentation in a film from its verbal blueprint or SCRIPT.

STRIKE: Order to take down the SET.

STROBE EFFECTS or STROBING: (1) The phenomenon most familiar in film as the appearance of spoked wheels revolving backward; this occurs because of the difference between the exposure time (frames per second) and the slower actual rotation time of the spokes in the wheel. This effect can also be caused by too-rapid panning. (2) Filming under the flicker of fluorescent lights. (3) The vertical flip-flop often seen in a movie when a TV screen is filmed because the television picture is not adjusted to the film camera's speed.

STROBOSCOPIC CINEMATOGRAPHY: Shooting film with STROBO-SCOPIC LIGHTING (short intermittent flashes) so that the subject being filmed moves imperceptibly during each period of illumination. The use of such lighting makes high-speed cinematography possible with cheaper and less-complex equipment.

STRUCTURAL FILM: Apparently coined by P. Adams Sitney to describe the work of Peter Kubelka, Robert Breer, Bruce Baillie, Michael Snow, George Landou, Ernie Gehr, Ken Jacobs, and Joyce Wieland. He defines it as follows: "The structural film insists on its shape, and what content it has is minimal and subsidiary to the outline. . . . Four characteristics of the structural film are a fixed camera position (fixed *frame* from the viewer's perspective), the flicker effect, loop printing (the immediate repetition of shots, exactly and without variation), and rephotography off of a screen." See further Sitney's essay and a rejoinder to it by George Maciumas in the *Film Culture Reader*, 1970, pp. 326–349 (edited by Sitney). See also ABSTRACT FILM, AVANT-GARDE.

STUDIO: Term applied (1) to the corporation or company under whose name films appear (e.g., Biograph, MGM, RKO, United Artists, Warner Brothers), (2) the entire physical plant owned by a film company, and (3) the working area or

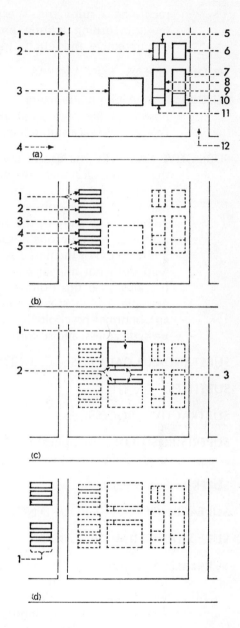

BREAKDOWN OF TYPICAL STUDIO COMPLEX. Access system: 4, public highway, 12, studio road for heavy traffic, 1, studio road for light traffic. (a) Services concerned with preparation of settings. 2. Prop store. 5. Electrical store. 6. Furniture store. 3. Sound stage I (studio). 7. Set store. 8. Assembly, plasterers, painters. 9. Carpenters, joiners. 10. Timber store. 11. Machine shop. (b) Services concerned with artistes. 1. Dressing rooms. 2. Wardrobe. 3. Unit offices. 4. Make-up. 5. Dressing rooms. (c) Services concerned with shooting. 1. Sound stage II. 2. Dark rooms. 3. Camera equipment. (d) Services concerned with finishing the film. 1. Editing suites. From *The Focal Encyclopedia.*

STAGE where shooting and sound recording take place. The *studio complex* embraces the latter two and includes more or less separate areas for set preparation and props, costuming, and make-up, the sound shooting stage, camera and

recording equipment, special visual and sound effects, music recording, editing, projection facilities, and the various executive and administrative staffs.

STUDIO CAMERA: See CAMERAS.

STUDIO FILM: A film made mainly or entirely in a film studio as opposed to a film shot on location. John Huston's *The Maltese Falcon* (1941) is a studio film.

SUBJECTIVE CAMERA: The use of the camera to give the impression that the images seen on the screen represent the field of vision of one of the characters in the film (though not one necessarily directly observed by the audience). Robert Montgomery's *The Lady in the Lake* (1946) is perhaps the most elaborate example of the subjective camera technique; the entire action of the film is seen through the eyes of the hero, who does not appear except in mirrors. Alfred Hitchcock has also used this point of view in *Spellbound* (1945), for example. The most common use is to communicate visually an abnormal psychological or physical condition: drunkenness, dizziness, and so forth.

SUBSTANDARD GAUGE: See GAUGE.

SUBTITLES: See TITLE.

SUBTRACTIVE PROCESS: See COLOR CINEMATOGRAPHY.

SUPERIMPOSITION: The optical or electrical imposition of one scene over another as in lap dissolves, montages, etc.

SUPER-8: See GAUGE.

SURFACE NOISE: See GROUND NOISE.

SURF-RIDING FILM: See GENRE.

SURREALISM: A movement or style in painting and film which seeks to transcend the "real" world and reveal the "super-real" world: e.g., the world of dreams, the unconscious, etc. *Un Chien Andalou*, dir. Buñuel and Dali (1928), and *The Seashell and the Clergyman* (1926) are notable surrealist films. See J. T. Matthews, *Surrealism and the Film*, 1971, and Roger Manvell (ed.), *Experiment in the Film*, 1948.

SWASHBUCKLER: See GENRE.

SYNCHRONIZE: When editing, to place the sound track in such a position with the picture portion of the film that they will "marry"—become one—for a desired effect—most commonly *lip synch*, where lips and words they speak strike the eye and ear at the same time.

SYNCHRONIZER: See APPARATUS and EQUIPMENT.

SYNCHRONOUS DRIVE (also Synch. motor): An electrical drive for a camera (usually) or a projector (for special effects) which runs at an absolutely constant speed, ordinarily determined by 60-cycle A.C. power.

SYNC MACHINE: See APPARATUS and EQUIPMENT.

SWISH PAN: See SHOTS: PAN.

SWISH: See TRANSITION: FLASH PAN.

SWITCHBACK: (1) FLASHBACK, (2) CROSS CUTTING for PARALLEL ACTION. The term was used in both senses during the silent period.

SYMBOLISM: The presentation of a reality on one level of experience by a reality on another level. Suzy's chute in her bedroom in Fellini's *Juliet of the Spirits* (1965) is a sexual symbol. In

SYMBOLISM: Not included in the release version of Von Stroheim's *Greed* (MGM, 1924) this dentist's gold-tooth sign figures in the novel *McTeague* as an element of an important MOTIF. Wisconsin Center for Theatre Research, Leibowitz Collection.

SYMBOLISM in Jean Cocteau's surrealist film, *Testament of Orpheus* (1959).

his *La Dolce Vita* (1959) the fish that is washed up on the beach at the end of the film is capable of many *symbolic* interpretations. In *The French Connection* (1971) the MOTIF of steam vents in the streets of New York is said to *symbolize* the hellish condition of a junk-oriented culture. Symbolism can be verbal (e.g., the concept of poaching in Renoir's *Rules of the Game*, 1939) as well as visual.

SYNAESTHETIC CINEMA: "The new cinema which has emerged as the only aesthetic language to match the environment in which we live. . . . Synaesthetic cinema is the only aesthetic language suited to the postindustrial, postliterate, man-made environment with its multidimensional simulsensory network of information sources. It's the only aesthetic tool that even approaches the reality continuum of conscious existence in the nonuniform, nonlinear, nonconnected electronic atmosphere of the Paleocybernetic Age." See further, Gene Youngblood, *Expanded Cinema*, 1970, pp. 75–134.

SYNCHRONISM: See EDITING.

SYNCHRONIZER: See APPARATUS.

SYNOPSIS: See SCRIPT.

TAKE: The filmic recording of each performance of a specific action. It is usual to make several takes of each shot and to select the best one for inclusion in the picture. Successive takes are usually numbered sequentially and are recorded by photographing the *number-board* or SLATE. The director usually decides how many takes from a given SET-UP are necessary.

TAP DANCE: A dance that is performed with loud tapping of the feet, heel, or toe with each step. The taps function essentially as percussive instruments and underscore the visual rhythms of the body with rhythmic sounds. Ruby Keeler tap-dances in Lloyd Bacon's *42nd Street* (1933) in musical sequences staged by Busby Berkeley. See also SAND DANCE, SOFT-SHOE DANCE.

TEAR-JERKER: See GENRE: WEEPIE.

TECHNICAL ADVISER: See PERSONNEL.

TECHNICOLOR: See COLOR CINEMATOGRAPHY.

TECHNICOLOR MONOPAK: See COLOR CINEMATOGRAPHY.

TECHNIQUE: Generally used to describe (1) any specialized methodology or process (and appropriate skills and equipment) used to solve a particular problem in filmmaking—e.g., lighting, lenses, special effects, and (2) the over-all distinctive quality or "signature" of a director resulting from the creative interplay between the what and the how of a film, its subject and treatment, its content and its form. In this latter sense technique is the equivalent of either the filmmaker's realized vision or his *means* of realizing it.

TELEPHOTO LENS: See VIEWFINDER, EQUIPMENT-LENSES.

10-K: See APPARATUS and EQUIPMENT: BRUTE.

TEST or **TRIAL PRINT:** "The first composite print from an assembled reel of picture negatives with its corresponding sound track." *Focal Encyclopedia*, p. 910.

THEME SONG: A song in a film that represents the film or comes to represent it among the general public: e.g., "Falling in Love Again" is the theme song of Josef von Sternberg's *The Blue Angel* (1931), "Moon River" is the theme song of Blake Edwards' *Breakfast at Tiffany's* (1961).

THIRTY-FIVE MM: See GAUGE.

THREADING: See PROJECTION.

THREE-COLOR PROCESS: See COLOR.

3-D: See STEREOSCOPY.

THRILLER: See GENRE.

TILTING: See SHOTS.

TIME-GAMMA-TEMPERATURE: The "curve" applies to one particular emulsion and one particular developer. It involves the acquiring of a particular contrast wanted by the director for a certain scene. The "curve" involves the plotting of a developing time against developed contrast—or gamma.

TIME-LAPSE CINEMATOGRAPHY: See CAMERA SPEED.

TIME SLOT: See SLOT.

TINTING: A method of coloring a film scene or sequence during processing to represent firelight, moonlight, lamplight, or changes of mood. The method was widely used during the silent period.

TITLES: Generally, any written or printed text introduced into a film.
 Crawling Title, CREEPER or ROLL-UP TITLE: A film title or text that appears to move slowly across the screen either vertically or horizontally. It is made by fixing the title sheet or card onto a concealed drum which is revolved in front of a camera. The creeper-title is often used to display the opening CREDITS of a film.
 Credit Titles: Listing of the actors and technicians involved in the making of a film.
 End Title: The title that indicates the film is at an end.
 Insert Title: A title or text appearing in the main section of the film (rather than at the beginning or end) for the purpose of providing information, commentary, summary, or dates, or to give the dialogue material in a silent film.
 Main Title: (1) The title of the whole film (e.g., *Gone with the Wind*). (2) All the beginning titles, including the film title and the opening credits.
 Pan Title: Any title which moves horizontally across the screen.
 Roll-up Title: See CREEPER-TITLE above.

Strip-Title or Subtitle: A text appearing near the bottom of the projected image, usually providing a translation of dialogue. that is in a foreign language.

Subtitle: See STRIP-TITLE above.

Superimposed Title: A title that is superimposed over screen action; increasingly common for credits.

TITLE THEME: (1) Musical motif or theme that accompanies the showing of the film title and credits. (2) Musical theme associated with or representing the title of the film: e.g., Miklos Rozsa's title theme to Hitchcock's *Spellbound* (1945).

TODD-AO: See PROCESSES.

TONE: (1) The "color" of a photographic image. (2) The mood of a film —its unity is found in the content and style of the picture.

TONING: The method, by chemical action during the developing process, of changing the color—or tone—of a particular photographic scene.

TOP-LIGHTING: See LIGHTING.

T-STOP: A lens calibration system that measures not only the light transmission of the lens, but its light-gathering power as well. Not to be confused with F-stop. T-stop is more definitive.

TRACKS: CAMERA TRACKS. See APPARATUS and EQUIPMENT.

TRADE JOURNAL: Any independent publication habitually read by the members of a specialized industry; the best-known trade journal for the entertainment industry is *Variety*, a weekly. Three dailies which report film-industry news and so on are *Hollywood Reporter, Motion Picture Daily,* and *Motion Picture Herald. Variety* also publishes a daily issue in Hollywood.

TRAILER: See PREVIEW.

TRANSITIONS: Any means used to connect shots. The most common are:

Burn In, Burn Out: Going from or to white (used by Ingmar Bergman).

Cut: The most abrupt and immediate of transitions from shot to shot. It is effected in the laboratory simply by splicing one

shot on another. On screen the appearance of the second shot immediately obliterates the first. See also *jumpcut, match-cut*, below.

Dissolve or Mix: The end of one shot merges slowly into the next; as the second shot becomes distinct, the first slowly disappears.

Fade-in: A shot that begins in darkness and gradually assumes full brightness.

Fade-out: The opposite of FADE-IN.

Flipover Wipe: A rather startling WIPE TRANSITION in which the first shot or image appears to turn over and show the second one on the back of the first. Often used for comic effects.

Iris-in: A shot that opens from darkness in an expanding circle of light. The effect is achieved by use of an adjustable diaphragm (iris) in the camera. Iris effects were frequently used in silent cinema, but have been comparatively rare since the coming of sound films. Some famous examples occur in *Birth of a Nation* (1915), *Intolerance* (1916), and *Greed* (1924).

Iris-out: The opposite of IRIS-IN. The effect is sometimes used today to bring a cartoon to its conclusion.

Jumpcut: A break or jump in a shot's continuity of time, caused by removing a section of a shot and then splicing together what remains of it. On screen the result is often abrupt and jerky, but it is frequently deliberate—as in the films of Godard.

Match-Cut: A transition that involves a direct cut from one shot to another that "matches" it in action or subject matter. This kind of transition is commonly used to follow a character as he moves or appears to move continuously. Film action and continuity are often dependent on match cutting. A striking example is the cut in Kubrick's *2001: A Space Odyssey* from a bone hurled into the air by a prehistoric ape-man to a shot of a gigantic space satellite hurled into outer space by the power of modern technology. This kind of transition is an essential one throughout *Slaughterhouse Five* (1972).

Soft-Edge Wipe: A WIPE transition in which the edge between the two shots is blurred or softened.

Superimposition: The printing of two different shots on the same strip of film. On screen one shot becomes visible through the other. Good examples occur in Renoir's *Grand Illusion* (1937).

Wipe: A transition from one shot to another in which the second shot appears and wipes off the first one, an effect comparable to that of a windshield wiper. Hitchcock plays with this convention in *Psycho* (1960) when Marion arrives at the Bates' motel during a storm. See also *flipover wipe, soft-edge wipe*.

WIPE. Type and direction of wipe indicated by hard lines and arrows. In practice, wipes are often soft-edged and thus less perceptible. From *The Focal Encyclopedia*.

TRANSMISSION: The ratio of light falling on an object compared to the light passing through the object.

TRAVEL FILM: See GENRE.

TRAVELING: See SHOT.

TRAVELING MASKS or MATTES: See SPECIAL EFFECTS.

TRAVELOG: See GENRE.

TREATMENT: See SCRIPT.

TRIACETATE FILM: See FILM.

TRIAL PRINT: See TEST PRINT.

TRICK FILM: See GENRE.

TRIPACK: See COLOR CINEMATOGRAPHY: INTEGRAL TRIPACK.

TRIPLE FEATURE: A film program in which three full-length feature films are shown. See also SINGLE FEATURE, DOUBLE FEATURE.

TRIPOD: A wooden or metal support for a camera. Generally, it has three legs although it may have less. For example, a unipod—loosely called a tripod—has only one leg. The purpose of the tripod is to give the picture a "rock-steady" appearance.

TRIPTYCH SCREEN: A center screen flanked by side screens. The most celebrated use of the triptych screen was in showing Abel Gance's *Napoléon* (1926). The side screens showed commentative sequences relating to the main action which was projected on the center screen. More recently, visitors to the New York World's Fair of 1965 had an opportunity to see

the triptych screen used for Saul Bass' film, *To Be Alive*. On Gance and the triptych screen see further: Kevin Brownlow, *The Parade's Gone By*, 1968.

TRUCKING: See SHOTS.

TRUST: See MOTION PICTURE PATENTS COMPANY.

TURRET LENS: See LENS.

TWO-REEL COMEDY: See GENRE.

TWO-SHOT: See SHOTS.

TYPAGE: In her biography of S. M. Eisenstein, Marie Seton traces the development of Eisenstein's use of nonprofessional actors to play major roles in his silent films to the *Commedia dell'Arte*. In this theatrical tradition individual personalities were not depicted by the players, but "composite portraits of 'types' of people who had been synthesized into one image by and for generations of faithful playgoers. They were, Eisenstein thought, a projection of the audience's own consciousness and an expressive manifestation of the people themselves." In the film *The Old and the New* (1929), the female lead was sought for many months, until Eisenstein found a person who satisfied his conception of the type he wished to depict. See further Jay Leyda's note on typage added to Eisenstein's essay, "Through Theatre to Cinema" in *Film Form*, 1949, p. 9.

"U" CERTIFICATE: A certificate bestowed on a film by the British Board of Film Censors and indicating that the film is suitable for universal exhibition to adults and to children who are not accompanied by adults. See also "A," "H" CERTIFICATES; RATING.

UNDERGROUND FILM: See GENRE.

UNDERWATER MOVIE: See GENRE.

UNIDIRECTIONAL MICROPHONE: A microphone that picks up sound traveling from only one direction.

UNIT MANAGER: See PERSONNEL.

UP SHOT: Synonym for LOW SHOT: See SHOTS.

UPSTAGE: To draw audience attention away from the character ostensibly dominating the action. Originally a term used to

describe literally action of a player during a live performance of a play.

VARIABLE DENSITY: See OPTICAL SOUND RECORDING.

VARIABLE SPEED MOTOR (also called a "wild motor"): A camera motor (sometimes a projector motor) that allows the operator a wide range of speeds—frames-per-second. This change in speed is manipulated by use of a rheostat. This motor is used on a camera recording silent sequences, and sound will later be postrecorded.

VARIFOCAL LENS: See LENS: ZOOM LENS.

VIDEO: A term generally used in television. It refers to the picture portion of a program or film. It comes from the Latin *videre* —to see.

VIDEO-CASSETTES: See CARTRIDGE.

VIDEOCORDER: See CARTRIDGE.

VIDEOTAPE: Recording medium to preserve television transmissions for playback. See CARTRIDGE.

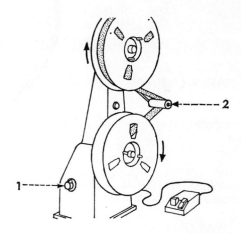

VIDEOTAPE POWER WINDER. Operated by foot switch at side; motor speed controlled by rheostat, 1. Sensing roller, 2, protects against a runaway supply reel by applying a brake and cutting off the motor. Constant take-up tension is maintained. From *The Focal Encyclopedia.*

VIEWER: An inexpensive and simple device for looking at a film print without projecting it. It consists essentially of two winding spindles, a light and a small screen. The film can be drawn through from spindle to spindle at any speed, but the image is inferior and sound is unavailable unless a SOUND READER is attached. See MOVIOLA.

VIEWFINDER: See APPARATUS and EQUIPMENT.

VIGNETTE: (1) A shot resembling a photographic portrait, showing only the head (or the head, shoulders, and upper part of the body), and shading off at the edges into a dark or misty background. John Wilkes Booth is first seen in vignette in *The Birth of a Nation* (1915). Film vignetting or *masking* was evidently an innovation of Griffith's cameraman G. W. "Billy" Bitzer. (2) A technique used occasionally in a film's exposition to introduce characters—as in Chaplin's *The Kid* (1920) and Welles' *The Magnificent Ambersons* (1942). In this sense a vignette is a little self-contained, expository scene.

VISTAVISION: See PROCESSES.

VISUAL LITERACY: See FILM LITERACY.

VISUALS: A term used to distinguish the several aspects of a film's images from elements of its sound.

VITAPHONE: See SOUND.

VITASCOPE: A projector designed by Thomas Armat. It was marketed by the Edison Company and was the projector used in the first commercial (public) film show presented in the U.S.A. This debut took place at Koster & Bial's Music Hall (now the site of Macy's department store) in New York, April 23, 1896.

VOICE-OVER: The voice of a narrator speaking while the VISUALS and other sounds continue.

VORKAPICH: A verb coined from the name of special-effects expert and film theorist Slavko Vorkapich. "To Vorkapich" is to indulge in remarkable special effects.

WALK-THROUGH: A rehearsal, conducted without exposing film in a camera.

WAR FILM: See GENRE.

WARNER BROTHERS BIOGRAPHY: See GENRE.

WEENIE: The object that motivates the main action in a serial—the missing plans, the lost city, the secret formula, the buried treasure. See also McGUFFIN.

WEEPIE: See GENRE.

WESTERN ELECTRIC SOUND SYSTEM (also called "variable density"): A system of sound recording, employing either "single-system" or "double-system" methods. Sound is recorded photographically by the intensity of light falling on the film emulsion.

WIDE-SCREEN: The term applied to a picture shown on a screen that has a ratio wider than the 1 to 1:33 ratio of the traditional motion picture. See also ASPECT RATIO.

WIDE SHOOTING: The term applied to shooting scenes that will be incorporated into a film, but for which no sound is recorded at the time of filming. Sound will be post-recorded.

WILD TRACK: A sound track recorded independently of any picture film. It will later be synchronized with its accompanying picture to give a "married effect." See SYNCHRONIZE.

WHISTLING THE PROJECTIONIST: Typical reaction of an impatient audience when there is trouble in the PROJECTION BOOTH which interferes with normal viewing or audibility of the film.

WHODUNIT: See GENRE.

WIPE: See TRANSITIONS.

WOMAN'S PICTURE: See GENRE.

WORKPRINT: See EDITING.

WOW: A variation in the speed of the recorder or the reproducer which causes the sound to change pitch and not be accepted as "natural."

WRITER: See PERSONNEL.

WURLITZER: Brand name of a popular kind of cinema organ, manufactured by the Rudolph Wurlitzer Company, North Tonawanda, New York. The original Wurlitzer organ was designed and constructed by Robert Hope-Jones. See also MOLLER.

"X" CERTIFICATE: A certificate bestowed on a film by the British Board of Film Censors indicating that the film is unsuitable for exhibition to children under sixteen. See also: "A," "H," "U" CERTIFICATES.

X-RATED MOVIE: See RATING.

X RATING: See RATING.

ZOOM: See SHOT.

ZOOM LENS (also called VARIFOCAL LENS): See LENS.